THE **Better**Photo Guide to
Digital NATURE
Photography

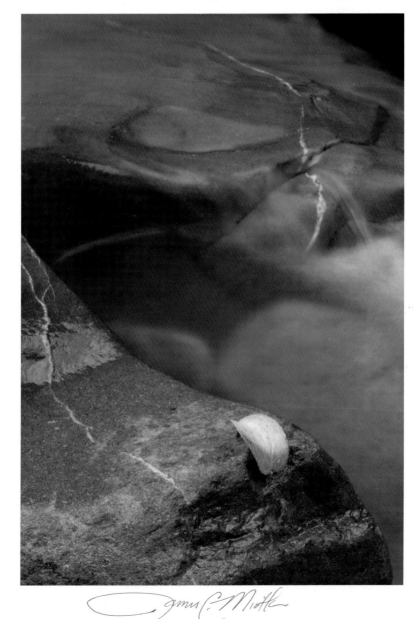

James C. Miotke

153 of 500

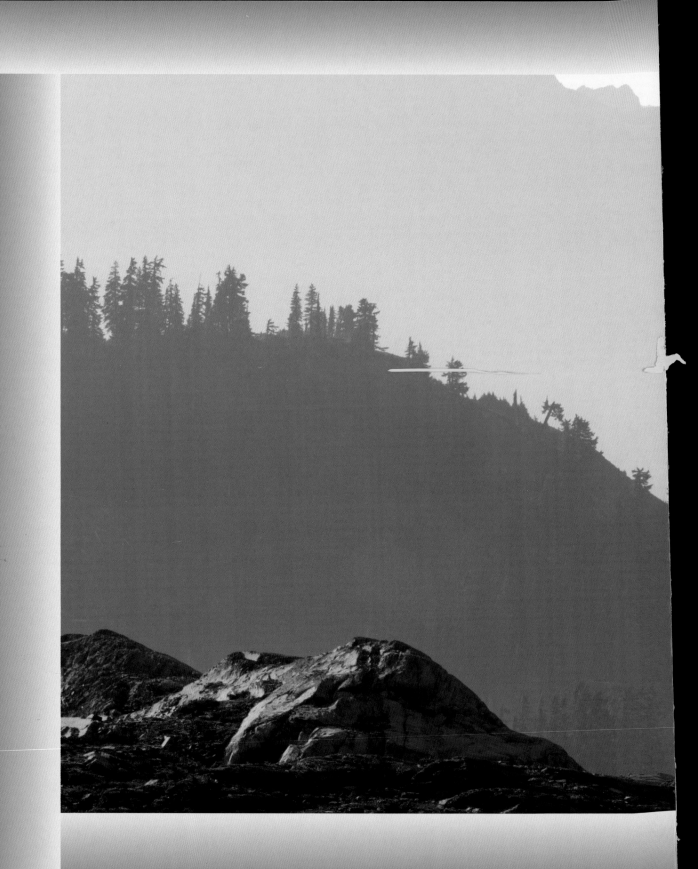

BetterPhoto Guide to

Digital
NATURE
Photography

JIM MIOTKE

AMPHOTO BOOKS

AN IMPRINT OF WATSON-GUPTILL PUBLICATIONS
NEW YORK

PAGE 1: 2 SECONDS AT f/22, ISO 100, 28–135MM LENS AT 27MM

PAGES 2–3: 1/750 SEC. AT f/8, ISO 100, 28–135MM LENS AT 100MM

PAGE 5: 3.2 SECONDS AT f/32, ISO 160, 100MM MACRO LENS

Editorial Director: Victoria Craven
Senior Development Editor: Alisa Palazzo
Designer: Areta Buk/Thumb Print

Typeset in 10.25-pt. Berkeley Book

First published in 2007 by Amphoto Books
an imprint of Watson-Guptill Publications
a division of VNU Business Media, Inc.
770 Broadway
New York, NY 10003
www.watsonguptill.com
www.amphotobooks.com

Drawings by Melody Hauf

Library of Congress Cataloging-in-Publication Data
Miotke, Jim.
 The Betterphoto guide to digital nature photography / Jim Miotke.
 p. cm.
 Includes index.
 ISBN-13: 978-0-8174-3553-0 (pbk.)
 ISBN-10: 0-8174-3553-0 (pbk.)
 1. Nature photography. 2. Photography—Digital techniques. 3. Digital
cameras. I. Title.

 TR721.M56 2006
 778.9'3—dc22

 2006014700

Printed in China

1 2 3 4 5 6 7 8 9 / 15 14 13 12 11 10 09 08 07

Acknowledgments

I am deeply grateful to many people who have helped me write this book. First and foremost, my wife, Denise, has always been my first editor, my business partner, and my best friend. Denise, I owe you big time!

I am also indebted to the team at Amphoto—Victoria Craven, Alisa Palazzo, Areta Buk (at Thumb Print), and Lori Horak—as well as the team at BetterPhoto—Heather Young, Kerry Drager, Jay Wadley, Amy Wadley, Keri Malinowski, Maureen Whitmore, Karen Orr, Brian Hauf, and Tori Martinez. Whether you have been accompanying me on nature photography adventures; designing new home pages; setting up the office; handling sales, customer service, and product development; and so much more, I seriously could not have written this book without your help.

Thanks to Melody Hauf who has again provided her fun drawings, as well as to Marti Hauf and Maggi Foerster, who have again provided a great deal of prayerful support.

Thanks also to the following students who contributed a few images to this book: Terri Beloit, Rob Berkley, Deborah Lewinson, Bob Clayton, Karen Glenn, Cindy Hamilton, Melissa Heinemann, Alicia Lehman, Edgar Monzón, John Richlin, and Kelly Toshach.

In addition, I feel honored to know and work with such great photographers as Tony Sweet, Jim Zuckerman, Brenda Tharp, and Lewis Kemper, as well as every one of the amazing instructors at BetterPhoto. I would also like to thank Jack Warren, Art Wolfe, Jay and Kim Deist, John Baker, Kathy Konesky, Richard Buchbinder, Richard and Sylvia Turpin, Elvira Lavell, and Jana Jirak and the BetterPhoto members. In particular, I give my thanks to the one thousand of you who answered my survey and provided me with pages and pages of questions to answer in this text. And Julian, of course.

To the members of
BetterPhoto
and nature lovers
everywhere

Contents

Introduction

WOULD YOU LIKE to consistently make photos that stand out from the regular, tired snapshots? You've come to the right place. In this book, I share with you the most time-tested, helpful tips that will give your photos that extra something special. Learn these simple techniques and you will immediately be able to create unique, uncommon, and amazing nature shots—consistently!

When I first started writing this book, I invited BetterPhoto.com members to take part in a survey. I hoped to learn what confused photography enthusiasts the most and what people most wanted to learn with regard to digital nature photography. Within a few days, one thousand people responded to the survey! The need for help on this subject was evident, and the questions asked gave me an excellent idea of the direction I needed to take. Overwhelmingly, people cited three things as the top concepts they wanted help understanding: light, composition, and exposure (especially with a digital camera).

These BetterPhoto members knew that working with light is what photography is all about, but they didn't know how to get from point A to point B. And they deeply wished for a command of the technical (and often frustratingly confusing) concepts of exposure, aperture, shutter speed, and ISO. Plus, they wanted to learn more about arranging the objects in their images and about deciding which compositions best fit particular scenes and subjects.

I'm sure that you feel the same way. Therefore, I've structured my book around these topics and added two additional—and equally important—concepts: rule breaking and learning through practical assignments. And, since many people wanted to learn about practical issues (such as planning, packing, equipment, and weather), you'll find Practical Matters pointers throughout the book; these tips are all centered on the real-world stuff you need to know when you go out shooting.

My goal has been to write a book that helps everyone, not just the few who have the opportunity to spend months at a time in the high alpine meadows (i.e., professional photographers). This book is for people with other jobs, with families, with limited financial resources. It's intended to both show you how you can connect with the nature available to you and make the best photos with what you have and what you can afford.

L.C.D.

To help you remember what to keep in mind while you're out in the field, I've come up with the acronym L.C.D., which stands for *light, composition, digital exposure.*

The order of the first three chapters follows this acronym, and then periodically throughout the rest of the book, I will address L.C.D. issues specific to a particular topic. So, for example, in the macro section, I'll mention any lighting, composition, and digital exposure issues and guidelines that relate to close-up photography.

ASSIGNMENTS AND TIPS

Reading about photography is great, but there's nothing like taking what you read out into the field and doing an assignment. Practicing what you've read will help you learn fast, and nothing is better than practicing immediately after you learn a new concept. The assignments will help you do this, and the tips that run throughout the book will provide quick helpful hints and techniques.

BE PATIENT

Be patient with yourself; making great photos is hard work. But, knowing what it takes to make great images will accelerate the learning process for you, and help you make awesome images right from day one. So, take a moment to stop and consider what goes into getting great images.

You have to carefully plan your day. Preparations for photo excursions must be extensive and organized. You have to be disciplined enough to wake up very early and get to work right away. You have be "on" for anything that comes your way. You have to work long hours, often feeling completely exhausted at the end of the day. The reward (in addition to a good night's sleep) is a growing collection of amazing photographs.

You need to be extremely organized, and have lots of initiative and an interest in creativity. Being detail-oriented, flexible, and able to envision how something should be (in other words, being a solution-oriented thinker), with good people skills, will not hurt. Ideally, you should be a real go-getter, able to be your own boss.

Don't rely on luck or chance. Great photographers, like people who are great in any other endeavor in life, put themselves in opportunity's way. And even if there is such a thing as luck, you simply cannot afford to believe in it. You don't have the luxury. Instead, take 100 percent of the responsibility. This is the first step to getting to the right place at the right time.

I was able to get the creative blur effect on these yellow roses using a special accessory called a Lensbaby (see Resources). A Lensbaby is a flexible lens that replaces your traditional lens and that you can push in and pull out. As you move the lens, it selectively blurs different parts of the scene. You can create similar effects with photo-editing software, such as Photoshop, but it's faster and more fun to use a Lensbaby.

1/250 SEC. AT f/11, ISO 100, LENSBABY

SCOUTING

You'll be much more likely to get to the right place at the right time and get great photos if you visit locations before you photograph them. You must "see" the subject before you can photograph it, and it's easier to see the subject if you've been on site. When scouting, scan the environment for things that will help your image stand out. When I look for subjects, I keep an eye out for the following items:

❏ **Subject.** This is the "star" or "main attraction" of the composition. What I'm after is a good focal point. I get subject ideas from researching magazines, from postcards, and from Web sites.

❏ **Light.** I look for the best light to express my idea or interpretation of the subject.

❏ **Background.** There should be an interesting— but not too interesting—"supporting cast" in the background.

❏ **Foreground.** I look for elements to spice up my wide-angle landscape photos.

❏ **Color.** I look for wildflowers and any other objects with warm colors in them, especially red.

❏ **Weather.** The edge of a storm or of an ecosystem makes for interesting photography (for more on this, see the image on page 39).

❏ **Graphic elements.** These are such elements as line, pattern, form, texture, and shape.

I then follow two main rules as I scout: (1) have a general plan but also a willingness to be flexible (I stop whenever I see something that excites me, whenever I feel inspired); and (2) look for "happy accidents" and hope for the best.

WHAT'S SO DIFFERENT ABOUT DIGITAL?

Truth be told, most of what you read in this book applies equally to both digital and film photography. Many of the techniques and principles—whether they involve composition, light, aperture, or finding the best subjects—are the same whether you're shooting film or digital.

You may, however, still feel confused by your new digital camera. Even if you have transitioned from film to digital and you fully understand the principles of photography, you may feel at a loss. The reason, most likely, is that you need to get familiar with the new camera knobs, dials, and buttons. Beyond that, there are only a few things that are truly different.

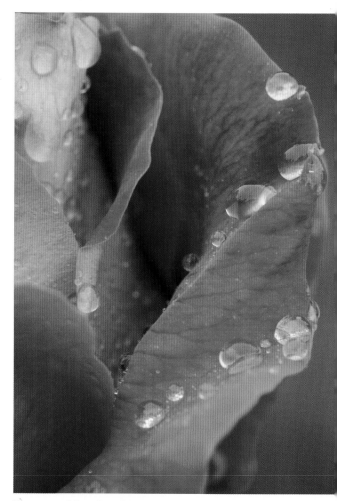

The curve of the edge of this rose petal and the beads of water drew me to this composition.
1/20 SEC. AT f/8, ISO 320, 100MM MACRO LENS

My All-Time Most Life-Changing Tips

I want to help you get going right away. If you only have enough time to read a small slice of this book, read this section. The following ideas each represent a major turning point for me in my photographic career. When I put each of these teachings into practice, the quality of my photographs dramatically improved. (The page numbers direct you to more in-depth related information.)

❏ Use an autofocus digital SLR camera. Equipment does matter.

❏ Use a lightweight but sturdy tripod, along with a remote shutter release. (see pages 118, 141, and 206)

❏ Shoot at dawn and dusk. For sunrise photography, get to your desired location *before* sunrise. For sunset photography, stay at your location till *after* the sunset. If you need a break, relax during the midday hours. (see page 32)

❏ Use the Rule of Thirds. (see page 54)

❏ Use graduated neutral-density filters to reduce the extremes in high-contrast scenes. (see page 72)

❏ Use a polarizer to increase color saturation. (see page 74)

❏ Control depth of field by selecting the right aperture number. Smaller numbers minimize depth of field and isolate a subject; larger numbers maximize depth of field and bring the entire scene into focus. If you have one on your camera, use the depth-of-field preview button. (see page 64)

❏ Intentionally blur your subject or its surroundings for interesting creative effects. (see page 174)

❏ Plan it, scout it, treat it like a job. Write up an itinerary or schedule for any upcoming photo trip.

Look at tourism Web sites, review work by other photographers of the place or subject on which you'll be focusing. Write down photo ideas, and collect photos that inspire you. Check the weather forecasts. Scout the place, but don't leave your camera behind. Never scout without your camera—carry it everywhere you go.

❏ Carefully back up your digital photos/files. (see page 209)

❏ Use the histogram to judge exposure, and use camera raw to interpret exposure, white balance, and many other factors back at the computer. (see page 80)

❏ Treat the natural world (plants, flowers, and animals, as well as other photographers, locals, and tourists) with kindness and respect.

❏ Include an interesting element in the foreground when photographing wide-angle landscapes. (see page 52)

❏ Aim to capture *story* and *character* when you shoot. (see page 178)

❏ Ask people you meet if you can take their picture. Do people belong in a nature photo? Yes, adding people to your nature scenes can often add a great deal of interest. (see page 130)

❏ Don't wait to put these tips into use. Don't do what I did and read about these techniques countless times before putting them into action. Often, I was surprised by my success when I finally got around to actually incorporating a particular technique into my planning and shooting routine. Take my word for it. Don't wait! Your journey to successful picture-making will be all the quicker if you start utilizing the above techniques today.

Everybody knows that you can take many photographs without a concern in the world for film and developing (although, this is a bit misleading since you may still have to worry about printing your photographs or uploading them to the Web one way or the other). The truly revolutionary differences between film and digital photography have to do with the LCD screen, the metadata being stored with each image, and the histogram, and I'll cover each of these more in the chapters that follow.

Seasoned film photographers will appreciate two other changes that come with digital technology:

1 Issues related to using the right film for the type of light (i.e., tungsten- vs. daylight-balanced films) are handled with something referred to as white balance on digital cameras. The digital advantage is that you can change your white balance setting in midstream. You no longer have to remove one roll of film from your camera and replace it with another when the light source changes.

A Note about the Images

Although all of the images in this book have been "optimized" in Adobe Photoshop, none have been greatly altered. By *optimizing* I mean enhancing color, correcting problems with contrast, removing dust spots, sharpening, cropping, and resizing. These are a few of the things that, in general, every image needs. For the few photos to which I added a color that wasn't really there, I'll tell you in the captions.

Also, most of the animals in this book were photographed in controlled situations. So, unless otherwise noted, the animals were photographed in captivity or in wildlife refuges. And lastly, I made all of the photos in this book with a digital single-lens-reflex (SLR) camera, with about a dozen images being contributed by students in my online photography course.

2 You can change ISO settings on the fly, thereby defeating your ability to "push" or "pull" film. You cannot push digital technology like you could film, but if you learn how to shoot and interpret raw files, you won't be concerned about pushing your exposure anymore. You can do it after the fact when you open up the file in photo-editing software. Of course, this doesn't help those who like to push film to get a faster shutter speed. The ability to increase ISO and adjust white balance on the fly, though, certainly makes up for this.

Bottom line question: Will you be able to get the same beautiful colors with digital that you used to get with film and, in particular, with slides? You bet! Digital technology has advanced beyond this standard of quality and continues to surpass it every year.

YOU HAVE MY PERMISSION . . .

I hereby give you my full permission to make your best effort to replicate the images that I've photographed for this book. Go ahead, flip through this or any of my other books, and note the pages with pictures you'd like to try to create for yourself. Use my photos as a starting point. I do my best to make it easy for you by explaining exactly which techniques I used to create each image.

I'm not worried about plagiarism. The truth is that it's practically impossible to take the exact same photo as another person, as long as you're making photographs for the right reason—to have fun being creative. If you try to replicate my work with this spirit at heart, I'm convinced you'll come up with something original. In fact, as I mentioned earlier, it's my goal that you make better photographs than you've ever made before, consistently. Like any other hobby, the basics of photography need to—and can be—learned. Once you learn these basics, you immediately begin capturing good photos and having a blast in the process.

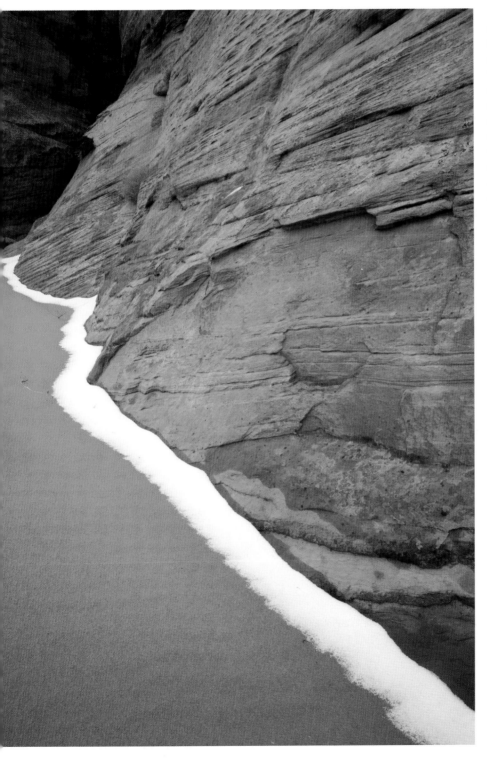

This photo illustrates the kinds of things I'm looking for when I scout locations and search for subjects: the wonderful clean line and the contrast between the white snow and the rich orange sand and rock. I found this spot traveling through the Southwest, when I stopped along the highway at a location recommended by a local guide and hiked up into the hills.

1/15 SEC. AT f/20, ISO 100, 16–35MM LENS AT 21MM

Preliminary Questions

Before you being photographing, give some thought to the following camera settings and visual concepts. To change the settings I mention here, crack open your camera manual for specific instructions.

Which Color Space Do You Want to Use?

If your camera features the choice, switch the color space to Adobe RGB. It's ideal to use the largest color space (i.e., color spectrum) available, and Adobe RGB is usually it. It's not a problem to convert from Adobe RGB to sRGB later, but you generally don't want to go in the opposite direction (from sRGB to Adobe RGB). If color information isn't captured in the first place, you cannot put it back in.

Do You Want to Photograph in Raw or JPEG Format?

To answer this question, first ask yourself whether you find working on your computer fun and relaxing. If you prefer "doing it yourself" and maintaining full control to the ease of "farming it out," then you're a good candidate for using the *raw* image file format, also called *camera raw*. Raw format is awesome because it makes it easy to reinterpret an image in the future. As both your ability to shoot and your photo-editing software skills improve, you'll be much more equipped to make a fantastic final image or print out of the "digital negative" that is your raw file. If you're serious—if I've successfully created a photo monster out of you—then you'll love the benefits of shooting in camera raw.

If you don't feel that comfortable yet manipulating your image in a photo-editing program, or you are just not that interested in spending additional time in front of your computer, then JPEG format (which takes up less memory space) may be fine for your needs.

What Is Beauty?

This is always a good thing to start thinking about when approaching the visual arts. I remember one day, back when I was in junior high school. As I was walking to school, a thought came to my mind that greatly intrigued me—and has continued to intrigue me since: What is beauty? It suddenly seemed so odd and arbitrary that one thing should be considered more beautiful than another. Who got to decide the definition of beauty?

At the time, I was most concerned with how this question related to girls. But now that I've grown up, I think about it in relation to sunrises, silhouettes, misty mornings, and glowing flowers.

So, what defines beautiful subjects for the digital photographer? There are so many things you can photograph. For the nature photographer, natural landscapes, macro details, flowers, and wildlife make

up the four basic subject areas—and they also cover a wide gamut. As you read each chapter, however, you'll get a better idea of what to look for when seeking subjects that are beautiful to your eye.

Don't limit yourself to a particular subject. When I go out with the intent of photographing beautiful coastal seascapes, I often get distracted and spend the whole day shooting flowers or a grove of trees that I found on the way to the beach. Be flexible and have fun when exploring the world around you. Switch gears whenever you feel inspired to do so. If you want to go back to your original subject, go ahead. There are no limitations.

As you explore each subject, be open to your emotional response to it. Slow down, and let this response soak in. Once you do this, you'll be able to creatively experiment—and see more of the natural beauty around you. You'll be able to express this beauty and your emotional response to it in your images. If you succeed, other viewers of your images will also have an emotional response to the scene. That is photographic success! And, that is beauty, too.

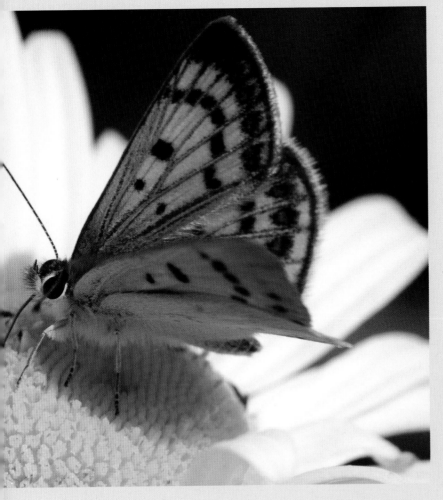

This image is a good example of the need to be flexible when searching for beauty in the natural world. I was originally interested in photographing fields of wildflowers set against a beautiful blue sky. However, when I noticed this colorful butterfly, I changed to a macro lens and worked quickly to capture the beauty of this scene.
1/200 SEC. AT f/14, ISO 200,
100MM MACRO LENS

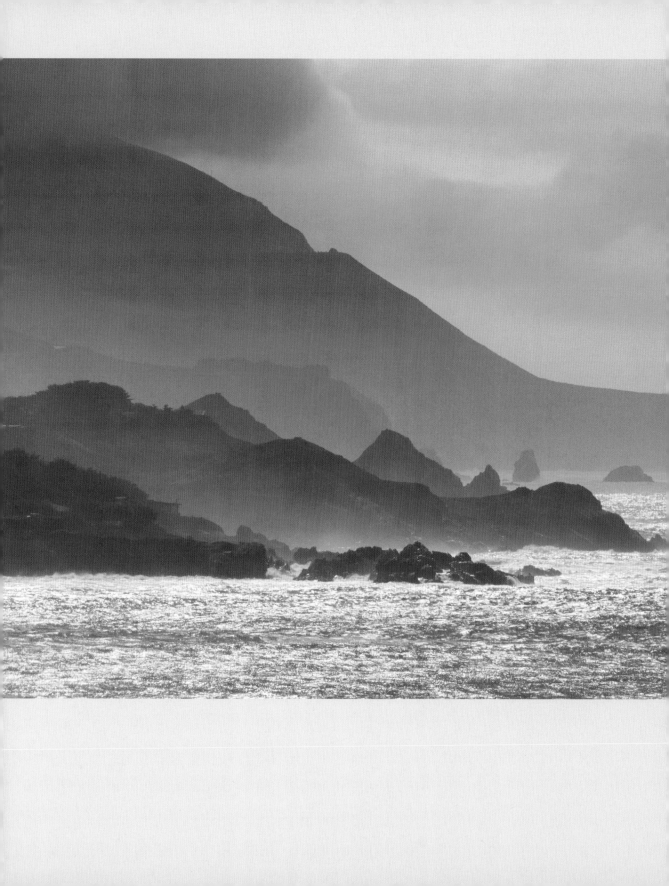

Light

THE WORD *PHOTOGRAPHY* comes from the Greek for *light* (*pho*) and *painting* (*graphe*), meaning, literally, painting with light. There's no doubt that light is *the* critical component when making photographs, which is why it is the first element in my L.C.D. acronym. For a nature photographer, the key is first to recognize the kind of light you have to work with and then to select the most fitting subjects for that light. Unlike painters, who can choose a different color at any moment, photographers must make the most out of the particular kind of light they are given.

While traveling down the coast, I wanted to make sure I had at least one image in case the weather changed. I'm glad I stopped when I did because the clouds rolled in just after I made this photo, and the good light disappeared. Although I took this shot in early afternoon, I gave it a late-day appearance by altering the color using the white balance controls in Photoshop's Camera Raw dialog box.
1/1000 SEC. AT f/11, ISO 100, 70–300MM LENS AT 300MM

Quality

ONE OF THE MOST important questions you can ask when preparing a shot has to do with the character or quality of the light. Is it soft and even or hard with high contrast? Is it a dull, bright, overcast light or a harsh, direct light? Is it warm (reddish) or cold (bluish)? To determine the character of the light, first look at any shadows in your scene. Hard, crisp shadows denote harsh, direct light. Soft shadows (or no shadows at all) denote a soft light, ideal for photographing wildlife portraits or colorful subjects.

So, what makes one kind of light more attractive than another? This is the key question. Light appreciation is best learned though experience, so I encourage you to spend time outside making photographs as you learn. Get out shooting in various types of light, and carefully examine your images back at home at the computer; if you don't have the computer hardware or software, you can have prints made and examine those. The goal here will be to break down the various ingredients of "good" light so that you know what to look for and how to analyze your work.

In general, there are three elements of light that affect its quality or character: intensity, direction, and color. The next few pages explore each of these components, as well as the key to successful nature photography: shooting at the right time of day.

ASSIGNMENT **Before You Start . . .**

Before you start making more images, collect the ten best photos you've ever made, as well as ten of your photos that don't quite work. Carefully study each image, writing down your answers to the following questions:

❑ Is the subject frontlit, sidelit, or backlit? (See pages 24–29 if you're not sure.)

❑ Was the image taken at or around sunset, midday, or early morning?

❑ Which creative exposure techniques, if any, did you use?

❑ Is the subject centered, placed according to the Rule of Thirds (see pages 54, 112, 156, and 194), or filling the frame (see page 150)?

❑ What is the problem with each image in the reject group? Why is each image failing?

❑ How many of the winning photos involved the use of a tripod, special filter, or other accessory?

Carefully study all your answers for both groups of images. What do you learn? Go over your notes and choose the lighting, exposure, and compositional techniques that stand out to you. If you make any discoveries, shoot your next subject with these in mind. You'll be amazed at how much this simple exercise will teach you about light, exposure, and composition. It will prepare you for your next excursion and give you focus, direction, and an understanding of what works best for you.

It was a bright day when I made this image, but the sunlight was somewhat diffused by the light cloud cover. If you are treated to a sky like this, include it in your composition; if the sky is dull, exclude it.

1/250 SEC. AT f/6.3, ISO 100, 28–135MM LENS AT 28MM

Intensity

THE LIGHT LEVEL in a scene—i.e., how bright or low the light is—is referred to as the *intensity*. Many students ask me for the secrets regarding what is traditionally called *low-light photography* (for example, shooting at dawn, at dusk, during twilight, at night, within dark forests, and in overcast conditions). Truth be told, almost all of my photographs—and certainly most of my favorite nature photographs—could be considered low-light images.

The fact is that conditions are usually best in marginal, low-light situations. I've made most of my favorite shots at sunrise or sunset, or in foggy, misty, or overcast conditions. This is counterintuitive to what most people think: that perfect blue-sky days are the best time to take out your camera. You can get great images under blue skies (especially if you use a polarizer to saturate the blue tones), but you will capture some of your best images under low-light conditions.

So, the tricks of low-light photography are really the tricks of all good photography. You will want to use a tripod almost all of the time and a remote shutter release whenever your shutter speed dips below 1/30 sec. You will want to get to the right place with enough time to prepare *before* the best light occurs. You will want to determine

What If Your Image Is Too Low-Contrast?

Since I often shoot in soft, low-contrast light, I usually end up with images that are too low in contrast. The colors don't "pop"! The solution is simple. When I open the image file in Photoshop, I immediately increase the contrast. This is a relatively easy thing to do in the camera-raw conversion process, in Levels or Curves.

TIP: USE YOUR TRIPOD

It would have been impossible to make over a third of the images in this book without a tripod. Without a tripod, you cannot shoot long exposure special effects (such as silky waterfalls), panoramas, and montages. Your depth of field choices will always be limited, and you will find it more difficult to use filters (such as the graduated neutral-density filter that I use when photographing landscapes). Even when you're not attempting any special effects, your tripod will keep you from discarding many almost-great photos (images that didn't make the cut due to slight blur). I could have shot many of my wildlife photos without a tripod, but the majority would have turned out soft due to camera shake. The same thing applies to macro and flower photography. You'll get to keep many more favorite photos if you habitually use a tripod.

what your subject is—what is most attracting you to a scene—and do everything you can to create a photo that speaks about only that subject, saying only what you want it to say.

BRIGHT OVERCAST CONDITIONS = NICE SOFT LIGHT

With all this discussion of low-light situations, you might wonder if bright days provide good photographic opportunities. Sure. You can make amazing nature images under bright light, especially when this bright light is softened by an overcast sky. I sometimes refer to bright overcast conditions as giant soft boxes. Commonly used in studio photography, soft boxes (as well as umbrellas and other diffusive devices) are accessories you place around a light source to soften the light. Direct light is harsh; soft indirect or diffused light can make your subject radiant and beautiful.

Soft light is wonderful for rendering color. If your flower photographs, for example, look strange, as if all the colors in the flowers are bleeding together, you're probably photographing in a strong, direct light. Try photographing the same subject in shade, on a cloudy day, or at dusk and dawn. You'll find that shade helps with color saturation, as long as you warm the light (more on this in the white balance section on page 42). If you're blessed with a bright overcast day, you'll find that this soft light does wonders for color saturation. Soft light is often easier to work with and expose properly because it is a low-contrast light.

This macro photo of dogwood blossoms, taken on an overcast afternoon in Yosemite Valley, is a good example of a subject in soft light.
1/60 SEC. AT f/2.8, ISO 200, 100MM MACRO LENS

Direction

LIGHT CAN COME from many different directions and hit the subject from different angles, and it's helpful to consider the location of the light source and the angle of the light when you make nature photos. Since we're talking about outdoor nature photography here, I'll refer to the light source as the sun, which it almost always is for our purposes, but these same concepts would apply for artificial light, as well.

FRONTLIGHT

When the sun is behind you, and the light hits the part of the subject that you see (or that is facing you), this is called *frontlight*. Frontlight can be good for color. Hard, direct frontlight, however, can wash out texture and make your overall image appear dull, flat, and lifeless. During the middle of the day when the sun is high in the sky, colors may appear less saturated, and your background may be distracting. Frontlight is better when the sun is low in the sky, for example when photographing a mountain peak illuminated by a warm sunrise or sunset.

When there are bold colors or a variety of colors in your scene, low direct frontlight works well. When you're photographing a big slab of gray rock or rushing white water, on the other hand, frontlighting is generally not the best (better to use soft overcast light).

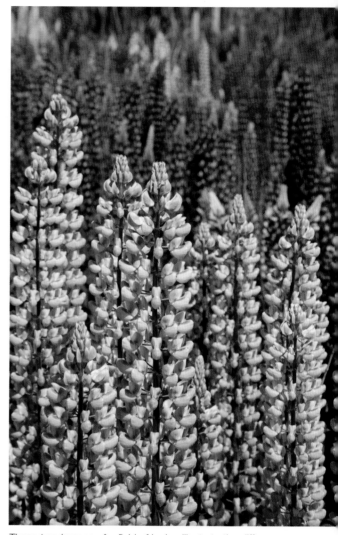

These two images of a field of lupine illustrate the difference between frontlight (above), which washes out the color a bit, and backlight (opposite), which results in richer, more glowing color.

ABOVE: 1/250 SEC. AT f/18, ISO 400, 28–135MM LENS AT 135MM;
OPPOSITE: 1/200 SEC. AT f/18, ISO 400, 28–135MM LENS AT 135MM

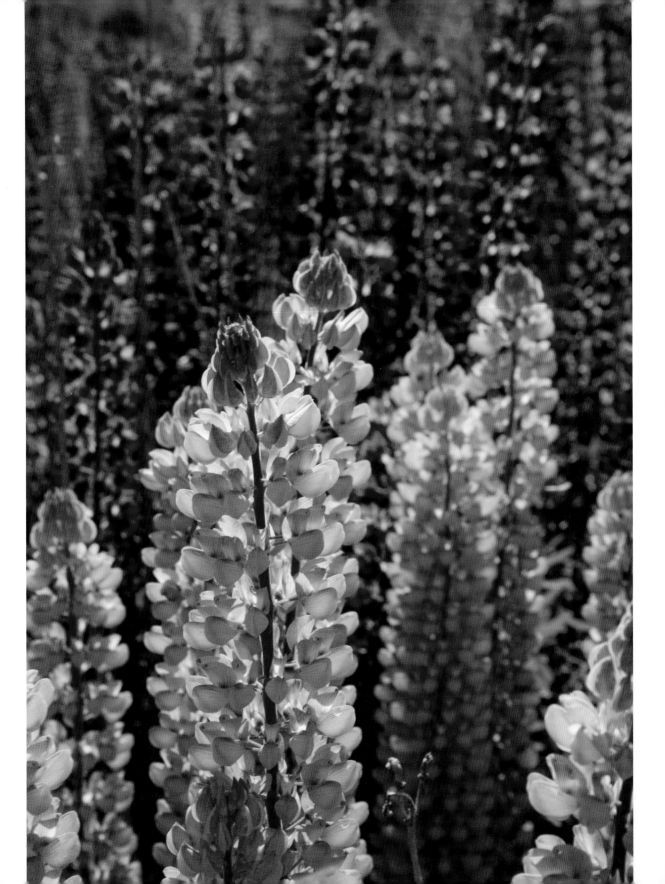

BACKLIGHT

When the sun is generally in front of you and behind your subject, this is called *backlight*. Whenever you point your camera toward the sun, you're shooting a backlit subject. Backlight can be tricky in that it can fool your camera meter, and errant beams of light can get into your lens and cause a problem known as *flare*. For this reason, frontlight is generally less problematic and easier to work with. However, backlight can help you create interesting effects. It can be dynamic and glowing, and it can produce clean silhouettes.

You don't have to render every backlit subject as a complete silhouette. This backlit exposure maintains some of the detail in the cacti while also making good use of rim lighting (backlight that illuminates the rims of a subject, making them seem to glow).

1/125 SEC. AT f/4.2, ISO 200, 70–300MM LENS AT 85MM

PHOTO © BOB CLAYTON

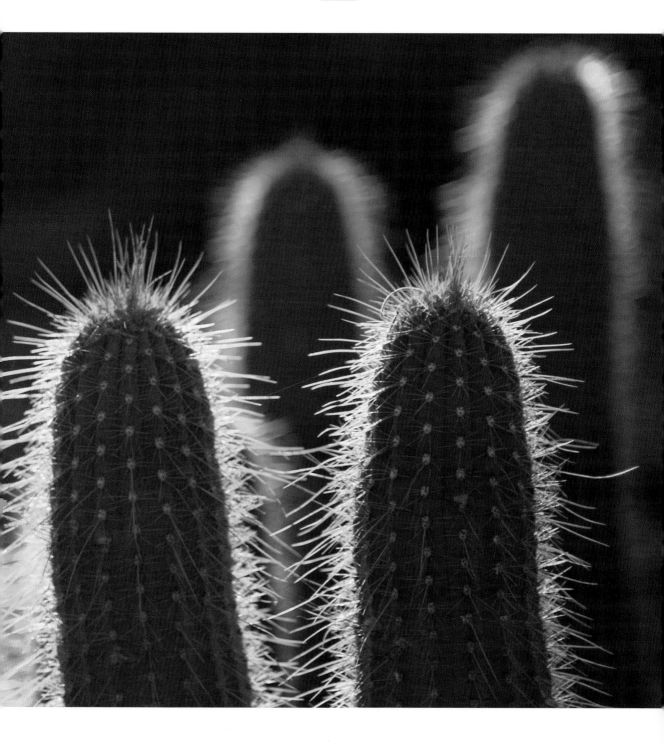

SIDELIGHT

When the light hits your subject from the side, that is *sidelight*. Sidelight can accentuate the three-dimensionality and depth of a scene, making the subject (especially one with texture) look more interesting. Even slight shadows add drama and give viewers something more enjoyable to look at. Light that comes from directly above, as when the sun is high in the sky, is another form of sidelight that some photographers refer to as *toplight*. Generally, such light is not particularly effective for photography. This overhead light is often harsh, producing hard-edged shadows and dull colors.

Sidelight that is not toplight, however, brings out texture. It increases the amount of shadows and heightens contrast in a scene. The light that results when the sun is low in the sky is also better for sidelighting than overhead midday lighting. Think end or beginning of the day as the best time for using this low sidelight. In addition, since you'll be at a 90-degree angle to the direction of the sunlight, consider using a polarizing filter; shooting in sidelit conditions is the time when the polarizer will be more effective.

How Do I Get Good Light?

Some students ask me how to get the good light. Upon further discussion, it becomes clear that what they're really asking is, "How do I get good light when I'm out shooting?" The question implies that you're working on your own schedule and then hoping that great light happens to swing by when you're out. What you really need to do is build your schedule around the light. Base your day on the fact that the good light is much more likely to occur early in the morning and late in the day, and then plan your other tasks around this photography schedule.

This starfish on a rock in Point Lobos, California, provides a good example of sidelight. Note how the variation in the brightness on the starfish accentuates the creature's form and texture.

1/80 SEC. AT f/4.5, ISO 100, 16–35MM LENS AT 16MM

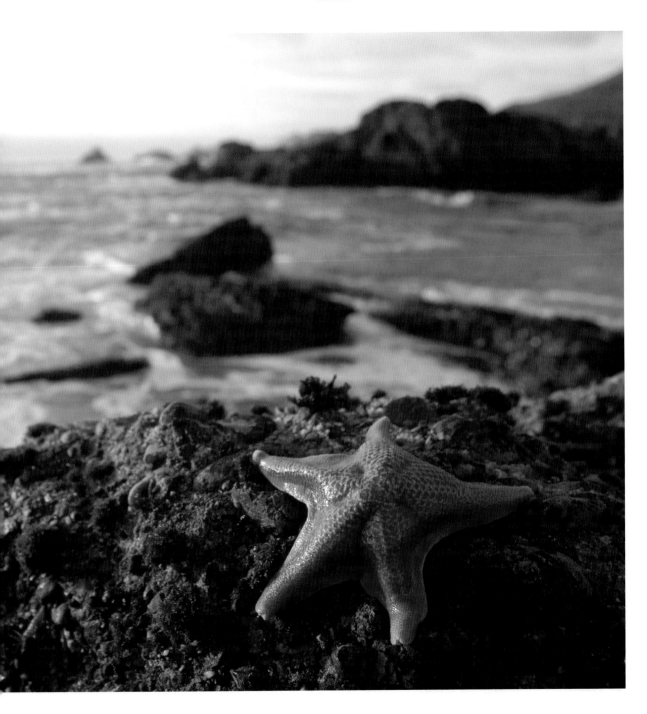

REFLECTED LIGHT

Soft light isn't always the answer to capturing colorful, beautifully lit scenes. Sometimes, you'll be blessed with reflected light that perfectly suits your subject. When water is in bright sunlight in the background of a scene, for example, use it to create beautiful specular highlights. These are the hexagonal or octagonal shapes often seen in the background in images of subjects that have a lot of highlights. You'll see this effect, something I like to call "the dance," when you photograph backlit dew on spiderwebs or plants. Specular highlights result when out-of-focus dewdrops become large globes. These globes of light take on the multisided shape of your aperture. Small aperture numbers, such as f/2.8, produce globes that appear as smooth circles. If captured in an organized, nondistracting way, such geometric elements in your background can add a touch of visual excitement to your scene. The sparkles on a body of water can also add a delightful dance of light to an image.

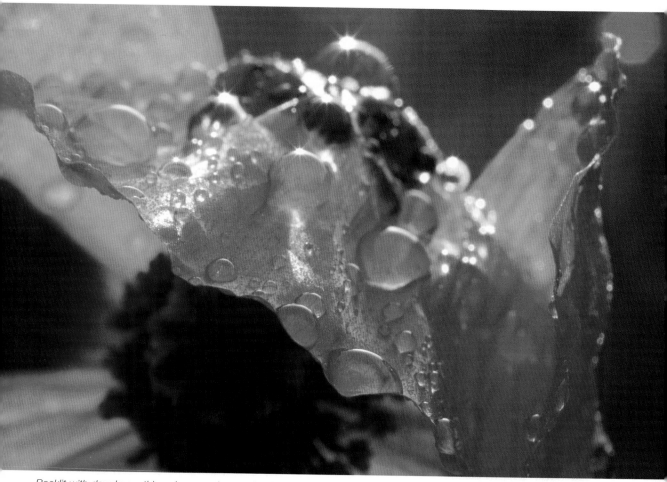

Backlit with dewdrops, this red poppy shows what I mean by "the dance." Look for this dance of light whenever you're photographing a scene with water in it. As you can see here, backlight also plays a huge role. Backlit dewdrops or raindrops can be a fantastic source of this sparkling light.

1/6 SEC. AT f/22, ISO 100, 100MM MACRO LENS

Avoiding Lens Flare

Lens flare occurs when light falls directly on the front element of the lens. The result can be a reduction in contrast or a blown out area in the final image. Think of the inside of your lens as extremely sensitive to direct light. To avoid lens flare, simply shade the front element of your lens with a lens hood to keep light off it. If you don't have a lens hood, try shading your lens with something else, like a hat. Just make sure the hat doesn't accidentally find its way into the composition.

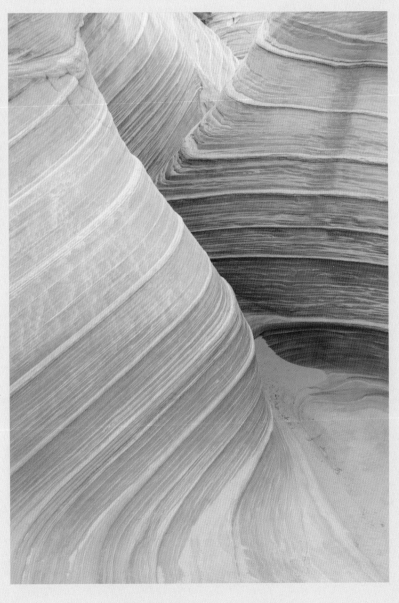

I positioned my hat just above the top edge of my lens to shade it and avoid lens flare while photographing The Wave in Coyote Buttes.

ABOVE: 1/25 SEC. AT f/10, ISO 100, 28–135MM LENS AT 135MM; RIGHT: 1/13 SEC. AT f/10, ISO 100, 28–135MM LENS AT 135MM

Time of Day

HERE'S THE TRICK most successful photographers swear by: Shoot in the early morning and late afternoon. The truth is that you'll find it much easier to get both colorful and dramatically directional light if you're outside at those particular times of day. Just by going out at the right hours, you'll take better pictures. It's as simple as that.

All you have to do is either get up early or stay out late. Sometimes you have to be willing to skip a meal in order to get the great photos. The most successful photographers often rise before dawn to get a head start on the sun and take advantage of the early-morning light. You, too, can shoot with the same degree of success; often 90 percent of the job is simply getting out there when the light is the most interesting. These special times of the day give you much more to shoot than sunrises and sunsets. They provide you with a wide variety of potential subjects in their best light.

> ### TIP: LEARN ABOUT LIGHT
> ### BEFORE YOU SCOUT
>
> Many photographers scout locations during the harsh midday light (since that light is not as conducive to photography). But you should only scout in midday if you've learned how to imagine different lighting conditions—i.e., what a scene would look like in a different light. If you can do this, then by all means, scout during the day when the light is less colorful and more direct.

SUNRISE

If you want to capture the best landscapes, go out in the morning. Get into the habit of shooting from about a half hour before sunrise to about 10:00 A.M. After 10:00, you can feel free to turn off your camera, relax, eat lunch, read a book, or take a nap through the midday hours.

This time guideline isn't limited to landscape photography; pictures of wildlife and smaller details (in addition to grand vistas) also benefit from morning light. The soft light from a sun that's low in the sky can cast a very flattering glow on any subject. Sure it's a bit challenging to not get grumpy when you make the effort to get out early and the sunrise isn't spectacular. But when this occurs, you can shoot other things such as macro subjects, and at the very least, you will have scouted a new place and time combination.

Most photographers, across the board, shoot at the end of the day, not at the beginning. It seems that only the most dedicated photographers get up before the crack of dawn to go take pictures. Those who don't are missing out. Sunrise can be fantastic! Lakes often turn into mirrors, reflecting the surroundings in perfect stillness. There are often few people around; most are still in bed stretching their arms and blinking the sleep out of their eyes. And who can blame them? Who wouldn't rather be in a warm and cozy bed instead of freezing in the shivering cold? Resist this temptation. Fight the thought that tugs you back into bed, and instead force yourself to get shooting so that you can take advantage of the early light.

From personal experience, I know of nothing better than the feeling of creative satisfaction, gratification, and serenity that comes after a successful morning making photographs. I know that I already have some images of value from my morning shoot and that everything isn't riding on how well my sunset turns out. With the whole day ahead of me, I've already "gotten the shot." This is a much happier place to be than waiting for the afternoon light, unsure if you're going to have favorable conditions. Once you've had this experience, you won't settle for anything less than taking advantage of every morning opportunity you get.

SUNSET

During the late afternoon and evening, the light can become especially warm. Due to the warmth, this may be an even better time to photograph wildlife than the chilly early-morning hours. More animals may be out and about, and the late light can cast a gorgeous glow on your subjects.

If a sunset catches your attention, by all means, take advantage of it and make images of it. Once you finish, however, turn around and look at what the sunset is illuminating. Photographing any subject, from landscapes to details to animals, washed in this golden light will likely result in a great photo.

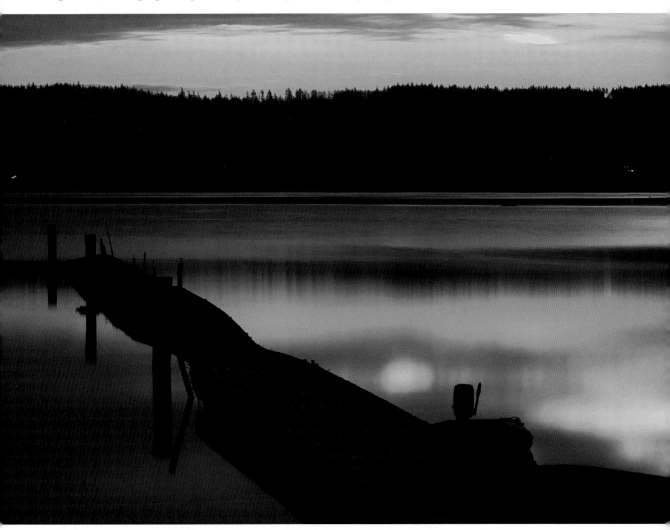

When photographing with student John Richlin, I was deeply impressed by two great qualites: (1) He likes to shoot in the rain; and (2) He doesn't mind getting up early to photograph the sunrise. This latter quality paid off big-time for John when he arrived early at Honeymoon Bay on Whidbey Island in Washington State. After mounting his camera securely on a tripod, he selected a middle-of-the-road aperture and a long shutter speed. The result speaks for itself!

15 SECONDS AT f/8, ISO 200, 70–300MM LENS AT 70MM

PHOTO © JOHN RICHLIN

SHOOT NOW OR COME BACK LATER

Dedicated nature photographers look at each scene to determine the best time to shoot. If they determine a different time of day will be better, they will come back to photograph the scene later. This is often required to get the best photos. However, most of us have limited time before we must return to our other responsibilities and obligations. We sometimes have to compromise quality for practicality. Even if we have the patience to wait for light, sometimes it simply isn't cost effective. If you cannot return to a scene at a more colorful or more magical hour, here are a few tricks:

- ❏ Use a graduated neutral-density filter to even out contrast.
- ❏ Use a pink, blue, or tobacco graduated filter to add a bit of color to a scene.
- ❏ Experiment with white balance (see page 42) to give the scene an unusual wash of color.
- ❏ Use a flashlight or reflector to increase the intensity of the light.
- ❏ Use a diffuser to soften the light.

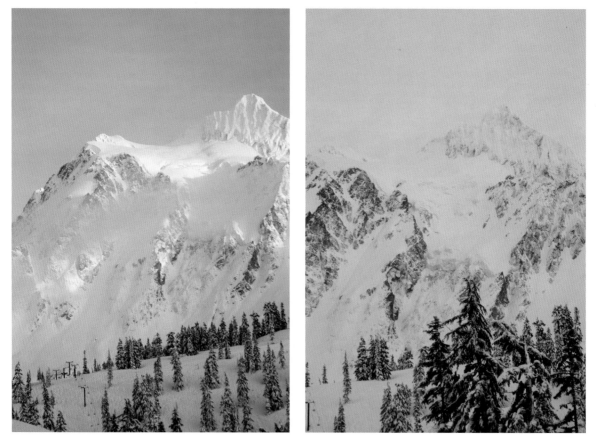

These images of the same mountain were created within only minutes of each other. Light can change in the blink of an eye. This is one reason why I'm inclined to shoot whenever I'm presented with interesting light, regardless of subject matter. I would rather do this than bet on the good light remaining or on better light developing later. Within fifteen minutes of making this first image, the horizon became enshrouded in low, dull clouds that cut off the sunlight completely. I was robbed of the glorious last light of the day, but this happens all the time—and is the main reason why I prefer to "shoot first and ask questions later."
LEFT: 1/15 SEC. AT f/22, ISO 100, 28–135MM LENS AT 117MM; RIGHT: 1/6 SEC. AT f/29, ISO 100, 28–135MM LENS AT 135MM

Remember that getting yourself to the right place at the right time is the name of the game when it comes to capturing the best nature images possible. Research plays a huge role in winning this game. Use the Internet to gather information, or ask people who've photographed at that location or who live there the following questions: When is the best time of day to view the location or subject? When do you see color on the subject, in the morning or at sunset? People may have to think before answering, but the few who notice and remember will make your excursion a million times more likely to be a success.

Bottom line: In order to get the best pictures you possibly can, be sure to find and utilize the kind of light you want. Start by identifying the character of light. Then think about subject selection and composition. The latter two are indeed important, but the most important thing is photographing the subject in its best light. Ask yourself what the idea is that you hope to express in your photograph. Ask yourself if your photo calls for harsh or soft light, or for frontlight, backlight, or sidelight? These are the kinds of questions you want to be asking.

ASSIGNMENT Practice Working Quickly with the Light

When you're photographing during sunrise or sunset times, remind yourself to work quickly, whether you're pointing your camera at the sun or in another direction. It's all too easy to get caught up in the beauty and inspiration of the moment and to forget that you have a job to do—and only a few moments in which to do it. Keep in mind that this is work. There's no problem with having a great time, as long as you remember to get the shot. This is especially true when you're working with early-morning and late-afternoon sun. The sun travels fast and dips below, or rises away from, the horizon in a matter of minutes. That's one reason why it's so important to arrive on the scene with plenty of time to spare. If you arrive just as the sun is rising, you'll be too late.

If you're afraid you might arrive late and miss the light, there are a few things you can do to prepare while on the way to your location, and it's a good idea to practice your set-up procedures so that you become familiar with them and with your equipment. This run-through assumes that you're not driving (don't try to follow these guidelines if you're the one in the driver's seat):

1 Attach the remote shutter release, if you have one, to your camera. (If you don't, it's a good idea to buy one. Or, use your self-timer.)

2 Attach your camera to your tripod, and attach anything else you might use, such as a lens hood, filter, filter holder, or flash unit.

3 Make sure your ISO, autofocus (AF), and other settings are reset to your defaults. My defaults, for example, are ISO 100, AF on, matrix metering, Daylight white balance, one-shot focus, Aperture Priority mode, and so on.

4 At the location extend the tripod legs as you walk to your site.

5 Place your tripod and compose quickly. Don't worry about things being perfect.

6 If you're not going to need continual autofocus, focus once with autofocus on and then turn it off. You won't need it anymore until you change compositions, and if it's on, it may eternally frustrate you as it tries hard to find a point of focus.

7 Meter off the best subsection of your scene. For example, if you want a silhouette, meter off the brightest part of the sky (from a spot that excludes the sun), and note the readings. You can then either use your autoexposure (AE) lock button to hold this reading or switch to manual mode and dial in the readings you noted. Either way, you're in business.

After you've captured a few images, breath deep and take a walk around, looking for other subjects. Look at things that interest you from a variety of positions, both high and low. Once you've taken the time pressure anxiety off yourself, you can explore at a more leisurely pace.

Weather

THERE'S NO TRICK when it comes to working in adverse weather conditions. Most of the time, the only way to get the most dramatic photographs is to get yourself out into the environment during the yuckiest of times. Then, you often have to remain out in the elements until you come across the subject and lighting conditions you're after. One of my favorite combinations occurs when beams of light come out as a storm breaks. If all goes well in such a situation, I get treated to a beautiful dancing light, shot against a dark, cloudy, gray background. Times like this, I thank the heavens above.

Occasionally, on cold mornings when I'm near a road, I can stay in my car as I wait for the light to change. If you do have to wait patiently, the trick is to enjoy the moment. I try to bring something else to do while I wait. If I can read a few paragraphs of a magazine article—looking up occasionally to make sure I'm not missing anything—I'm happy. I rarely sit back, hope, and wait though. Most of the time, I continue shooting until the weather becomes more interesting. Shooting is the best way to pass the time. Within reason, patience can pay off in big dividends. But don't beat yourself up if you need to move on. This is one of the great challenges of photography—balancing your photographic needs with other needs.

GRAY SKIES

Is the weather forecast grim? Get out your camera and start shooting! I pray for storms and bad weather. Since everything else in photography seems to be backward, why shouldn't your thinking about weather be the same? In the world of photography, small numbers equal large aperture openings and long shutter speeds, so "bad" weather equals "good" photographic opportunities!

Comfort may be a luxury that goes by the wayside, but bad weather can be awesome for many kinds of photography. You may wish that all your photographic outings be conducted under blue skies. You may not rush out to freeze in the wind and rain. However, marginal weather is often the very thing that makes it possible to make great images. What do photographers have against blue skies? Nothing, they have their purpose. A deep blue sky, especially when punctuated with color-catching clouds, can add a wonderful element of color to your composition. The best method is to use the weather you've been given and shoot the appropriate subjects for that weather. Don't dread gray skies; put them to good use.

Many people believe that the best time to photograph any subject is when the sun is out and skies are colorful. However, this philosophy, if you adopt it, will rob you of some of your best photo opportunities. This cherry tree in my front yard underwent a magical transformation after an ice storm encased everything in the yard in ice.
1/90 SEC. AT f/11, ISO 1600, 28–135MM LENS AT 100MM

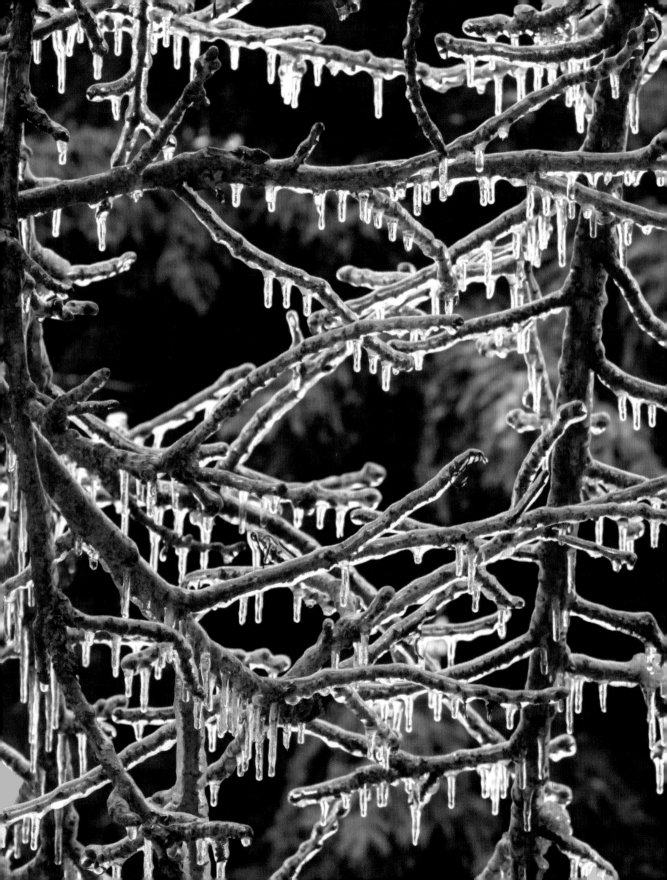

COLD WEATHER AND YOUR HANDS

Unfortunately, there isn't a great solution when it comes to gloves for photographers. No matter what you do, your hands will get cold when you work the camera. What I do in extremely cold conditions involves three components:

1 I wear fingerless gloves made especially for photographers. Mine are made by Lowepro.

2 Over my Lowepro gloves, I wear ski gloves that I can remove before shooting.

3 If it's especially cold, I bring along hand warmers—metal heating units that fit in your pockets—to help take the chill out of my fingers in between shoots.

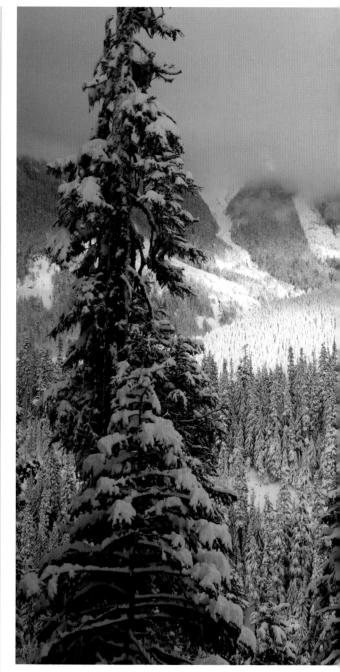

The snowy conditions actually added a wonderful extra ingredient to this image, which I made just after a blizzard.
1/500 SEC. AT f/4.5, ISO 100, 28–135MM LENS AT 53MM

PRACTICAL MATTERS

Planning for All Kinds of Weather

Before heading out, check www.weather.com, listen to the radio, or watch the weather forecast on TV. I always try to check the weather the evening before I head out shooting. Often, the experts are wrong, so I don't necessarily stay home if they're predicting unfavorable weather. Clearly, the more long-range the forecast, the less likely it is of being correct. All the same, these forecasts give me a good starting point.

TIP: LOOK TO THE SKY

I find that I can get the best weather forecast by simply getting up early and peering into the sky. If I see stars, that's a good sign. That might be the beginning of a glorious, colorful sunrise. If you do this, be sure to look in all four directions before concluding that the weather is bad and heading back to bed. Often, looking out one window will reveal overcast skies, but looking in the opposite direction will give you a preview of dramatic clouds being broken up by exciting beams of light.

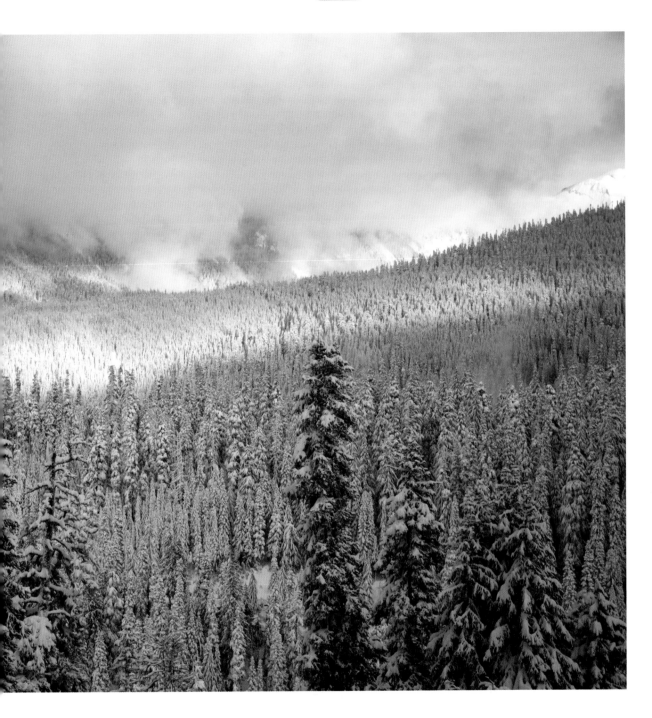

SNOW AND ICE

When photographing in winter, do your best to be the first person out. There's nothing as pure, pristine, and beautiful as a snowfall before people have trampled through it. If you head out into snowy conditions, get snowshoes for yourself and your tripod; if you don't have wide feet on your tripod, the legs can easily sink into the snow.

The beauty of snow is that it hides a lot of the ugly, man-made signs of "progress" and purifies the environment. Fog and mist can perform this magic act, as well. Mist, fog, ice, storms, and snow all can play a big part in successful outdoor photography. So, keep an eye out for bad weather. I get especially excited when I come across the effects of an ice storm. Such supercold, wet conditions can coat trees with frost and turn branches into an intricate, interlaced network of crystal.

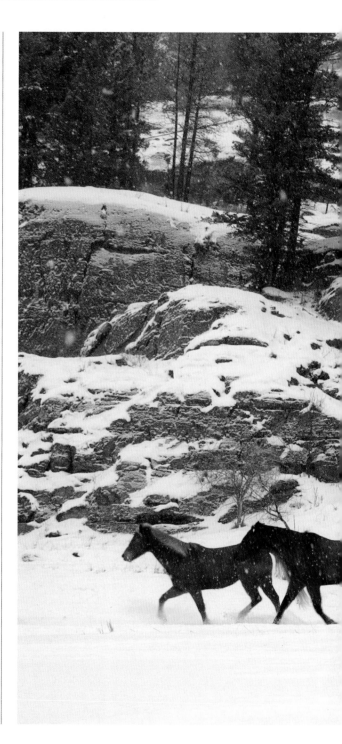

Conditions were cloudy when I set up to photograph these horses, and as soon as I attached my camera to my tripod, it started to snow. If you're blessed enough to be shooting while the show is falling, use a shutter speed of 1/60 sec. or slightly faster to capture gently falling snow and keep it from looking too blurry.

1/180 SEC. AT f/8, ISO 200, 28–135MM LENS AT 28MM

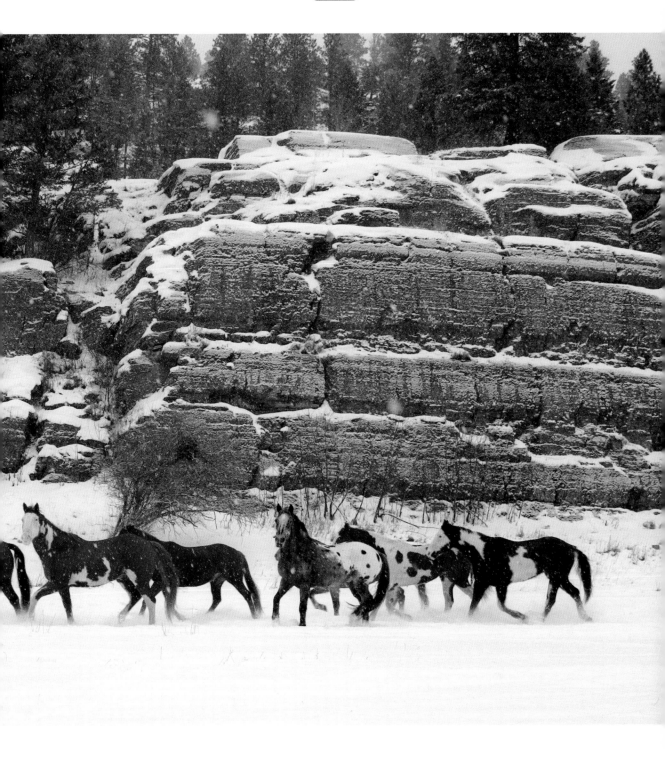

White Balance

WHEN YOU THINK of color, you probably think of it in terms of finding color in your subjects, and I talk about that on page 56. In terms of light, however, you should pay attention to the color of the *light* itself. It may surprise you to learn that light actually comes in many hues, each of which has a profoundly different effect on a subject.

The more technical among us describe the various colors of light as different *temperatures*. For example, candlelight can be expressed as 1900 kelvins, or 1900 K, and noon daylight might be around 5500 kelvins. Color temperatures of less than 5500 K get progressively warmer, or more red; color temperatures greater than 5500 K get progressively cooler, or more blue. Most people, including myself, don't find it easy to think of light in terms of kelvins and temperature. And, the concept of white balance can be confusing. However, it need not overwhelm you. So to simplify the whole issue, I'll just focus on the white balance settings that matter the most to nature and landscape photography, and eliminate the other settings, which are used much less frequently in these disciplines.

First of all, digital nature photographers should avoid using the Auto white balance (AWB) setting. This setting has its purpose. It's great at what it's designed to do: remove color from light so that the light appears neutral. As much as this might help when photographing some non-nature subjects, neutralizing the color of light is usually the last thing you want when photographing the outdoors. I pray for the times when a setting sun adds an extra touch of warmth to a subject. Bob Clayton's photo of the backlit cactus on page 27 shows an example of a warm light that you would not want to balance into oblivion.

When nature photographers encounter color in the light, they want to capture it, not remove it. This is especially true for warm light; warm colors make such interesting photographs because the color blue is around us all the time. It's everywhere. But glowing orange, pink, and red hues are rare treats.

Continuing with the white balance settings, the cold light from a flash will often flood your subject in an unflattering light. You can balance this either by using the Flash white balance setting while shooting or by making adjustments in the computer when processing your images (if you're shooting raw, see the next page). However, since flash is rarely used in nature photography, I would leave Flash off your list of most essential white balance settings.

For 90 percent of all shooting, you'll be much better off if you set your white balance to the Daylight setting. This will allow you to capture the light as you see it. The other 10 percent of the time, you will likely turn to the Cloudy, Shade, or Custom settings. As midday open shade can cause subjects to look unnaturally blue, you'll probably want to warm such blue scenes up. Again, you can do this either while shooting (using the Shade white balance setting or a warming filter over your lens) or back at the computer (using software to add red and thereby lessen the blue tint). I find that the three most-used white balance choices are Daylight, Cloudy, or Shade.

The most important thing is that you learn to notice the various colors of light. When you do, you'll be able to compensate for colors casts (usually blue ones), and your pictures will immediately improve. You'll see firsthand how subtle changes in tone can completely transform your photos.

WHITE BALANCE AND SHOOTING RAW

One of the reasons I love the raw, or camera raw, format (also see page 78) is that it lets me think about white balance later. I still do think about white balance when I'm shooting, but instead of overly worrying about it, I relax, knowing that I can easily adjust white balance when converting my raw files. This has the added advantage of allowing me to see the effects of various white balance settings on the scene—as I apply them. It's one less thing to think about when shooting.

The low, early-morning light in this scene provided a warm tone and those good catch lights (the eye highlights). However, since I was shooting JPEGs at the time (rather than in camera raw), I took pains to get the white balance correct while shooting. If you know your way around Photoshop, you can still correct JPEGs shot with the wrong white balance. I simply prefer camera raw because it has more information and makes the process so much easier.
1/350 SEC. AT f/8, ISO 100, 28–135MM LENS AT 100MM

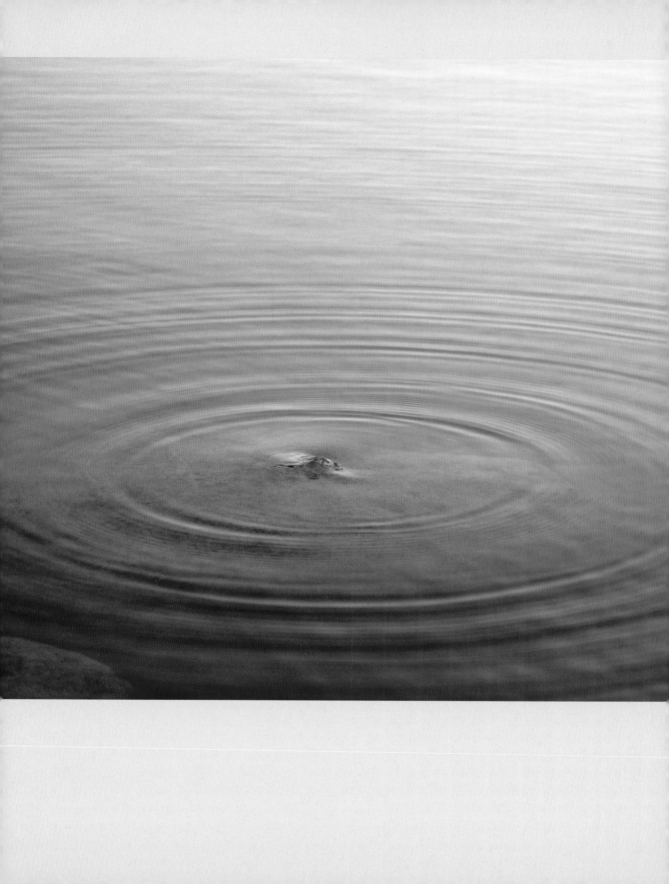

Composition

COMPOSITION (the second element in my L.C.D. acronym) involves the placement of objects in a scene. In this section, I'll cover the general, basic concepts of composition. Then in the later sections on landscapes, macro, and animals, I'll provide compositional tips and tricks specific to each of those subjects as they come up. Regardless of your subject, however, the information in this chapter will help you improve your images.

This composition hinges on simplicity and the Rule of Thirds. By placing the center of the ripples in the lower left, I captured a composition that balanced uniqueness with simplicity.
1/60 SEC. AT f/6.3, ISO 100, 28–135MM LENS AT 100MM

Simplicity

YOUR PHOTOS WILL always benefit from simplification. The world is too complicated as it is. When the eye sees an image, it naturally wants to be able to easily make sense of the scene. I have yet to meet a photographer who can make complex, complicated compositions that work. And, I have yet to meet a viewer who enjoys an overly complicated composition.

How do you simplify? This can be a challenge when you're surrounded by telephone wires, for example. It can also be tough when you're surrounded by natural "litter" (nonphotogenic objects cluttering up your composition). The first stage is to take two steps forward to move in closer to your subject. Whether you physically move closer or you use a more telephoto focal length on your lens, strive to fill the frame with your subject.

MAKING CHOICES

When I was a teenager, I came across a set of audio cassette tapes called *The Psychology of Winning* by Denis Waitley. I must have listened to these tapes a hundred times or more. A couple of years later, I attended a lecture by Dr. Waitley and had a few moments to speak with him before the talk. I told him how I wanted to be a successful writer, an accomplished musician, a Harvard graduate, and more. He thought for a moment and said, "My advice is to pick one, just one, and *win* at it. Then you'll find success in other arenas as well."

You can apply the same advice to photographic composition. When presented with a scene, it's only natural to "want it all." You just can't fathom leaving anything out. Since you're enjoying the grand vista, you assume you must include every

> **TIP:** REMEMBER THE MAIN ATTRACTION
>
> Always remember what originally attracted you to a particular scene. It's easy, in all the excitement of trying different lenses and different techniques, to forget your point. What made you stop and look? What drew you to the scene? If there's time, writing down your main attraction as soon as you recognize it will often help you keep it in mind as you experiment with a variety of photo techniques.

single element in your photograph. You want your audience back home to get some semblance of what you've experienced. By trying to include everything, however, you end up with a photo that says nothing.

Your photos won't succeed until you make some hard choices. Look at each scene and say to yourself, "Pick one, and *win*!" Determine which one object (for example, an animal or a mountain) or element (for example, a pattern) in the scene is attracting you the most—is the main center of interest. Then, zoom in on that one thing. Turn your camera on end to shoot in the vertical orientation, if necessary.

Your one center of interest may occasionally comprise two or more objects or elements. That's okay as long as your true subject—that thing that is attracting you to the scene the most—is the *relationship* between those objects. In any case, if you succeed in defining that one subject and in putting all your efforts into capturing the essence of it, your photos will undoubtedly improve.

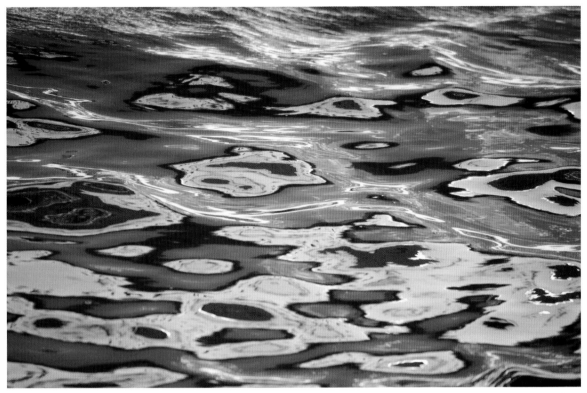

The red color in this image is a reflection of a nearby boat. Although some might have been tempted to include the boat in the composition, I didn't want to do that. My main center of interest was the pattern of reflections and the abstract quality I saw when I filled the frame with this pattern. So, I sacrificed the boat and put all of the visual weight on the reflections. Force yourself to make the hard choices. Decide what's going to stay and what's going to go, and your image quality will soar.

Photographic Goals

In order to simplify a scene, you need to figure out what is crucial. You need to decide which photographic goals are most important to you. As any high school counselor will tell you, successful people take time to think about goals all the time. This is not necessarily the same thing as deciding which subject to shoot. Your photographic goal is about what you want to do with a particular subject, how you want to interpret it in a photo. In fact, I sometimes think of the subject as more of an excuse. It is simply a placeholder that gives me an excuse to play with light, composition, and exposure. Those are the qualities that I find most fascinating.

Guidance counselors will also tell you that getting most people to define goals can be like pulling teeth. And yet, this is the key to success in any endeavor. After all, how you can succeed if you don't know what success means to you? But once you've defined your photographic goals, you can go about using the central L.C.D. principles (light, composition, digital exposure) to attain your goals.

SACRIFICING THE GOOD FOR THE BEST

The dedicated photographer is all too familiar with the need to make visual sacrifices. Often you're faced with a scene that forces you to choose between two or more potential subjects. But this isn't necessarily a bad thing. Contrary to popular belief, sacrifice is not about choosing the good over the bad. That's too easy. True sacrifice is about choosing the better over the good. Sure, you might be able to make a decent photo of a lake at sunset. However, you'll be able to make a great image if you decide which co-subject to sacrifice: the lake or the sky. Is it better to capture the wild variety of color and cumulous clouds in the sky, or do you find the lake surface more interesting? Here's your new motto: Be selective, choose, and decide.

It's just like reading a menu at the restaurant; it can feel overwhelming sometimes. Perhaps you want many different things, and you're afraid you're going to make the wrong choice. But you have to tell yourself that "it's no big deal, just pick one." The same thing goes with composition. When in doubt, pick one item around which to center your efforts. Once you've made your choice, be very selective—and careful to include it, and only it, in your composition. If, after you've photographed your first choice in a satisfying way, you feel compelled to move on to a second and even a third subject in the overall scene, by all means, feel free to do so.

TIP: CLOSE ONE EYE

I often tell students to squint to reduce contrast and to view the scene in its basic tonal values. In addition to squinting, also try closing one eye. This will further approximate what the final image will look like. Since the final photo will be a two-dimensional abstraction of reality, and since closing one eye reduces your sense of depth, you'll get a better idea of how the camera will interpret and render the scene.

PRACTICAL MATTERS
Taking Notes

Even though a lot of information is stored within each digital image (in the EXIF data, or meta-data), it still helps to take notes the old-fashioned way. There are certain things that can never be stored in EXIF data; for example:

❑ Your intentions.
❑ The location.
❑ Subject names.
❑ Filters used and reasons for using them.

Such note taking, when combined with a careful study of each image's metadata, will greatly accelerate the learning process. The trick is finding a solution that allows you to take notes in an easy, practical way. You want this to fit in reasonably with your workflow. You don't want it to hold you back, especially when you may be creating several hundreds of images during any given session. Some people use a voice recorder. This is easy during input but difficult during output. In the field, you can record notes quickly, but since these notes are not visible, it takes time to locate them or to transcribe them from the audio format.

I prefer a simple notepad in the back pocket. I still have to rewrite the same basic info over again and again, but I find the practice so helpful that I still continue to take notes in this manner.

I still find a good, old-fashioned notebook to be the most efficient way to record data that the EXIF feature does not include.

ELIMINATING DISTRACTIONS

Once you've identified the thing that is that one essential element in a scene, use the tool you have at your disposal to best convey that point: a telephoto lens. Even when you're photographing a wide, scenic view, pull out your telephoto lens to see if you can be selective and capture the one powerful detail that will tell the whole story.

Would it really hurt to move closer to your subject? If the surroundings are not exciting, move in closer. If the surroundings include interesting elements, then the true subject of the photo may be a combination of the center of interest and these surrounding elements. The relationship between these elements may be what you're really

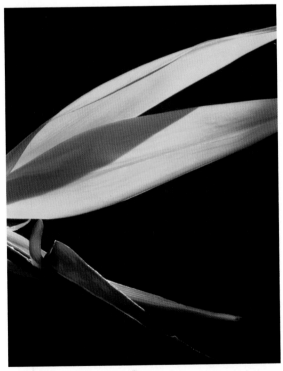

This image of a bird of paradise is very striking for two reasons. First, the light is beautiful. More importantly, however, the subject is huge in the frame. The photographer, a student in my online photography course, moved in very close with her macro lens to capture this close-up.

2 SECONDS AT f/32, ISO 100, 100MM MACRO LENS

PHOTO © DEBORAH LEWINSON

most interested in capturing. If that's the case, go ahead and shoot the larger scene. At all other times, move in closer to eliminate distractions.

If you see a distraction in your viewfinder, trust me, it will be *huge* in your final image. If you don't see any distractions in your viewfinder, also scan the scene with your naked eye (i.e., not through the viewfinder). Look at the scene from just above your viewfinder, seeing if you notice anything that might jump out. Close one eye and squint, which may further help identify any elements that might jump out and distract the eye. If you cannot make use of an element or if it doesn't serve your overall purpose, it is a distraction and it needs to be removed. Use it or lose it, that's my motto.

I first work to eliminate as many distractions as possible in camera, simply by repositioning myself before I shoot. After doing my best while shooting, I often clone out distractions after the fact in photo-editing software. When telephone or power wires, dwellings, signs on construction sites, or the effects of man-made "progress" occasionally get past my careful eye, I remove them with Photoshop's Clone Stamp Tool or Healing Brush Tool.

THE GRADUATED NEUTRAL-DENSITY FILTER

When photographing landscapes, watch out for two things: a horizon that's right in the middle of the composition and a large difference in tonal values from dark to bright. A graduated neutral-density filter can even out contrast in an image with extensive tonal range (see page 72 for more). Without this filter, you have to decide what is of greater value: the detail in the darker areas of the scene or the detail in the brighter areas of the scene. The answer to this question comes only when you know exactly what about the scene is most attractive to you. Once you know the answer, you can recompose to place the horizon in either the upper or lower third, depending upon which part of the scene you'd like to emphasize more (see page 112 for more).

Orientation

ANOTHER EASY WAY to make your pictures more interesting is to turn your camera on end and shoot vertical pictures. It sounds so simple, and it is. You'd be amazed at how infrequently people turn to the vertical format. Most photographers continually shoot pictures in the horizontal, or landscape, orientation without ever thinking about turning the camera and shooting in portrait-style format. Simply turning your camera on end can often eliminate unnecessary clutter and fill the frame more successfully with the most important objects in each scene.

When you consider orientation, think about the psychological effect each option carries with it. Horizontal photographs connote a serene, if static, feeling, while vertical photos come across as dynamic and impressive. When you find a subject you like, shoot at least one horizontal and one vertical composition to get a feel for how orientation affects your photographic expression.

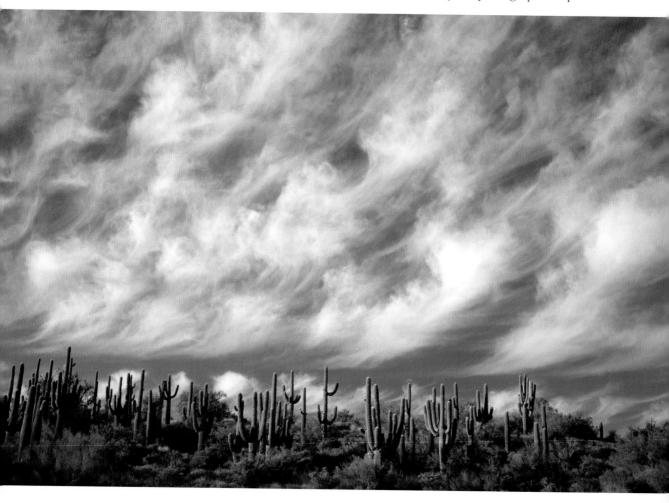

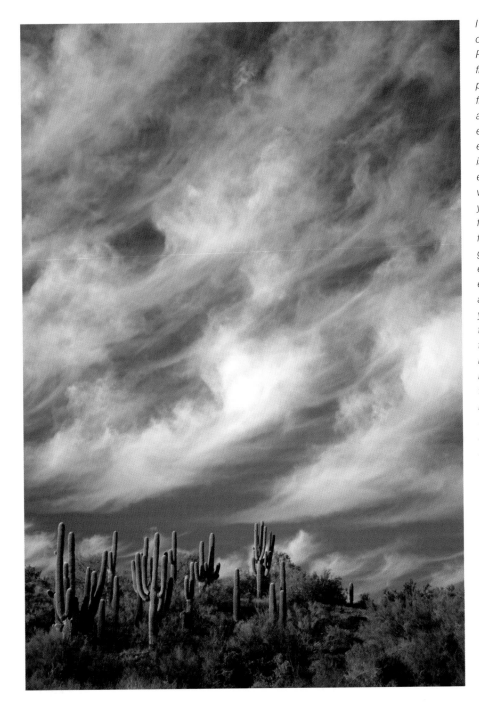

I noticed this hillside of cacti while driving to Page, Arizona, with my friend Jay. I asked him to pull over, and we had a field day with the late-afternoon light and interesting clouds. One excellent habit to develop is turning your camera on end to compose in the vertical format. Whenever you think the subject will fit better, whenever you feel like experimenting to give your scene a different twist—in truth, whenever you're photographing any subject that interests you—it's a good idea to turn to the vertical orientation after photographing in the horizontal. I like the horizontal version here the best, but the vertical may come in handy and fit a magazine publisher's needs better than the horizontal. Having both, I can't lose.

LEFT: 1/200 SEC. AT f/4.5, ISO 100, 28–135MM LENS AT 60MM; OPPOSITE: 1/250 SEC. AT f/4, ISO 100, 28–135MM LENS AT 44MM

Lens Choice

LENS CHOICE has more of an impact on composition than you might first imagine. That's why you don't want to settle for the first view you compose. Experiment with a variety of lenses to see how each changes the overall look of the subject. See how many different ways you can render the scene or subject. Zoom lenses are great for this; they make it easy to view the scene at a variety of focal lengths, from super wide-angle to strong telephoto. This is only a quick peek at the differences between wide-angle and telephoto lenses. There are tons of options in between, but this introduction will get you thinking about the choices and how they affect your composition.

WIDE-ANGLE

It doesn't take long to learn that a wide-angle lens enables you to include more in a scene. A side effect of this trait is that objects in the background look further away and smaller than they otherwise would. However, you can use this to adjust the proportions of various objects in your composition. If you want to make a distant object smaller, use a wider focal length.

Also, you get a more extensive depth of field with wide-angle lenses. (See page 64 for more on depth of field.) That's one reason why these lenses are popular for landscape work. It's easier to get both the foreground and the background in focus. A wide-angle lens is a fantastic choice when the surrounding environment adds interest and additional meaning to your subject. Just keep in mind that supporting elements in the background may be diminished too much. Also, your subject may be unpleasantly distorted, your horizon may bend, and trees may lean in due to keystoning

Vignetting & Wide-Angle Lenses

When using filters on a wide-angle lens, watch out for a problem known as *vignetting*, which is the darkening of the edges of the image. If you notice vignetting in your photos, it may be that the edge of your filter or filter holder is visible to your lens. In the worst cases, you can actually discern the filter or holder. Sure, you can clone out these problems in your image-editing software, but why waste your time? It's most efficient to simply make sure that your filters are large enough to go beyond the limits of your current focal length.

(when straight, vertical elements seem to curve toward the center of the composition due to lens distortion). If you get these effects and don't want them, use a more telephoto focal length.

TELEPHOTO

One common use for the telephoto lens is to eliminate distractions that surround the subject. Don't forget to scan the scene through a telephoto focal length. This can often result in interesting images of smaller details that effectively communicate the entire scene to your viewer. When using a telephoto lens, you need to be especially careful about your point of focus, because depth of field is shallower with a telephoto lens than it is with a wide-angle one. This means that less of the elements in the image will be rendered in sharp focus from back to front. Even more so than ever, you need to carefully decide which object or objects in the scene you want in focus.

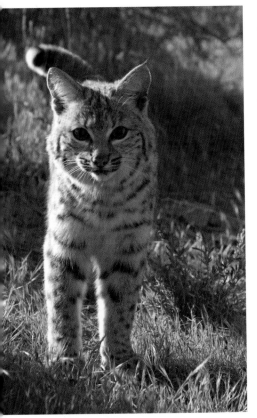

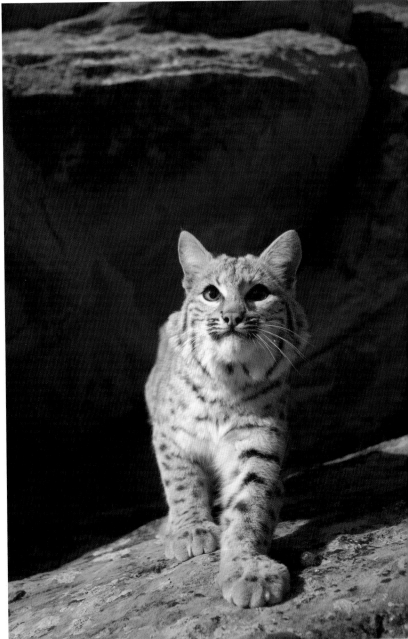

The Telephoto Lens As Trash Compactor

A telephoto lens brings distant objects closer together. Like a trash compactor, it compresses both the field of view and the depth in a scene. In addition to narrowing the view (and thus enlarging the subject and eliminating distractions), a telephoto also compresses objects and appears to reduce the distance between foreground and background objects. In essence, it helps you take out the trash, photographically speaking.

These two photographs feature the same subject, but the one above left is the result of using a telephoto lens and causes the bobcat kitten to look like an ordinary house cat. For the image above, I replaced my telephoto with a super wide-angle lens and got close to the kitten while she was walking on the red rock.
ABOVE, LEFT: 1/90 SEC. AT f/6.7, ISO 100, 28–135MM LENS AT 95MM; ABOVE: 1/750 SEC. AT f/3.5, ISO 100, 28–135MM LENS AT 28MM

The Rule of Thirds

THE RULE OF THIRDS is a design principle based on the Golden Section, which is a proportional guideline that can be traced all the way back to ancient Greece. The ancient Greeks discovered that spatial and visual relationships based on rectangles with longer sides that were roughly one third greater than the shorter sides (think of a 4 × 6-inch photo, for example) were more pleasing to the eye. The Rule of Thirds develops from this and gives photographers a quick and easy way to add vitality to any photo. The idea is simple: Instead of placing your subject in the center of your photo, place it a little off to the side.

More specifically, to use the Rule of Thirds imagine a grid of four lines across your scene that's made from two evenly spaced horizontal lines intersecting with two evenly spaced vertical lines, like a tic-tac-toe grid. When composing your scene, position your subject at one of the four places where these lines cross, called the *sweet spots*. This placement will cause the eye to travel around the photo before coming to a satisfying rest on your subject. This successful, quick—within a split second—tour around the photo is much more likely to occur when you follow the Rule of Thirds. Additionally, this off-center placement makes it possible for your subject to interact with its environment in the background. The effect is subtle but amazing. With this trick, you will instantly see a big improvement in your pictures.

Begin your study of the Rule of Thirds by consciously look-ing for photos that place the subject in one of the four sweet spots. Once you're aware of it, you'll be amazed at how often you see this principle being applied. The place-ment of this backlit cypress tree in the lower right sweet spot allows the subject to interact visually with the sup-porting elements in the background. Note: I altered the color in the final image by adjusting the white balance.
1/320 SEC. AT f/11, ISO 100, 28–135MM LENS AT 70MM

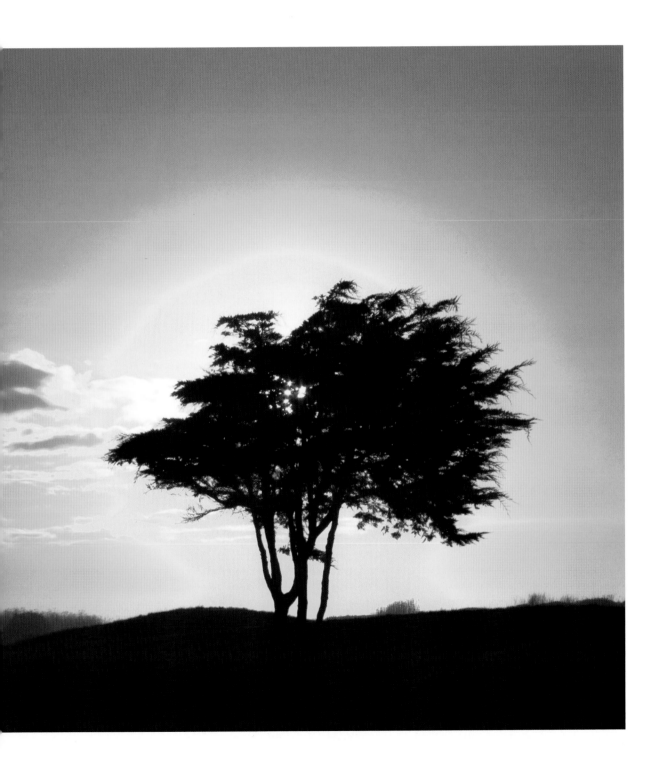

Color

WHEN COMPOSING scenes (whether they be of landscapes, flowers, or animals), it helps to understand color. With some basic color information in mind, you'll be more equipped to keep an eye out for the colors that will best express your vision.

When you are seeking a subject, pay attention to color. Consider how each color will affect the composition. Warm colors (red, yellows, oranges), for example, tend to feel more animated, more alive. They excite and invigorate the eye. They also appear closer than cool blues, which seem to recede into the distance. Cool colors (blues, greens) are calming and more common in the natural world.

A color wheel is a useful tool for understanding the basic color relationships. This wheel has six colors, but color wheels often have twelve or more colors. The three primary colors are red, yellow, and blue, and are called such because they cannot be made from any other colors. The three secondary colors are orange, green, and violet, and they are made by combining two primaries: red + yellow = orange, yellow + blue = green, and red + blue = violet. (A color wheel with twelve colors would show tertiary colors, which are made by combining a primary with a secondary, such as blue-green or red-violet.)

You can have a lot of fun with color by keeping an eye out for subjects that exhibit primary or secondary colors. When you see bold color, move in extremely close with the goal of filling the frame with your subject. Better yet, see if you can find a scene with both a primary color and its complementary color. Complementary colors, or complements, are two colors that lie directly opposite each other on the color wheel. When placed next to each other complements intensify each other, so filling the frame with complementary colors is a fantastic way to make images with impact.

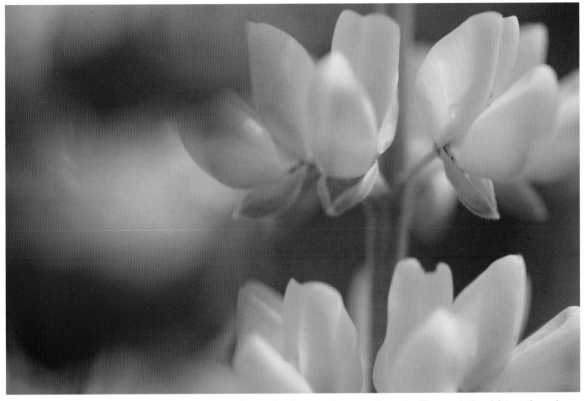

These purple and yellow lupines provide an example of naturally occurring complements. The purple (or violet on the color wheel) stands out the most against yellow since it has no yellow in it.

1/1250 SEC. AT f/2.8, ISO 125, 100MM MACRO LENS

Color Associations

Here are a few common psychological color associations. Use them to construct scenes with deep symbolic impact.

Red = heat, blood, love, lust, meat, warmth, fire, danger, and pain

Blue = cold, calm, tranquility, authority, sleep, winter, and sadness

Yellow = cheerfulness, brightness, optimism, and curiosity

Green = growth, spring, fertility, and life

Orange = warmth, exuberance, fun, and inspiration

Black and white are not, technically, colors, but I include them because they do have a place in photography.

Black = solidity, mystery, death, and evil

White = purity, goodness, blindness, life, and heaven

All of these color associations are both personal (explaining the subjective nature of photographic appreciation) and universal (explaining the tie to the symbolic and the collective unconscious). Actively seeking out, and focusing on, color will add impact, drama, and emotional feeling to your images.

Geometric Elements

MANY TIMES, you can compose your photo in a way that accentuates line, shape, and patterns. Line is one of the most powerful geometric elements you can use in your photographs. What's more, lines are readily available in the natural world; they're not difficult to find. All it takes is an eye for these geometric elements. The lines you find may be long, short, fat, thin, curved, straight, or even zigzagged.

However, it's not enough to just shoot line or form or pattern. If you notice a strong line in a scene, for example, you can do so much more than simply snap a picture of it. One great technique is to use line to guide the eye through the image in a satisfying way. Lines that lead the eye up to your subject create an easy path to follow and make viewing the image more fun. Guide the eye through your photograph instead of just letting whatever will happen happen.

Rivers, waterfalls, trees, and textures in sand are all great sources of line in the natural world. When you come across such lines, see if you can position yourself so that a line leads the eye to some interesting visual component. If you're open to occasionally including man-made elements in your nature images (we are part of the natural world,

after all), look for photogenic country roads, wood fences, and stone walls. I steer clear of metal fences and other nonphotogenic examples of line. I love tree-lined lanes, especially when they're covered with fall leaves or a fresh snow. If it has charm, I use it.

Line is just one geometric element to consider when composing scenes. Pattern also offers fantastic photographic opportunities. A pattern is simply a collection of repeating graphic elements. Three or more lines might begin to make a pattern. Include five plus one break or anomaly in the pattern, and you're really onto something. If you fill the frame with pattern, you'll likely be thrilled with the resulting composition.

TIP: CONSIDER LINE DIRECTION

Think carefully about the orientation of the line or pattern of lines in a composition. Horizontal lines can be calming but may also be boring. Vertical lines connote strength and upright character. Diagonal lines can be the most dynamic of all, and a softly arcing S-curve can produce a satisfying sense of serenity.

The diagonal lines in the middle of this composition lead the eye up and into the picture, and they give the image energy. This sets off the repetitive horizontal patterns created by the striations in the rock. If you're photographing something vertical, like these slot canyons in northern Arizona, you can turn your camera slightly on the diagonal to emphasize the slanting, dynamic feel of the subject even more. As long as the scene doesn't include a person or the horizon, you can take artistic license with regard to orientation and verticality.
2.5 SECONDS AT f/22, ISO 100, 28–135MM LENS AT 135MM

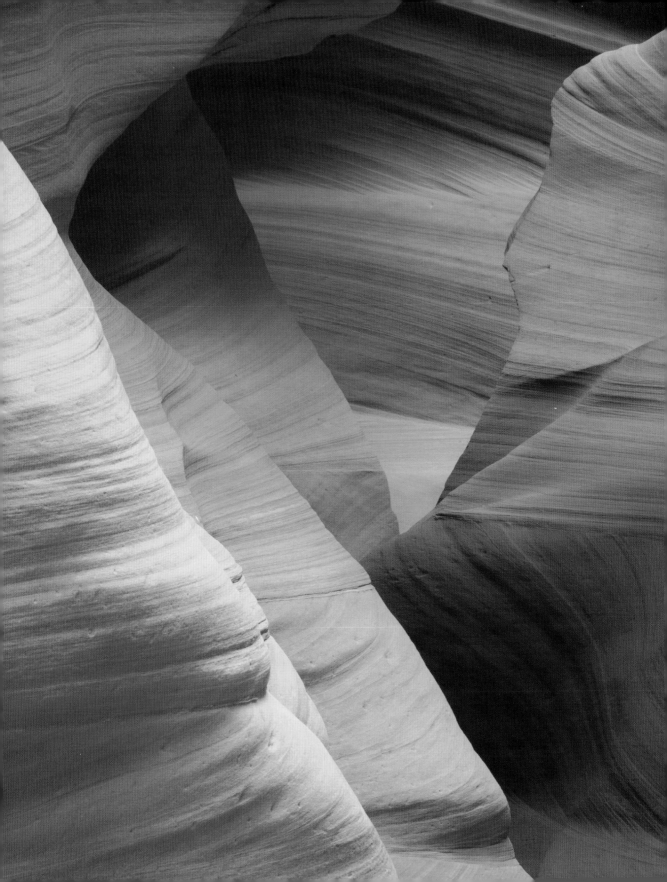

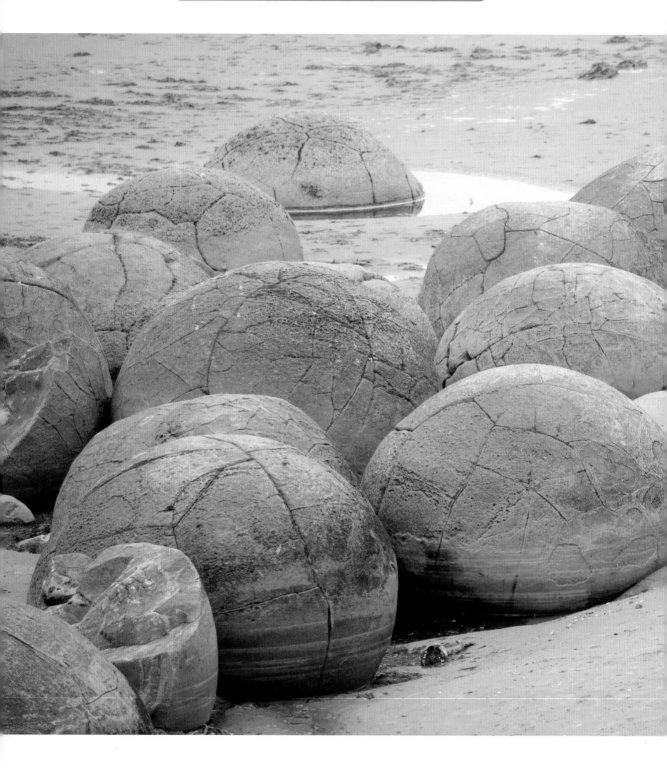

ASSIGNMENT

Consider Composition

When you think about composition, ask yourself the following questions:

❏ What is your subject, and how can you simplify the scene to speak only of that subject?

❏ Is the subject distant, and if so, is the composition satisfying?

❏ What am I balancing in this composition? What is balanced with what?

❏ Is the orientation appropriate, both on a spatial and a psychological level?

❏ What psychological effect is color creating?

❏ Is a diagonal, or skewed, orientation energizing or unsettling?

❏ Is the composition utilizing any geometric elements, such as line or pattern?

With digital photography, there's really no excuse to not try different compositions. Experiment. Take the compositional guidelines in this chapter to heart, but try them out for yourself. Don't be afraid to question them. Shoot a subject from afar, with acres of negative space around it. Then move in so close that it fills the frame. Then move in even closer. Or, center your subject within the frame. Then place it according to the Rule of Thirds. Try a vertical as well as a horizontal composition.

When you get home, study your photos, and note how each composition makes you feel. If an image elicits the emotional response you're after, then you know you've made a powerful composition.

In addition to line, other geometric elements such as shape, form, texture, and pattern all offer excellent building blocks to use in your composition. These boulders have a distinctive shape, and they also deal with pattern, since there are so many of them. Moving very close enabled me to accentuate the shape, which was what was most unique about the scene.
1/200 SEC. AT f/9, ISO 200, 70–300MM LENS AT 300MM

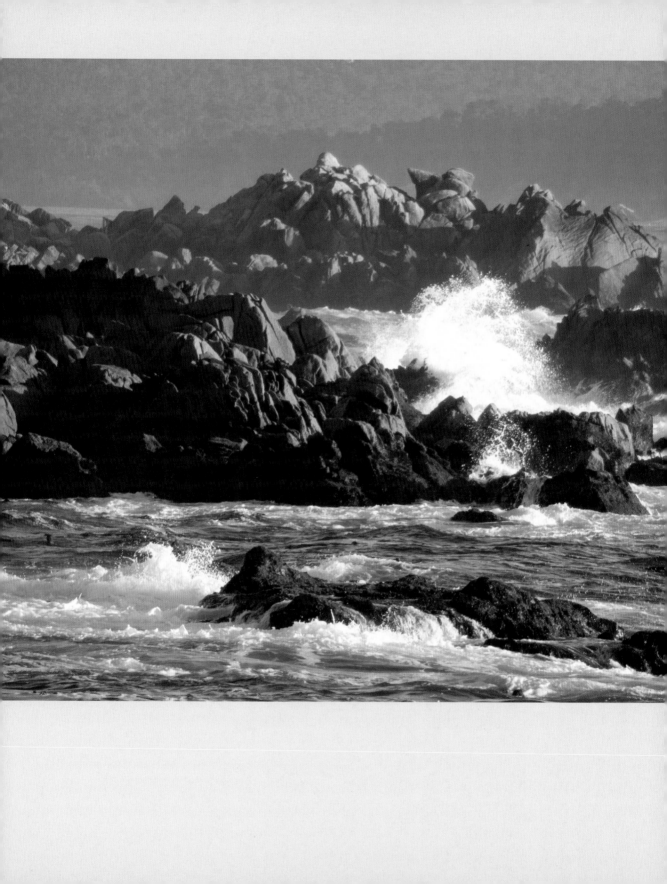

Digital Exposure

MANY PHOTOGRAPHERS freeze up when they hear the word *exposure*. I know I did when I first started. I felt overwhelmed by the technical choices. My photography teachers would throw out complex terminology and make unreasonable demands. For instance, they forced me to photograph in manual (M) exposure mode. For many people (myself included), this is like being taught how to swim by being thrown in the deep end. All it did was give me too many things to think about as I first got going. You don't need to reinvent the wheel when it comes to digital exposure (the third part of my L.C.D. acronym). There are ways to simplify the challenge. Breaking things down into doable steps, you can both master exposure and make great nature photos in the process.

If you live in California, or get an opportunity to visit the Golden State, be sure to tour the coastline. In particular, I recommend the northern coast—from Big Sur through Pebble Beach (pictured here), up to Mendocino, and then all the way up to Redwood National Park. The word dramatic *doesn't do it justice. You will be impressed at every turn—and be forewarned, there are many, many turns on Highway 1. It's a long, slow, windy drive, but it's worth the effort.*
1/60 SEC. AT f/5.6, ISO 100, 70–300MM LENS AT 300MM

The Three Components of Exposure

THE THREE components of exposure are aperture, shutter speed, and ISO. How you balance these three elements means everything in the world of creative exposure. The first step to mastering exposure is to think of it in terms of two things: overall brightness and creative effects. If you understand how the three components of exposure work together, you can get an exposure that's both correct (with the right overall brightness) and creative (with the depth of field, selective focus, blur, sharpness, noise, or other effects that you desire). And once you have the basic exposure concepts under your belt, you'll be freed up from the technical to focus on the creative aspects of nature photography.

APERTURE

The aperture is simply the adjustable opening through which light passes into your camera. Most importantly, aperture size affects depth of field (or how much of your picture is in focus from front to back) and is represented by f-stop numbers.

The larger the f-stop number (f/32, for example), the smaller the aperture opening. The smaller the aperture opening, the greater the depth of field. To make this easier to remember, simply think "larger f-stop number = larger depth of field." That's all you'll ever need to know about aperture.

Digital Cameras Make Aperture More Complicated

Many digital cameras display many more f-stop numbers than film cameras. That's because they break things down to one-third fractions. Examining the EXIF data on a particular photograph, you might see f/20 or f/13. If you'd like to simplify your life, feel free to work with aperture in the traditional one-stop increments: f/1.4, f/2, f/2.8, f/4, f/5.6, f/8, f/11, f/16, f/22, f/32. If you need to increase your aperture 1 stop and your camera is currently set to f/11, you would need to go to f/16, not the f/13 on a digital camera.

TIP: GIVE YOURSELF A BREAK

Since aperture, shutter speed, and ISO control exposure, how you choose to set these three components affects the brightness, blur, and texture of your photo. Just as a student conductor would not be expected to be a master of all instruments from the get-go, you aren't expected to master all three components right from the beginning. Simply choose one, and master it first. Then move on to the other two.

Note how the background is busier in the second example (opposite, bottom). That's because I used a larger f-stop number, which yields greater depth of field (meaning more of the image is in focus from front to back). Remember that a larger f-stop number represents a smaller aperture opening.

Depth-of-field preference often depends on personal taste, and on the subject and composition. Sometimes, having everything in sharp focus is more appropriate for a subject than selective focus that throws areas out of focus. Other times, selective focus is the more effective choice. Experiment to see what works and what doesn't.

OPPOSITE, TOP: 1/8 SEC. AT f/5, ISO 100, 100MM MACRO LENS;
OPPOSITE, BOTTOM: 1 SECOND AT f/13, ISO 100, 100MM MACRO LENS

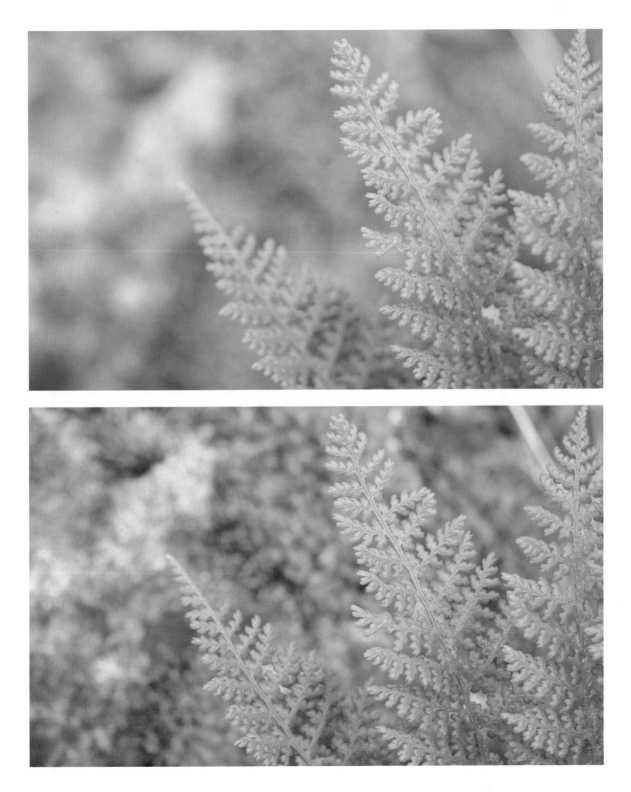

SHUTTER SPEED

Shutter speed indicates the amount of time the shutter (at your desired aperture) remains open during an exposure (letting light hit the digital sensor). You change one, or both, of the other two exposure components (aperture and ISO) to compensate for changes in shutter speed. In this way, you can maintain the same degree of overall brightness while achieving different creative effects. This makes the difference between just considering exposure as overall brightness and considering exposure as a way to get interesting creative effects.

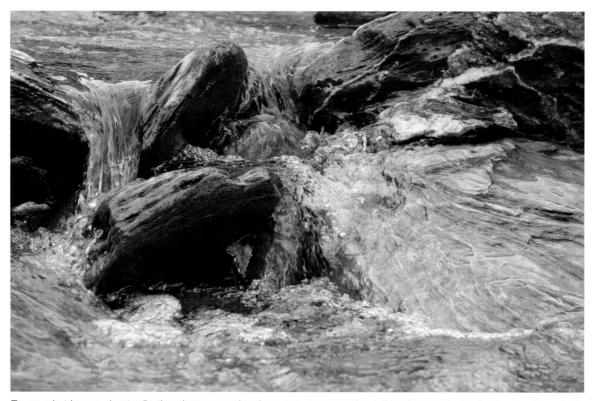

To see what I mean about adjusting shutter speed and aperture, compare these three images. In the first image, the water is rendered frozen in mid-current, because I used a fast (or short) shutter speed. A slightly slower (or longer) shutter speed results in blurrier water. And with an even slower shutter speed, the result is that silky, "cotton candy" effect. For each exposure, I also adjusted the aperture to maintain the same degree of overall brightness illuminating the scene.

ABOVE: 1/500 SEC. AT f/13, ISO 1600, 70–300MM LENS AT 195MM; OPPOSITE, TOP: 1/10 SEC. AT f/20, ISO 50, 70–300MM LENS AT 195MM; OPPOSITE, BOTTOM: 2 SECONDS AT f/36, ISO 50, 70–300MM LENS AT 195MM

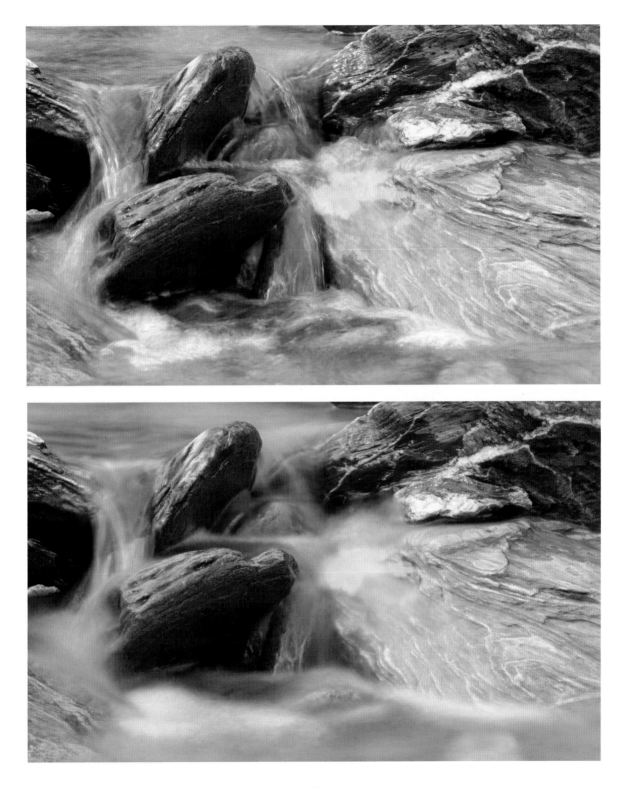

ISO

With digital cameras, ISO represents how sensitive the camera sensor is to light. Those who have used film know of ISO as representing film speed, or ASA, and the film's sensitivity to light. It's the same thing. The true beauty of ISO in the digital world is that you can change it at any time (rather than having to use the same ISO until you finished a roll of film). You need not limit your understanding of exposure to aperture and shutter speed; as a digital photographer, you can change ISO more frequently, and this greatly increases your creative options.

What If I Have ISO 50?

Honestly, I don't see much of a difference between ISO 100 and ISO 50. I only go down to ISO 50 when I need a slower shutter speed in bright conditions and my aperture opening is already as small as it will go.

TIP: AQUARIUM SHOOTING

The aquarium can be a great location to shoot. If there's one near you, plan a trip and bring along the camera. If you're careful and selective, you can capture fantastic underwater images even before you get certified as a scuba diver. You just need to know how to shoot through the glass tank. Here are a few tips:

❑ Use a rubber lens hood (which is also good, by the way, when you're shooting through an airplane or car window). This accessory will enable you to press your lens up against the glass surface, minimizing reflections and distractions in the glass.

❑ Don't use a polarizer. This filter isn't recommended when shooting through a tank because it can cause colorful flare.

❑ Keep the camera parallel to the tank glass. Tilting the camera can result in strange magnification irregularities.

The advantage of increasing your ISO (i.e., increasing the digital sensor's sensitivity to light) is that you can take pictures in darker areas without using a tripod or of moving subjects, such as the jellyfish in this aquarium shot. The drawback of increasing your ISO is a problem known as noise, *which is a grainy texture that may occur at high ISOs (left). Noise occurred here because I maxed out my ISO for these shots. Even though I was using a tripod, I needed a fast shutter speed to stop the action of the jellyfish. This was the only way I could get a sharp subject in the extremely dim lighting.*

OPPOSITE: 1/30 SEC. AT *f*/3.5, ISO 3200, 28–135MM LENS AT 28MM; BELOW: 1/50 SEC. AT *f*/5.6, ISO 3200, 28–135MM LENS AT 135MM

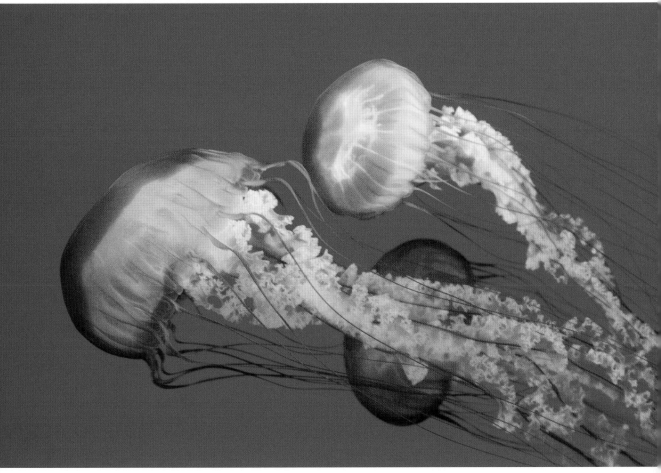

Exposure Modes

SO, IF YOU WERE to tell me that you'd like to create that "cotton candy" effect when photographing waterfalls, and I told you that all you need is a slow shutter speed, your result (without doing anything else but lengthening your shutter speed) would be an overexposed, overly bright image. Why? The answer likely has to do with which exposure mode you chose.

If you change one exposure component, you also need to alter at least one of the other two components to enable the same amount of light to reach the camera's sensor and maintain the same overall brightness. For example, if you lower your *f*-stop number (aperture) to isolate focus (rendering everything but your subject out of

Is a Semi-Automatic Exposure Mode Still Overexposing the Picture?

If you're using a semi-automatic exposure mode and are still seeing a drastic change in overall brightness, it could be that you're inadvertently overriding the camera's automatic recommendations. For example, if you take a reading and then increase the ISO (while the aperture and shutter speed are "locked in") this would result in an increase to the overall brightness.

If you take a reading in Aperture Priority mode, choose the highest *f*-stop number (aperture), lock your exposure, and then increase ISO or slow down shutter speed, the resulting image will look washed out or overexposed. Most cameras do their best to keep this from happening, but occasionally, something slips past the guard. If your images are turning out over- or underexposed, first select ISO, then press down the shutter button to take a reading and make the picture. Refraining from adjusting the ISO after you take this reading should do the trick in the majority of cases.

focus), then you would need to increase your shutter speed (given that you keep your ISO constant). While this may sound overwhelming at first, modern cameras have options called *exposure modes*, which make the job of setting exposure much easier. The most important exposure modes are:

❏ **Aperture Priority.** You set the aperture, and the camera automatically adjusts the shutter speed for you.

❏ **Shutter Priority.** You set the shutter speed, and the camera automatically adjusts the aperture for you.

❏ **Program.** On some cameras, these semi-automatic modes get an exposure reading and allow you to shift the aperture or shutter speed one way or the other.

❏ **Full Manual.** This mode requires that you adjust both shutter speed and aperture.

❏ **Full Automatic.** The camera sets everything. Avoid this one because it takes the control away from you and makes it much harder for you to learn which settings produce each creative effect.

You can choose one of the first four modes listed to get creative control of your exposure. However, the first three—Aperture Priority, Shutter Priority, or the adjustable Program mode—are the ones I most recommend. With any one of these three, you won't need a degree in advanced mathematics to accurately manipulate your exposure settings. This is because the overall brightness of your photo should not change when you use one of these three semi-automatic exposure modes. These modes assume that you adjust ISO using a separate control and will do their best to give you an accurate overall brightness.

There are times when none of these exposure modes will be able to give you what you want. One of these situations is when your scene contains too great a range of tones. When the scene has both bright highlights and dark shadows, one or the other has got to go.

EXPOSING FOR CONTRAST

Contrast, also known as *tonal range*, is simply the difference in brightness values between the dark and the light areas in a scene. A high-contrast scene is one with both very bright and very dark areas, while a low-contrast scene is one in which the tones are closer to one another in value (with less range).

Without using special filters, you cannot expose a high-contrast scene without sacrificing either the bright parts or the dark parts. As the saying goes, you can't have your cake and eat it, too. You need to expose for one or the other. If you try to include both bright and dark areas, the result will be an image with blown out bright areas and overly dark shadow areas.

When working, think in terms of areas of brightness more than in terms of subjects. If you have a large bright area with a small dark accent, you'll want to expose this differently than if you're photographing a scene with a lot of dark areas and one tiny bright spot.

The first image (left) shows how unsuccessful a shot can be when you try to include both extremely bright and extremely dark areas in the same shot. Neither area ends up looking good. And, notice how much warmer the stone in the direct light is than the stone in the shade, which is much cooler. (In addition to illustrating contrast, this shows why you need to understand white balance: The shade area is much too blue.)

In the bottom image, I photographed the bright area and the shaded area separately, and then merged them into a composite shot on the computer. Notice how both the bright and the shady areas come out far better when photographed individually than they do when they're captured together in one shot. Examining the shutter speeds, you can see how the camera attempted to find a decent compromise in the top image, a shutter speed partly between both extremes.

TOP: 1/13 SEC. AT f/25, ISO 100, 28–135MM LENS AT 135MM; BOTTOM: 1/40 SEC. AT f/25 (BRIGHT HALF), 1/3 SEC. AT f/25 (SHADE HALF), ISO 100, 28–135MM LENS AT 135MM

Filters

YOU CAN USE filters for overcoming contrast—and so much more. The filters I use most are graduated neutral-density (ND) filters and polarizing filters. If you do a lot of landscape photography, you absolutely need at least one graduated ND filter. (These are also sometimes called *split ND filters*, and they are half gray and half clear.) If you use this filter correctly, you'll find that the colors in your landscapes look much more accurate. The skies will be darker, the foregrounds will be brighter, and your entire image will show more of the beautiful, colorful details you were trying to capture.

When it comes to graduated ND filters, I highly recommend that you get the square or rectangular variety instead of the circular, screw-on kind. The idea is to line up the point of gradation with your horizon. Much of the time, you'll want to place your horizon in the upper or lower third of the composition (per the Rule of Thirds), rather than in the center. So, it makes sense that the rectangular kind of filter would be much better—much less limiting—than the circular graduated ND filters, which force the line of gradation to be right smack in the middle of your composition.

I find that the large, rectangular filters are easier to hold without getting my fingers in the picture. These filters come in a varying degrees of darkness; a .3 (or 1X) features a dark half that blocks out 1 stop of light, while .9 (or 3X) blocks out 3 stops. Shooting digitally, you'll want at least a .6 (or 2X) and more likely a .9 (3X). When the horizon is flat and well-defined, I use the version with the hard-edge transition. The soft-edge transition is better when the horizon isn't so linear (i.e., a jagged mountain range). If I were to use the hard-edge filter in the latter situation, the mountains would be noticeably darkened. You can either buy a filter holder designed to keep the filter in front of your lens or you can simply hold the filter in front of the lens when shooting.

Sometimes it's difficult to see the line of gradation on your graduated filter when you look through the viewfinder. Moving it up and down as you hold it in front of your lens will make it easier to see the filter line so that you can put it in the right place in your composition. If your camera features a depth-of-field preview button, be sure to use it when positioning your graduated filter. You'll often be surprised at how much the line of gradation can be altered by your choice of aperture.

> **TIP: JUST HOLD IT**
>
> Instead of using a filter holder, I simply hold the filter in front of my lens. It's faster than screwing the filter holder on and off. Plus, if you forget your filter is on the lens and turn your camera to the vertical orientation, you won't accidentally have the filter orientated the wrong way.

Here's what happens when you use a graduated neutral-density filter. Pale, washed-out skies become rich in color. In addition, foreground land becomes more saturated. The graduated neutral-density filter makes it easier for your camera to get the best exposure for both the bright and the dark areas of your images.

LEFT: 1/40 SEC. AT f/22, ISO 100, 28–135MM LENS AT 28MM; BELOW: 6 SECONDS AT f/22, ISO 100, 28–135MM LENS AT 28MM

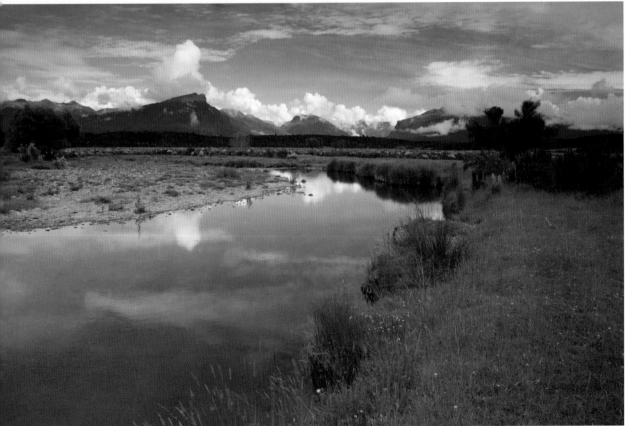

HAZE AND THE POLARIZER

The polarizer is another filter that does the digital nature photographer a lot of good. By reducing glare in water (both the kind you see, as in a lake, and the kind you don't see, as in the air), this filter increases color saturation. It is most commonly used to make blue skies bluer (and sometimes almost black), but this filter also helps a great deal when you're shooting other subjects. For example, I like to use a polarizer when I'm photographing wet autumn leaves or a meadow under trees.

The trick with the polarizer is that you have to be at a right angle to the direction of sunlight. In other words, your subject should be sidelit for the polarizer to have the greatest effect. The way to find out if you're in the right spot is to simply try it. When I arrive at a scene, I often hold my polarizer and turn it around to see the effect on the subject. If parts get darker, I know the polarizer is working. If nothing changes (or the result isn't pleasant) or if I decide I don't want to apply the polarizing effect at all, I put the filter away. Don't

TIP: ONLY USE "LIGHT EATERS" IF ABSOLUTELY NECESSARY

Keep in mind that cameras feed on light. They need it to survive. If they aren't able to take in enough light at any given moment, the pictures they produce will likely be blurry. The reason: If the lens opening (aperture) is as large as it can possible be, and the sensitivity of the camera sensor (ISO) is either set as high as it can go or as high as you want it to go (to avoid noise in your photo), then the camera has no other choice but to leave the shutter open for a longer amount of time. If either you or your subject moves during this time, the result will be a blurry picture. If you did not intend to make a blur effect, you'll feel frustrated. So, unless it's truly required to create a certain effect, don't put anything in the camera's way (such as a polarizing filter) as it tries to get its fill of light.

leave the filter on your lens when you're not actively using it because it blocks out some of the light traveling into the camera.

WARMING FILTERS

These aren't absolutely necessary anymore, especially if you shoot raw files. And, if you shoot in JPEG or another format, you can still warm images up using Levels or Curves in Photoshop. However, you'll make your job easier if you cut this additional, postproduction step from your workflow. I often use the warming filter (or a warming white balance setting, such as Shade) when I'm shooting many images in the shade; if I'm just shooting one or two before moving back into the sun, I usually leave it off. Since I'm shooting raw files, I know that I can easily warm up each image via the white balance controls as I open up and interpret the raw file.

OTHER FILTERS I USE

I sometimes use colored graduated filters to add a softly transitioning bit of pink or blue to part of the composition. I also sometimes use neutral-density filters (entirely gray filters, instead of the half gray/half clear graduated filters) to slow my shutter speed for coastal scenes, streams, and waterfalls.

USING FILTERS WITH COMPACT DIGITAL CAMERAS

It's easier to use filters with a digital SLR, because you can see exactly what part of the image you're affecting before you shoot. However, you can also use these graduated filters with compact digital cameras. Simply hold the filter in front of the lens, and use your LCD screen to determine the best position of the gradation. You may need to do some experimentation and exposure compensation. If, for example, your meter does not take readings through the filter, your meter may not be aware that you're filtering the scene. Watch the results (and, if possible, the histogram) in the LCD screen to see if you need to compensate. This is a lot easier, by the way, if you use a tripod.

With the polarizer, you can first hold the filter up to your eye (without worrying about the camera just yet) and turn it. If you see a change in the appearance of the sky or wet objects, then the filter is working. If not, your current point of view is not at the correct angle to take advantage of the effects of polarization.

See if these filters help you get more color saturation and more detail in the bright and dark parts of high-contrast scenes. It's always better to get detail in your highlights and shadows while you're out shooting—in camera—rather than to try to enhance what details you have in photo-editing software after the fact.

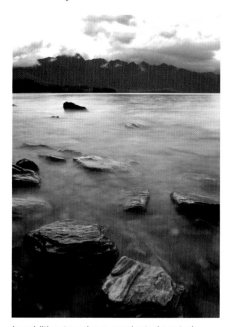

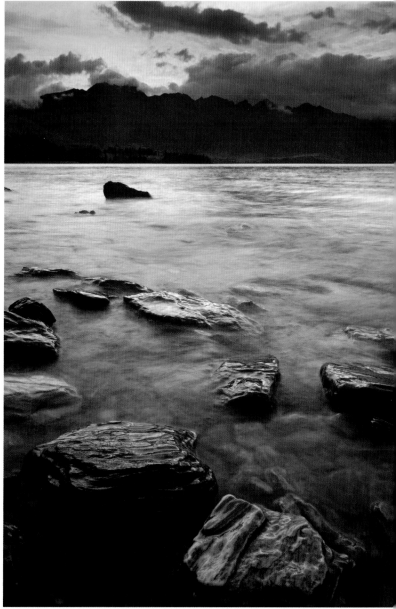

In addition to using a graduated neutral-density filter (with a simple gray color on the upper half), I sometimes use a graduated pink filter to give the sky some color. That's what I did here to make the clear sunset more colorful. However, afterward I noticed that the image didn't look convincing because the lake itself was still clear and colorless. To remedy this, I added red to the entire image in Photoshop. This made the water appear red, as well, and the resulting image succeeds. There's nothing wrong with adding a little color, either with a filter or with Photoshop. All that's required is that you do it well, make the result look natural and believable, and disclose the fact that you've enhanced the image.

ABOVE: 4 SECONDS AT f/22, ISO 50, 16–35MM LENS AT 26MM; RIGHT: 1.3 SECONDS AT f/22, ISO 50, 16–35MM LENS AT 26MM

An Introduction to Interpreting Raw Files

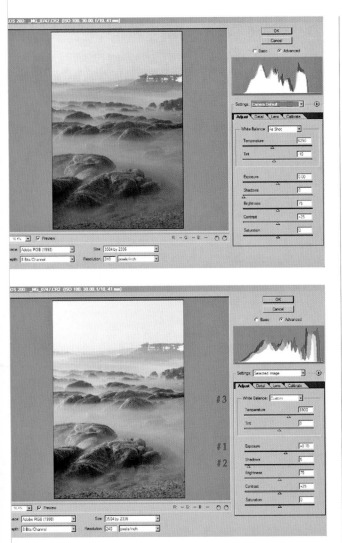

In the screen shot with the original image file (top), you can see that both the Exposure and Shadows sliders are set to 0, and the White Balance pop-up menu reads As Shot. In the screen shot with the altered image file (bottom), you can see both the adjustments to the sliders and the White Balance, and the resulting effects on the image.

THIS IS A QUICK introduction to raw using Photoshop's built-in Camera Raw converter. There are other ways to open raw files, but this primer should point you in the right direction regardless of which tool you use to open your raw files.

Once you can see and open your raw files in Photoshop, you'll see that Photoshop's Camera Raw converter gives you many tools to manipulate your photographs when opening each file. While every one of these tools is useful in *some* cases, I'm going to focus on the three tools that are useful in almost *all* cases—the tools you can't live without: Exposure, Shadows, and White Balance. You can save other controls (such as Brightness, Contrast, and Saturation) for later. Mastering Exposure, Shadows, and White Balance will take you far in your efforts to enhance the look of your photographs.

Here are the three simple steps I take when opening any image, as illustrated in the second screen capture at left:

1 I move the Exposure slider to the right to brighten the photograph. I usually move it until the right "peaks" of the histogram come close to the right edge. But be careful; it's usually best if you don't move it so far to the right that a spike appears on the right-most pixel of the histogram.

2 I then move the Shadows slider to the right to darken the blacks in the image. In this case, be careful to not cause spikes to appear on the *left-most* pixel of the histogram.

3 Then, if necessary, I choose an option from the White Balance pop-up menu that produces the most pleasing and/or realistic color in the photo.

Brightening the highlights by moving the Exposure slider to the right and darkening the shadows by moving the Shadow slider to the right will increase contrast and make the colors in your photo pop. Adjusting the white balance (if necessary) will make the overall tint appear more natural. I usually just adjust Exposure and Shadows, only fiddling with White Balance when there appears to be a problem. For example, if the image looks yellow and suffers from a color cast (even after I adjust Exposure and Shadows), then I might adjust white balance. Nine times out of ten, the white balance does not require adjusting.

Viewing the screen shots, you can see why many photographers refer to raw as *the digital negative*. Just as a photographer in the darkroom can make a great variety of interpretations when printing from a single negative, a photographer shooting in camera raw can easily create many varieties when opening the raw file. Raw gives the digital photographer much more latitude and flexibility than other file formats. It allows you to create an image that reflects your exact tastes. If you want it darker or brighter, higher or lower contrast, warmer or cooler . . . you name it, you can interpret the image just as you'd like it to look. The only drawback is that going through this process on every image is slow and tedious when compared to the speed and ease of opening a JPEG.

RAW AS A SUBSTITUTE FOR BRACKETING

Bracketing is the practice of making several exposure of the same exact scene at a variety of cumulative exposure values. It has less to do with creative effects and more to do with getting the overall brightness correct. Photographers usually bracket to cover themselves, making sure they get a usable exposure of the shot. However, if you shoot in raw format, you don't need to bracket. Many digital cameras are now incredibly good at

metering scenes, and with raw, you have so much flexibility with regard to exposure when processing the image.

Should you still worry yourself about getting an exposure that is dead on? If you shoot raw, I don't think so. If you're shooting JPEG files, you would want that JPEG to look as good as possible without tweaking. But with raw, since you have to process each camera raw file when you open it, you can trust your meter more, knowing that you'll get plenty of latitude in exposure.

However, one advantage of continuing to bracket using your camera's autoexposure bracketing feature is that you get three shots. This will give you a better chance of getting a properly sharp version when you're photographing at slower shutter speeds in low light. Of course, this also means you'll have three times the amount of images to sort through later.

The choice of whether or not to bracket your exposures is entirely up to you. In this digital age, with camera raw and the histogram, it seems unnecessary to me. With all this flexibility and latitude, I see no need to quibble over 1/3-stop differences in exposure anymore.

PRACTICAL MATTERS
Staying Organized

Develop an organizational system that makes sense to you. It can be as simple as storing unused memory cards in one pocket and used memory cards in another. It can be as complex as taking notes and using numerical systems to keep track of what you've shot and where you are in the workflow process. Whatever method you use, you need some way to stay organized. The particular steps you use are less important than the need to find a system—any system—that works for you.

Exposure Compensation

EXPOSURE COMPENSATION is a feature that allows you to skew the camera meter's reading a bit in one direction or the other. You can choose to add 1 stop of light (+1) when photographing a bright scene (such as one with snow or a beach). When the meter reads a particularly bright scene, it shortens the exposure, letting less light in, and the result can be gray or otherwise underexposed whites. Using exposure compensation to add a stop of light will cause the camera to expose for twice the amount of time it deems necessary, and the result will be a brighter overall exposure.

Exposure compensation gives you an easy way to shift the overall exposure to affect the brightness of the image. However, don't confuse it with direct aperture or shutter speed control. While exposure compensation allows you to shift the exposure in one direction or another, it only affects overall exposure without applying any creative effects. Using Aperture Priority mode, you can limit or extend depth of field. Using Shutter Priority, you can freeze or blur motion. You cannot make these creative effects using exposure compensation.

So, use exposure compensation to correct brightness, but use your exposure modes to control depth of field and convey motion.

USING THE HISTOGRAM TO ENSURE PROPER EXPOSURE

The real power of the exposure compensation feature becomes evident when paired with the in-camera histogram. Both while shooting and when converting raw files, many photographers (myself included) judge the quality of the exposure (the overall brightness) by viewing the histogram. If you are continually frustrated with the task of identifying good exposures vs. bad ones, the histogram might be your next favorite thing.

First, you may find it helpful to remove color from consideration. In the world of exposure, color has no meaning. When a photographer says, "You should meter off of something that looks medium gray," this is slightly misleading. You don't need to look for something gray. It can be any color. What you really want is an area of medium brightness, regardless of color. Therefore, if you have an image

Removing color from the equation can often help you think like a camera meter. As far as proper exposure is concerned, color is meaningless. The only thing that matters is brightness. And, it's often easier to interpret value without the element of color to distract you.

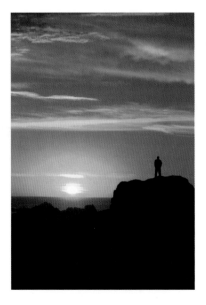
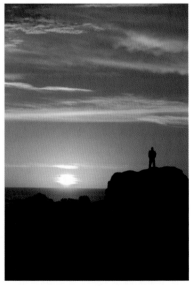

of a sunset with a lot of orange, ask yourself, "Where in this scene is there a medium orange?" You don't want a bright orange or a dark orange but rather something right in the middle. When you see a scene in black and white, you can begin to guess at where the medium tones are, but wouldn't it be nice if you could get rid of the guesswork? Wouldn't it be nice if you had a tool that graphically represented everything in a picture so that you could determine the bright, dark, and medium areas scientifically. Well, you do—the histogram.

A histogram is a graphic representation of all of the pixels in a digital photo. Think of it like you would a simple bar chart or graph. The horizontal axis represents the spectrum of brightness levels in your photograph, from darkest to brightest. The vertical axis represents the number of pixels that consist of each particular tone.

Many people mistakenly think that the object of looking at the histogram is to confirm that the majority of pixels are in the middle of the histogram. As long as they see this middle mountain of black, they think they're getting a "good" exposure. They've been misled to think that too much on the left means underexposure and too much on the right means overexposure.

Actually, this is only partially true. Many scenes will contain many dark areas, and many other scenes will contain many bright areas. So, don't search the histogram for the "ideal" mountain in the middle. The better way to interpret the histogram involves watching the extreme left and right ends of the graph. The real concern is a histogram with a spike at the extreme left or extreme right end. A thin line going up the left edge indicates an image in which the shadows don't contain satisfying detail. A thin line going up the right edge indicates an image in which highlights are blown out and don't contain satisfying detail.

To make this superclear, take a look at the histogram and black-and-white image together below. The left-most spike indicates that a lot of the picture is pure black. In some situations, this would mean that those parts of the image are underexposed. However, my image contains a pure black silhouette of the shore and a man witnessing the sunset. So, there's nothing wrong with that area being black; in fact, that's how I wanted it. The right-most spike indicates that something in the photo is pure white. In some situations, this might indicate overexposure, but in my image, it's the sun area, so I don't consider it overexposed at

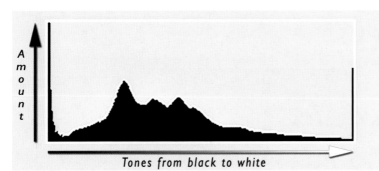

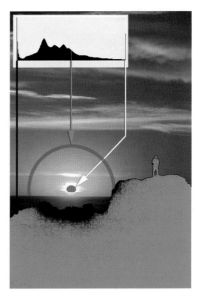

The histogram above shows, in chart or graph form, both the range of tones in an image and the amount of pixels that correspond to each tone. This histogram corresponds to the left-hand image on the facing page.

In this paint-by-numbers illustration at right, green represents the parts of the image that are pure black. Red represents the parts that are pure white. The parts of the scene that are medium gray fall within the blue arch. That area of the sky is the medium tone from which I took my meter reading.

all. (I would be misguided if I were to try to lower the exposure to bring out detail in the sun.) This right-most spike is not as high as the left-most spike, which means that significantly less of the image is occupied by this totally white object.

PRACTICAL APPLICATIONS

The histogram comes in handy in the field, giving you an alternative to examining the LCD on your camera to determine proper exposure. When bright sunlight makes it difficult to view the LCD screen or when you want to confirm that no important parts are underexposed or overexposed, turn to the histogram. With it, you can check your exposure quickly and then move on to more shooting.

I use the histogram all the time when I'm out shooting to make sure I'm not blowing out detail in the highlights or losing detail in the dark parts of the photo. When you see a spike at the right-most end of the histogram, this means your highlights are getting blown out or overexposed. If you don't mind this happening (as I didn't mind with the sun), you have nothing to worry about. If, on the other hand, it's important that you retain detail in that area, turn down the exposure with the exposure compensation feature mentioned previously.

Compensating for overexposure requires that you set the exposure compensation to a negative number. On my camera, this negative number is to the left of the center of the exposure compensation indicator. This makes it easy for me to remember: When I want the spike in the histogram to go left, I move the exposure compensation to the left.

Look at the histogram in the upper right of these Camera Raw dialog boxes in Photoshop. The first is underexposed, with a spike appearing at the left-most end of the histogram. If I were viewing this histogram in my camera, I would then turn my exposure compensation to the right, to a positive number. If I went too far to the right, I might end up with a histogram like this second example, which is overexposed. Note how the bright areas are far too white, and the spike is on the right of the histogram. Turning my exposure compensation back down to a negative number (but not as far down as before) will likely result in the third version, which is just right.

> ## TIP: SET A WARNING
>
> You may be able to set your camera to show blown out highlights as blinking warning lights in the picture you see in the LCD screen. If you prefer this, feel free to use these instead of, or in addition to, the histogram. When you see them, turn your exposure compensation down to a negative number and shoot again.

Exposure Recap

So, to recap, here again are the steps for perfectly exposing any scene:

1 Analyze the scene. If your composition includes a large tonal range—both bright and dark areas—consider recomposing. Try to find a composition that gives the camera meter a fighting chance.

2 If recomposing isn't an option, photograph the scene as is.

3 Check your histogram for overexposure or underexposure.

4 If you see the histogram's left-most value spiking, use the exposure compensation feature to add light. If you see the right-most value spiking, turn your exposure compensation to a negative number to bring in less light.

5 Repeat steps 2 through 4 until you get an exposure with an overall brightness that works for you.

If you can already sense the glorious benefits of using this system, go for it. It really is as simple and helpful as it sounds. If the technical aspects of this are making your head spin, take a break and then come back to it. Read through everything one more time, and then try it out for yourself. Trust me, once you have the histogram and camera raw format under your belt, you'll be so glad you learned them. Understanding the histogram and camera raw will change the way you look at exposure forever.

ASSIGNMENT Intentionally Blur Your Subject

If you were the kind of kid who didn't mind coloring outside the lines in kindergarten, you're going to love this assignment on exposure. That's because I want you to *purposely blur* your subject. Blurriness can be good, as long as it looks intentional to the eye and adds interest to the photo.

You can create flowing, "cotton candy" waterfalls and streams by setting your camera securely on a tripod and using a slow shutter speed—something from around 1/10 sec. to 2 seconds or slower. But you don't have to stop at just blurring moving water. You can get more adventurous than that. Here's what I want you to do: Switch to Shutter Priority exposure mode and select an especially slow shutter speed (I like 1/8 sec. to 1 second, depending on the subject). Then, try the following two techniques:

1 With your camera securely mounted on your tripod, zoom in or out while the shutter is open.

2 While handholding your camera (that's right, you can go tripod-free), sweep the camera up or down, left or right, or even in little circles as you shoot. You can even swivel the camera as you shoot, rotating it on the lens axis.

Make many, many exposures, experimenting with a variety of shutter speeds and motions. Shoot a lot to give yourself a lot of choices when it comes time to pick your favorites. The goal is to get an image that feels balanced and organized, even though it's painterly and abstract.

One last tip: Avoid including any sky or other superbright objects in your composition when doing these sweeping or zooming techniques. Bright areas will often be overly eye-catching in the final images. I often do a practice zoom or sweeping motion to make sure my path is free of such bright areas before I make the actual exposure.

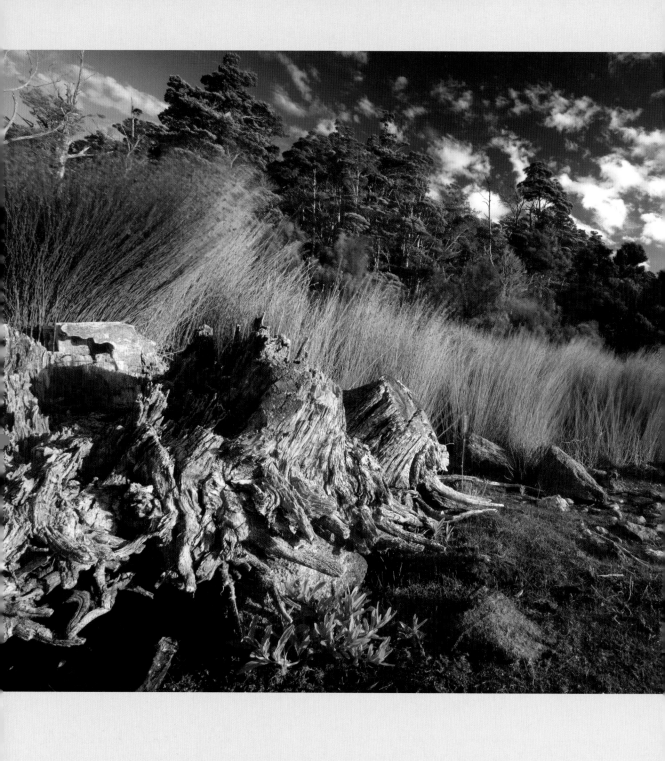

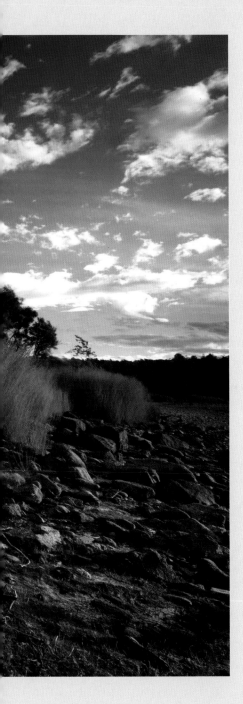

CHAPTER 4

Landscapes

All places are photogenic.
It's our job to figure out how.
—Robert Caputo, *National Geographic
Field Guide: Landscapes*

BY FAR, the most popular kind of photography (besides recording our family and friends) is landscape photography. And the primary goal in landscape photography is to convey the awe-inspiring natural beauty witnessed first-hand in a grand, sweeping vista. Simply snapping a picture of such a view is almost always disappointing, but there's hope. There are several techniques you can use to make landscape images stand out, starting with first thinking about what it is you're really trying to achieve.

To photograph the shore of Lake Te Anau in New Zealand, I turned to my wide-angle lens, a polarizing filter, and the last light of the day. These ingredients help to convey a sense of place in an eye-catching way.
1.3 SECONDS AT f/22, ISO 100, 16–35MM LENS AT 16MM

Conveying a Sense of Place

LANDSCAPES, like travel photographs, are all about *place*. When you're considering a landscape scene, ask yourself this: What is the character or personality of this place? Is it peaceful and serene, dramatic and rugged, or colorful and exciting? Once you've identified the character of the place, do whatever you can to convey this character to the viewer. Use any tricks that you have up your sleeve. If the place feels moody and brooding, perhaps wait for dark, dramatic clouds. If you can see for miles and miles, use extensive depth of field and include interesting objects both near and far.

Once you know how you would describe a place, you know how you need to photograph it. Your goal is to elicit an emotional response in your viewers, and a great place to begin is to figure out your own feelings about the place. Only then can you accurately relay these feelings to someone who is not experiencing the place in person. Strive to give the viewer an immediate emotional feeling when viewing the photo. If the photo looks like it could have been taken anywhere, you need to try again, working harder to figure out and communicate what makes this particular landscape so special.

EDGES

All nature landscape photographers should pay attention to what Galen Rowell used to call "edges." Edges can refer to edges of weather fronts, actual physical edges of geographic areas, or "edges" of time, and they often provide especially interesting photographic opportunities.

Look for the edges of storms, fog banks, forests, land (i.e., the coast), and days (i.e., sunrises and sunsets). At the edge of a storm, you may get beautiful glowing beams of light set against a dark gray cloud background. At the edge of fog bank, you can find interesting foreground subjects set apart from the misty, nondistracting, moody background.

PRACTICAL MATTERS
Talk to Locals & Visit Postcard Racks

When you first arrive at a location, ask locals for advice and recommendations. Whether you're at a campground, park visitor center, or roadside lookout point, talk to the people you rub elbows with. Don't be shy. Rangers, other tourists, staff, local business owners . . . ask any friendly-looking person if he or she knows of good places to visit and good times to visit them. See if you can find out some hidden "back road" gems, as well as the places people usually go. However, process the advice that you're given. Remember that these people are rarely photography enthusiasts. You may have to filter what you hear and take only the information that corroborates with what you know about photography. If a local tells you the best time to view a particular scene, for example, be there one hour earlier, just in case. Take advice with a grain of salt, and use your own best judgment. After all, you're the photographer.

One of the other things I do when I first arrive at a scenic location is study the postcards for sale at local stores. These may or may not be great photos. Either way, they give me visual clues. They tell me where to go and what to look for. The image of the waterfall on page 99 was inspired by an image I discovered in the postcard rack.

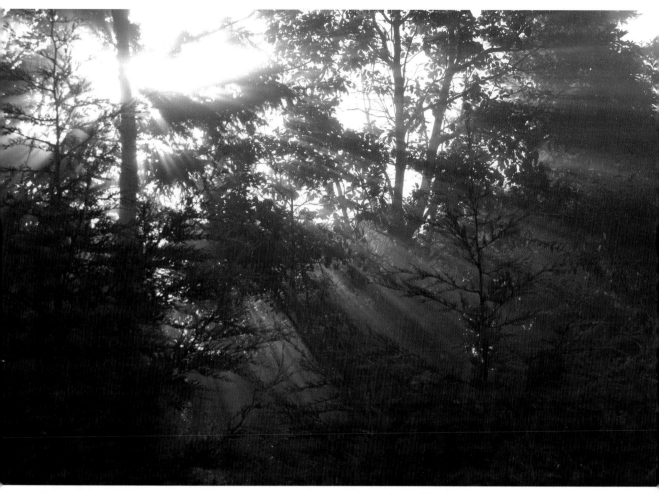

Fog can make many scenes magical. When you see fog, stop and photograph it. When I noticed low fog while cycling in western Washington, I stopped at a place where the sunlight was filtering through the trees. The backlit trees became somewhat silhouetted, and the fog gave definition to the beams of light.
1/250 SEC. AT f/8, ISO 100, 28–135MM LENS AT 80MM

Time of Day and the Landscape

IF I HAD TO determine what conditions are needed to make a great landscape photo, great light would easily be the number one requirement. The right light can make the dullest of scenes and the most lackluster subjects appear interesting, whereas even the most exciting subjects can rarely be made to look special when photographed in lackluster light. Composition is also important, as is exposure (and the use of filters, when appropriate). Don't forget our L.C.D. acronym. However, I can have great composition and use the right filter, but without great light, my photos will be unimpressive. So, in keeping with L.C.D., the next few pages address light issues that pertain most specifically to shooting landscapes.

Again, the key to finding the best light is going out at the best time of day. (I touched on this in the Light chapter, but it bears repeating here with regard to landscapes.) This means getting out early in the morning and going out again late in the day. These are the times when the light will be best. The rule here is very simple: Photograph landscapes in the early morning and late afternoon. How much easier can it get than that?

You will double your results, particularly, if you get up early. If someone told you you would double your money by rising early, you'd do it, right? Well, this guarantee extends to golden light, too. All you have to do is get up early. Every morning may not be glorious, but neither is every sunset. But the amount of golden light you encounter (and therefore the amount of keepers you get) will noticeably increase.

WHAT ABOUT MIDDAY?

Some photographers like to continue shooting during the midday hours; others prefer to relax, read up on and scout locations, visit museums, or work on their images on the computer. Taking advantage of midday light can add more images to your file. Just be aware that the light is often harsh. Working in shade—even using translucent pieces of fabric to create shade when it's lacking—can help when photographing small subjects.

Midday shooting isn't always a bust. Keep an eye out for deep blue skies, attractive clouds, and good color no matter the time of day. I didn't hesitate to shoot when I saw this red rock (opposite), and the result was worth it.

RIGHT: 1/50 SEC. AT f/16, ISO 200, 18–200MM LENS AT 18MM/PHOTO © KATHY KONESKY; OPPOSITE: 1/250 SEC. AT f/9, ISO 400, 28–135MM LENS AT 28MM

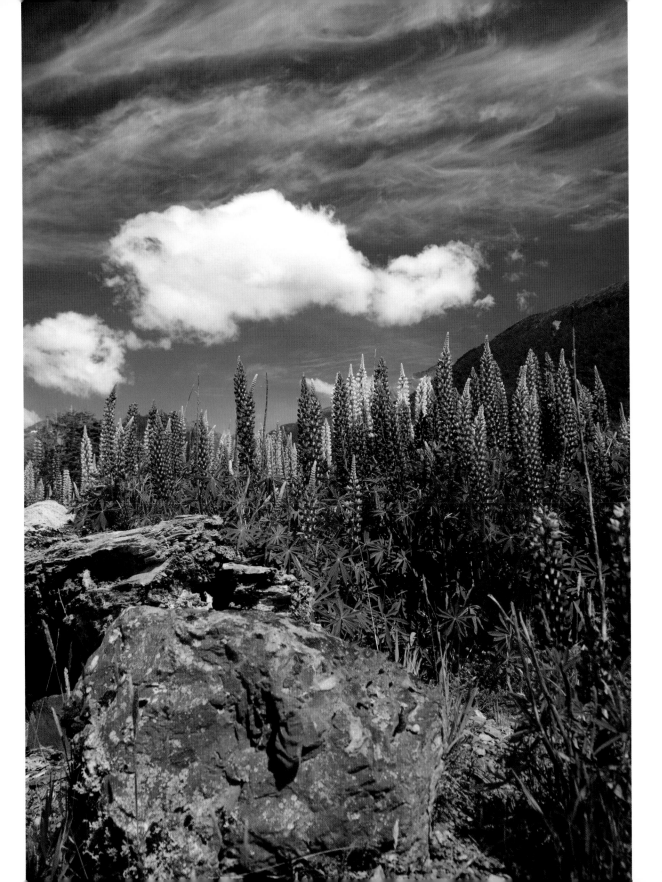

However, when your subject is an expansive landscape, the only thing you can do is work with the light you've been given.

I have captured a handful of good landscapes during the middle of the day, but I created most of my favorites in the early morning, late afternoon, or evening. I also don't enjoy working in midday as much as at the "edges" of the day, because the light is rarely exciting or inspiring. The mornings and evenings are simply more rewarding.

LOOK AT POSTCARDS, BUT DON'T COPY THEM

On the previous pages, I recommended visiting the postcard rack when you arrive at a new location. And while I believe this is a useful exercise, you will find an interesting characteristic if you look closely at those images: Most of the time, postcard skies will be very blue with less-than-amazing light. This is because only a small percentage of postcard images are created during the early mornings or late afternoons. More often, those images are shot closer to the middle of the day.

My theory on this is that these images are meant to cater to people (i.e., tourists) who shoot mainly at that midday time. The postcards sell more because the buyers recognize the places they've visited, and few are looking for the most artistic photos. They are looking for a simple memento or view that they can send back to the folks at home. So, while you should use postcards for site information, don't feel you must copy the light (and therefore the creative interpretation) exactly. Try going to those locations at other times of day.

However, this doesn't mean that I never shoot when the sun is high in the sky. When I do work in midday light, I look for deep blue skies (especially when these skies also feature nice, puffy clouds), color in the landscape (especially warm colors, such as red), and smaller subjects in shade.

POLARIZERS AND THE LANDSCAPE

Sometimes, you'll find yourself in a good location in the middle of the day without an opportunity to return at a later or earlier hour. One thing you can do to make the most of midday light is to use your polarizing filter (see page 74). The general rule is that your camera has to be pointing at a right angle to the sun for the polarization to work. However, you may not have realized that the sun is at a right angle when it is directly above you. Your subject is being sidelit, but from the top. Thinking in three dimensions rather than just two, you can try that polarizer, if, for some crazy reason, you happen to be photographing in midday light.

TIP: THE EARLY BIRD
AVOIDS THE WIND

A big advantage of shooting in the morning is that you're less likely to encounter windy conditions. Early morning air is often calmer than air later in the day and, therefore, provides more opportunities to capture crisp, clear reflections in calm lakes and ponds, as well as tack-sharp macro shots of flowers. Without a breeze to disturb them, such macro subjects are much easier to capture in sharp photos.

The polarizer works best when the direction of light is perpendicular to the direction in which you're pointing your camera. When the sun is in positions A or B (opposite, top)—at a right angle to the direction of the camera, you will likely see the greatest polarization.

However, don't forget about position C (opposite, bottom); the sun is again at a right angle to the direction of the camera—but vertically this time. Midday can be a great time to use a polarizer, because you'll often find yourself positioned with the light coming from directly above you.

SHOOT WHEN THE LIGHT IS GOOD

As with any subject, with landscapes there's no need to get locked into shooting only in the mornings and evenings. Since weather conditions change, good light can happen at any time. It's always best to simply look around you to see what, if anything, is happening with the light. If it appears magical from your point of view when you're out shooting, it likely will look magical in your photos.

No matter what, stop and shoot when the light looks special. Better yet, get ready to shoot *before* the light becomes special. Especially when you're driving, there's a natural tendency to keep moving. Be very assertive, and stop the car whenever you see an interesting subject or an attractive light. Even if it means occasionally grazing all morning on granola bars instead of sitting down for a hot meal, opt for the good light. Never bet that the light will be as attractive on a return visit as it is at the present moment.

Yes, the truth is that you still have to get up and out early, and continue shooting into the late morning. This is the price you pay to get memorable photos. Additionally, when you're shooting in the early afternoon, keep going until a half hour after sunset (as long as the light remains good). Don't stop shooting when the sun sets on the horizon. Some of the most magical colors occur *after* the sun has gone down below the horizon.

Travel Planning

The enjoyment of outdoor photography extends beyond the actual trip itself. You can also enjoy *planning* the trip and then reliving your adventures long after the fact via your memories, stories, and photographs.

When it comes to planning a photo excursion, there are many helpful resources on the Web. For arranging flights, I turn to AlaskaAirlines.com and Expedia.com first. These are just my personal preferences. My backup options include Travelocity.com and Orbitz.com. I also turn to Hotwire.com to find the best deals on rental cars. When booking flight reservations, I reserve a window seat, and keep my camera and telephoto zoom lens with me in case I happen upon an unbelievable view at sunrise or sunset.

I pack everything I won't need on the flight into checked luggage and carry on my camera gear, a laptop, one or two books, and a notepad. I travel nonstop when possible since I like to work on my laptop while flying—an additional battery that replaces my CD-ROM drive gives me about five to six hours of power, which is more than enough for most flights. All the same, I plug into any outlets I can find in airports when changing planes and waiting for my next flight. Earplugs are great to have on hand and a neck pillow is sometimes worth the bulk.

ASSIGNMENT Shoot the Same Scene throughout the Day

This is an assignment I love to give to my online photography students. Don't take my word for it when it comes to shooting at the right time of day. Try it out. Begin by photographing a local landscape at late afternoon or early evening. If the sun is out, find a subject that will get direct light as the sun goes down, and photograph it in the last light of the day. Then photograph the same scene at different times in the day, including at early morning. You'll see two things. First, the light changes drastically throughout the course of the day, which has a great effect on the subject. Second, you'll see how photographing in late-afternoon and early-morning light can do more than anything else to make your images shine!

Compare these photos. Study them closely to see how many things you can observe about how the light changes through out the day. How did its direction change? How did its color change? What about its intensity?

In addition, taking pictures of the same scene throughout the day will train your eye to be able to estimate what a scene will look like in a different light. With this training, you'll be able to visualize where and how the light will appear later that day or early the next day (although it is true that anything can happen and you might get surprisingly different conditions when you return).

Similarly, photographing the same location throughout the year will train you to visualize how a scene will look in different seasons. Either way, this training in visualization will greatly help you get yourself to the right place at the right time.

In closing, if you haven't ever actually begun shooting before sunrise or just after sundown, do it today and tomorrow. Better yet, if you have the opportunity, take a short trip and habitually shoot in the morning and evening for several days in a row. I can't encourage you enough to do this. It will change your life, photographically speaking.

TIP: DO THE PREFLIGHT CHECK

After I do the preliminary work of setting up my tripod and roughly setting up the shot, I often go though a really quick checklist:

❏ Horizon level okay?

❏ No distracting elements along the edges or in the corners?

❏ Autofocus turned on?

❏ ISO correct?

One morning while leading a group of photographers to a wildlife shoot, I noticed this early-morning light and had to stop. The single tree, illuminated in this very low light might not catch the eye of most people, but as this shot shows, it pays to broaden your idea of "good light." Stop and shoot whenever the light looks interesting, and be open to light that you might have passed on previously.

1/8 SEC. AT f/29, ISO 100, 28–135MM LENS AT 38MM

Overcast Skies

WHEN YOU'RE GREETED by an overcast sky, don't pout. Rejoice! Overcast skies soften shadows and even out contrast. Surprisingly to many, an overcast day provides great light for landscape photography—as long as the light is bright enough and you're photographing the right kind of subject. Overcast conditions that are too dull will produce light that's flat (too low contrast). Images shot in this light usually look lifeless. A bright overcast condition, on the other hand, will produce wonders if used wisely. Most notably, it will increase color saturation, often making colors look richer and more beautiful. Overcast light is also great for wildlife subjects, as I'll get to in chapter 6.

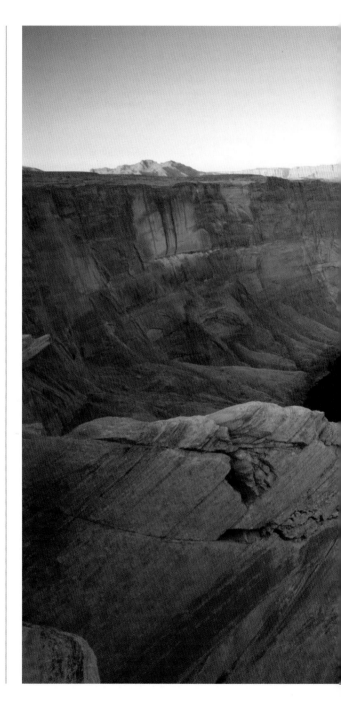

The pair of photos on this and the next three pages shows the value of a bright overcast sky. I took the first photo here just after dawn on a freezing winter morning in northern Arizona. My friend and I thought this would be a great place to shoot at first light, but when we arrived, we realized our mistake: The canyons were so deep that they were engulfed in shadows and would remain so until midday. I did my best to even out the contrast between the bright areas and dark shadows, but when my friend's face started turning blue in the extreme cold, we called it quits and headed off in our warm car to the next destination. Compare this to the version on the following pages.

8 SECONDS AT f/22, ISO 100, 16–35MM LENS AT 16MM

White Skies

If you're dissatisfied because a dull white sky takes up a major portion of your composition, you have two choices:

1 If you can't live without the sky in your composition, use a graduated neutral-density filter to darken it. This brightens the landscape and nicely evens out the contrast.

2 If you can live without the sky, eliminate it. Use a more telephoto lens and tighten up your composition so that the sky simply isn't a part of the picture.

Actually, this second option applies to every object in your picture. If it isn't important, eliminate it. Even when the sun and sky are not a part of your composition, light is still the most important component. And, the beautiful thing about the sky is that even when you keep it "offstage," it is still greatly influencing the character of your photograph.

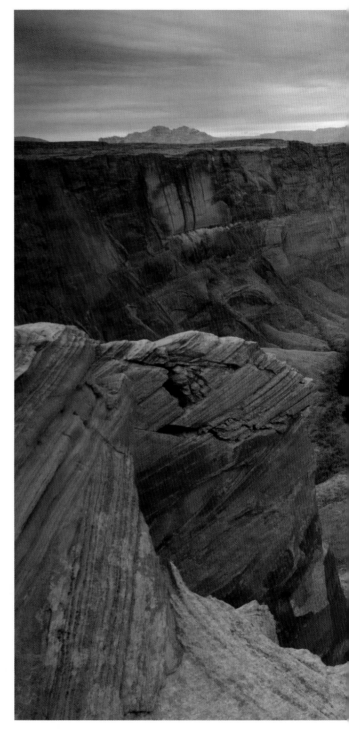

A few days after taking the image on the previous pages, we were on our way back to Phoenix when we decided to revisit the same location—but this time, near the middle of the day. It was overcast and much warmer, and we were delighted with how successfully the overcast sky illuminated the red rock in the canyons. The result is proof of the value of soft, diffused light when photographing landscapes.
1 SECOND AT f/22, ISO 100, 16–35MM LENS AT 16MM

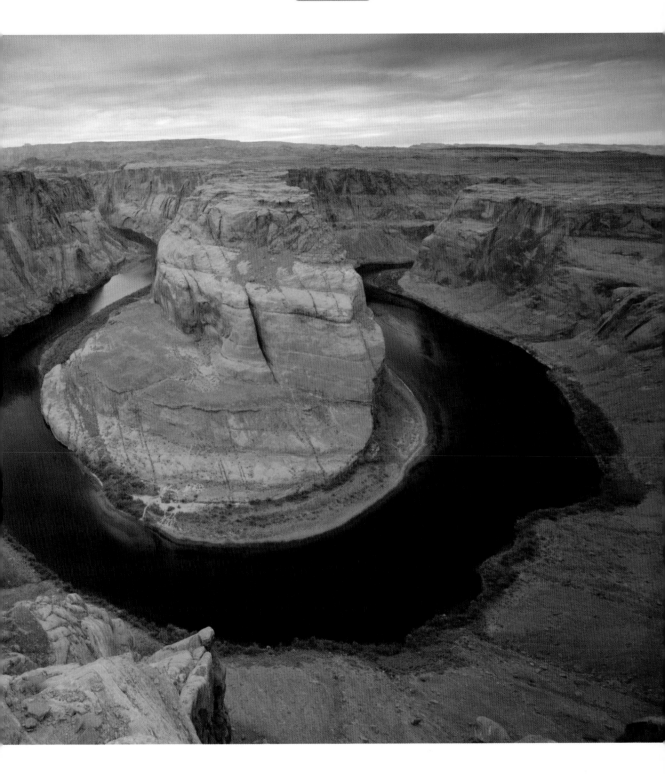

Waterfalls and Rainbows

WATERFALLS ARE easier to shoot on overcast days. For one thing, the light is dimmer, which makes it easier to use slow shutter speeds to create that streaming, cotton candy effect. It's also easier on overcast days because the number one cause of problematic, unattractive waterfall images is direct light.

If you can photograph your waterfall in shade or on an overcast day, you'll be much more likely to capture details in the flowing water. Direct light causes highlights to look too washed out. When you shoot in such blue-sky conditions, remember to warm up your image. Do this with either a warming filter, your white balance settings, or Photoshop after the fact. Either way, the goal here is to remove the blue cast (the reflection of the blue sky on your scene) without adding so much warmth that the scene looks either brown, muddy, or unrealistic.

Also, look for a splash of color, such as fall foliage or wildflowers. Waterfalls and streams often render as an overabundance of grays, whites, and blacks. Including a colorful assortment of leaves or flowers in the foreground will go a long way toward making your waterfall photo stand out. And photographing this type of scene when it is lit by indirect, soft lighting will keep your highlights from being overexposed, or blown out.

Waterfall Recap

BAD	=	Waterfall in direct sunlight
BETTER	=	Waterfall in shade or overcast conditions
BEST	=	Waterfall in shade with colorful foreground elements

RAINBOWS

When you're out photographing and you see a rainbow, use your polarizer, and spin it slowly. If you look through the viewfinder while you do this,

you will see the rainbow disappear and reappear. Obviously, you want to be careful to make sure you do not polarize the rainbow into nonexistence. Instead, rotate the filter until the polarization is at its least effective point. This should actually enhance the rainbow's colors by reducing the interfering haze and causing the colors of the rainbow to appear more saturated.

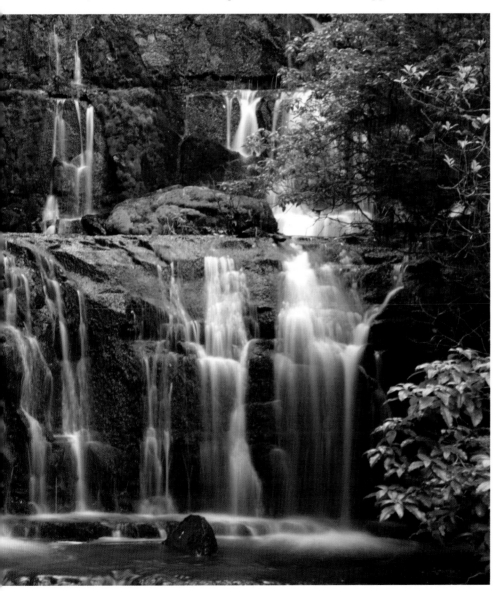

This photo works because the waterfall is both shaded by the forest and illuminated by an overcast sky.
5 SECONDS AT f/29, ISO 50,
28–135MM LENS AT 56MM

Mountains

WHEN YOU'RE HOPING to photograph mountains and mountain peaks, use guidebooks, maps, and sunrise/sunset tables to determine which parts of the mountain will be in direct sunlight during sunrise and which will be lit during sunset. A composition that includes both the mountain and another element of the environment will tell viewers more about the subject. When you're framing your shot, locate an object in the foreground to include in your overall composition. This could be grass, wildflowers, an interesting tree or rock, you name it.

With this in mind, look for nearby lakes. These provide an awesome opportunity to photograph both the peak and its reflection (see pages 115 and 127). Don't bother shooting this kind of scene, though, until the wind has died down and the lake surface is calm. Mornings can often be a good bet for getting those perfect mirrorlike surfaces, but it can happen in the evening, too. Also, look for rivers and streams. These can be especially effective at reflecting the color of the sky, and they can also provide a great line leading up to your peak.

Also consider including people in your composition. A person can add meaning and give the picture a needed sense of scale. With this frame of reference, the viewer will be able to appreciate the grand size of the mountain. (Also see page 133.)

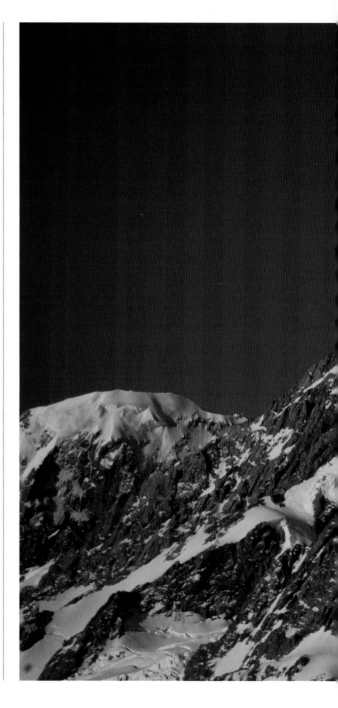

Notice how the use of a telephoto lens enabled me to get very close to this peak. Without any context or environment around it, the subject is less storytelling (compare to the image on page 102). Here, the size of the peak and the last light of the day are the true subjects of the photo.
1/50 SEC. AT f/9, ISO 50, 70–300MM LENS AT 250MM

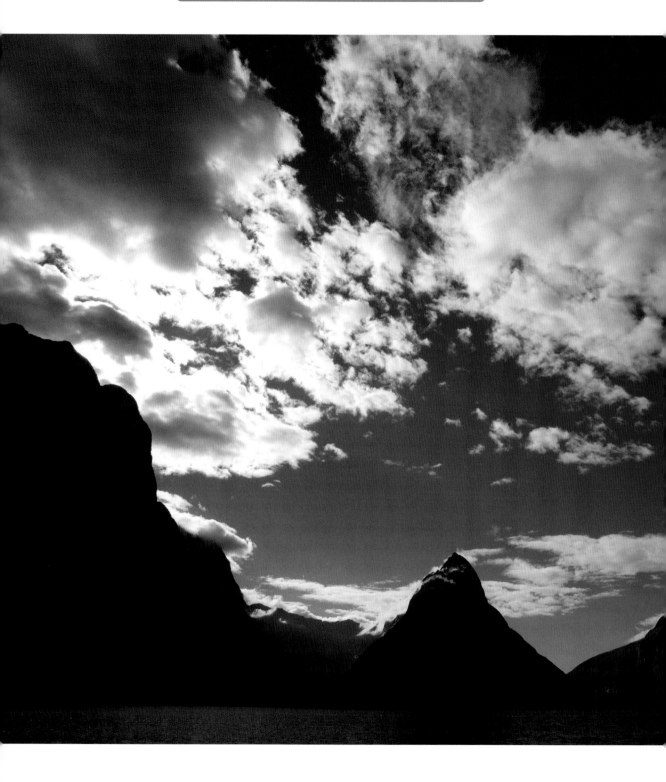

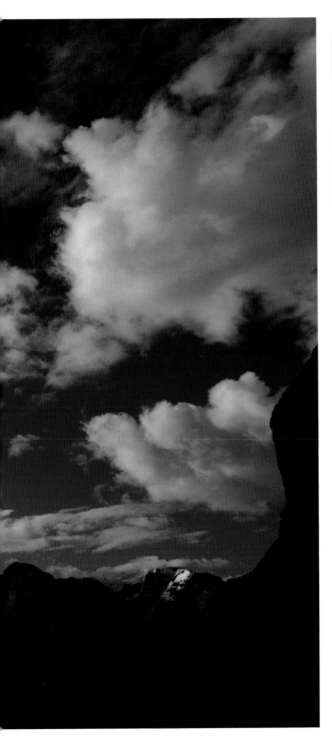

Planes, Trains & Automobiles

How you travel is up to you. I, personally, like to fly if the main destination is more than a five-hour drive away. If my destination is in my region (the Pacific Northwest), then traveling by car works best because I can easily carry all the necessary gadgets and gear without worrying about airport security or baggage handlers having to deal with photo equipment. Car travel takes more time but opens up the possibility of camping (airplane travel gets troublesome with camping gear).

When you travel by car, aim to spend less time on the road and more time exploring each location. Less time in the car means more time shooting. (And, if you're happy photographing in one location, stay there.) Try to structure your trips so that there's less distance between potential photo stops.

When planning to camp, I call up the campground or visit its Web site to reserve a spot. When my destination is a national park, I spend time on the official park Web site, as well as on Web sites of other photographers who have visited that park. I hike and backpack on occasion, but I find that car travel gets me to more destinations in a shorter amount of time and, therefore, increases my photographic yield. Choose whichever mode of transportation works best for your needs.

I kept L.C.D. in mind when making this image, so it's a good example of how to use the acronym. Concentrating on light (L), I waited till just before the late-afternoon sun dipped below the mountain peaks in Milford Sound and was able to create a backlit image (this also ties in to D, as you'll see). For composition (C), I used a wide-angle lens and balanced the composition by placing the sea and mountains in the lowest third of the image, giving a great deal of weight to the dramatic sky. To get my digital exposure (D), I exposed for the medium-blue tones of the sky, which threw the peaks into interesting silhouetted shapes.

1/1000 SEC. AT f/16, ISO 500, 16–35MM LENS AT 16MM

Clouds

I PHOTOGRAPH CLOUDS any chance I get. You, too, can use them in your pictures if they're dramatic and interesting. Use them outside the picture as a light diffuser if they're uninteresting; even clouds that are visually uninteresting are useful, because they transform bright direct light into soft even light. You simply need to identify what kind of cloud cover you're working with and make the most of it.

There's nothing more heartwarming and fun than to be out enjoying clear blue skies. Throw in the kids and a couple of hot dogs and you have the makings of a downright great day. But as I've mentioned, this is generally not the best time to be taking photographs. Clear blue skies can look uninteresting in photos. Similarly, a completely cloud-covered sky can both be boring and throw off your camera meter if you're not careful. A sky with both blue sky *and* clouds, on the other hand, can result in some dynamic drama.

The trick is to use what you've been given. If you have wonderful, puffy thunderclouds, consider using your polarizer to gently increase color saturation. If you're faced with overcast conditions, photograph wildlife portraits (see page 177), or slap on your macro lens and find some interesting flowers, plants, bugs, or butterflies (see page 135).

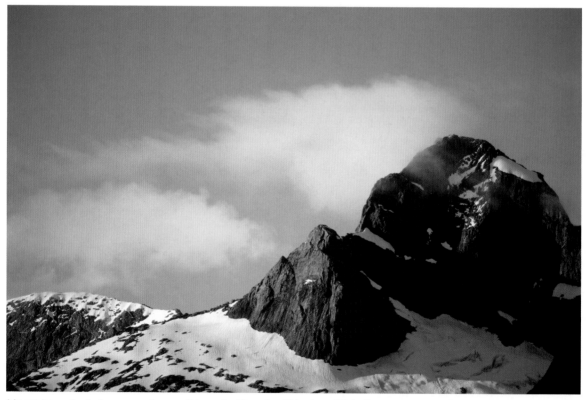

Mountains make their own weather, as this peak with a cloud blowing off it in the southern Alps illustrates. For this image, I turned to my telephoto zoom and moved in as much as I could to the part of the scene that most intrigued me.
1/320 SEC. AT f/5.6, ISO 100, 70–300MM LENS AT 300MM

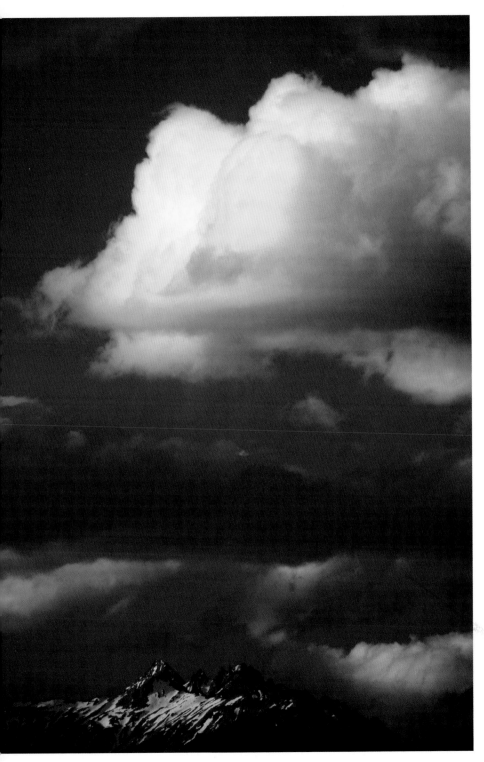

I placed the mountain peak in the very lower part of the photo because the true subject here is the gigantic cloud. The peak gives this image a sense of scale, causing the viewer to more greatly appreciate the grandeur of the cloud.

1/15 SEC. AT f/9, ISO 50, 70–300MM LENS AT 300MM

Sunrise and Sunset

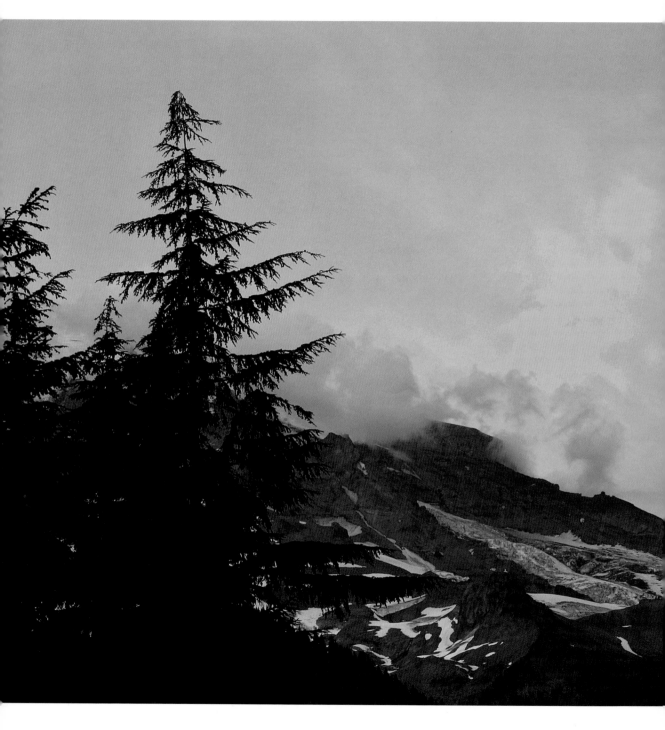

PRESUNRISE and postsunset twilight are fantastic times to capture the color in the sky as it heats up to a warm orangey gold or fades to a deep periwinkle blue. But you have to work quickly.

As far as subjects go, landscapes generally allow you to take your time and breathe deep. Sure, you have to pay attention to the light, but you can usually go slower than when photographing a wedding or your kid's soccer game. The only time you must truly rush with landscapes is when the light is changing fast or when you see signs that it will be changing in the near future. For example, when the sun is about to rise above or dip behind the horizon, you want to move very quickly around your camera. At these times, since the sun isn't as bright as it usually is, you may be able to capture it without rendering it as a complete blob. The ideal here is to retain the beautiful round shape of the sun, and shooting quickly through these brief moments of opportunity should help you reach that goal.

While on Mount Rainier one evening to photograph the sunset, my student Terri Beloit turned around to see what it was like behind her, and this peak was glowing differently from the striking, bold colors of the sunset. It was very peaceful and calming. Terri did at least three right things to get this image: (1) she put herself in the right place at the right time; (2) she explored her options, turning around to see what the sunset light was illuminating; and (3) she worked very quickly to capture the fading light.

2 SECONDS AT f/16, ISO 100, 18–55MM LENS AT 55MM

PHOTO © TERRI BELOIT

Simple Composition and the Landscape

OKAY, I KNOW I said light was the all-important ingredient when shooting landscapes. But what would a landscape be without thoughtful composition? How you arrange the objects in your landscape is also important. To successfully translate the scene and convey what it was like to be at that place, getting composition right is crucial. So, the next few pages will address the second element of L.C.D. as it specifically pertains to landscape photography.

When photographing landscapes, look for powerful, simple subjects. For example, a single tree is one such subject. Whenever you notice a

With this first image (top, near right), I hadn't yet made up my mind as to the subject of the composition. I was interested in the contrasting colors (light tree against dark trees), but I was distracted by the helicopter. As a result, the image suffers from a white, characterless sky that dominates most of the composition. I thought carefully about the scene and zoomed in on the tree, excluding the helicopter. I was able to eliminate most of the sky but not all of it, and I was concerned that this bit of sky in the upper right would distract the eye and lead it out of the frame (top, far right). What's more, I noticed a distracting truck in the background. To remedy both problems, I moved closer to the subject and lay down on my belly on the grass to get an angle of view that enabled me to hide the distractions in the lower part of the composition behind a slight rise in the ground (bottom). This did the trick, eliminating both the sky and the truck (opposite).

ABOVE, RIGHT: 1/125 SEC. AT f/7.1, ISO 100, 28–135MM LENS AT 53MM; ABOVE, FAR RIGHT: 1/100 SEC. AT f/5.6, ISO 100, 28–135MM LENS AT 135MM; RIGHT: 1/60 SEC. AT f/4.5, ISO 200, 50MM LENS/PHOTO © SYLVIA TURPIN; OPPOSITE: 1/100 SEC. AT f/5.6, ISO 100, 28–135MM LENS AT 135MM

lone tree, stop and see if there's an angle from which you can give it due justice. If you can create a clean, organized composition, go for it. Simple subjects have symbolic power and can be the beginnings of great compositions.

This goal of simplicity applies whether you're working with a lone subject or a group of elements. Keep your compositions concise and to the point. If certain elements are distracting or are not crucial to what you're trying to convey, move in closer or recompose to avoid including them in your view.

Change your point of view or switch lenses or focal lengths if you have to. Crouch down low, or better yet, lie on your belly when you shoot. And before you shoot, scan the scene for the following distracting elements and eliminate them:

- ❏ Telephone or power lines
- ❏ Buildings
- ❏ Street signs
- ❏ Litter
- ❏ Natural "litter" (such as dead leaves or twigs)

TIP: SCAN WITHOUT THE VIEWFINDER

Scan the scene for distractions while keeping your finger on your remote shutter release and your eye near your camera but not looking through the viewfinder. It's often easier to see distractions in this way.

Foreground Elements

THE SINGLE best trick I have for you when composing landscapes of scenic grandeur is to find a foreground element. Look around for something of interest that you can include in the closer parts of your picture. If you find an especially interesting object, move in close so that you can feature it as a key point of visual interest for the eye.

One great way to photograph such foreground elements is with a wide-angle lens. When the camera is very close to the subject, a wide-angle lens will make the foreground object larger. However, you have to be careful, because the wide-angle lens can cause objects in the background to shrink so much that they become

difficult to notice. For example, a wide-angle lens can make a silhouetted foreground object in a sunset composition look large but will make the sun look tiny. Similarly, the wide-angle lens will enable you to tell a story about the entire environment as it becomes lit by the sunrise, but the sun won't play a huge part in this picture. A telephoto lens, on the other hand, will make the sun look larger than life. A telephoto lens can also help you exclude any distractions so that the eye can concentrate solely on the sun and its immediate surroundings.

Go too wide, though, and your sun will shrink down to a tiny dot (plus you run the risk of accidentally including distracting elements). Go too telephoto, and your sun will lack a sense of context. Once you've found a good foreground element, experiment with a variety of lenses to get the composition that you feel will do the best job of balancing all the elements of the photo.

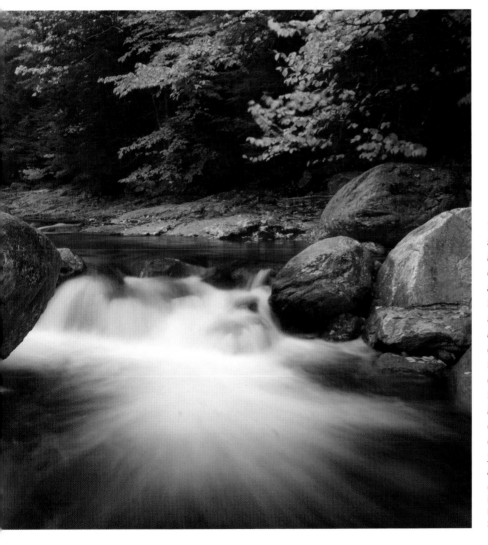

The image opposite of a stream in autumn lacks impact because it has no center of interest. The image at left is easier for the eye to "read." A slow shutter speed of 2 seconds enabled me to created a "starburst" of water in foreground, giving the eye a place to rest before exploring the rest of the picture. Foreground elements like this are the best-kept compositional secrets—they can do so much to make your landscapes grab the attention of your viewers.

OPPOSITE: 2 SECONDS AT f/32, ISO 100, 28–80MM LENS AT 80MM; LEFT: 2 SECONDS AT f/22, ISO 100, 28–135MM LENS AT 18MM

Using the Rule of Thirds

THERE'S NO BETTER TIME to practice the Rule of Thirds than when photographing landscapes. When you visualize that imaginary grid (see page 195) as you look through your viewfinder, there are two ways you can apply the Rule of Thirds specifically to landscapes:

1 Place the center of interest on one of the four intersection points of the grid, the "sweet spots."
OR
2 Place the horizon on the upper or lower horizontal line, without concerning yourself with the vertical lines.

Generally, the idea is to keep the horizon outside of the middle horizontal section, the "foul zone." This will, among other things, force you to decide which part of your scene deserves the most weight. Which do you find more important, the land or water below the horizon or the sky or clouds above it? You need to decide so that the eye understands what you are highlighting in your image. You want to divide your landscape up into thirds. The "star" of the show—the main interest—should get no less than two thirds of the space, and the supporting elements should get no more than one third.

You can bring the horizon line even further away from the center of the composition if the subject warrants it. For example, if you want to emphasize the immensity of the sky, you could put the horizon just above the lower edge of the frame. For a classic Rule of Thirds composition, however, place the horizon as close as possible to the lower or upper horizontal grid lines. And again, most importantly, don't let the horizon fall in the middle third foul zone. If your landscape happens to include an interesting detail, you can go further with the Rule of Thirds and place this object in the upper right, lower right, lower left, or upper left intersection points, or "sweet spots" (see image below).

What if your scene features an interesting focal point but placing this element on one of the four intersections would cause the horizon to land in the middle of your photo? Again, you have to decide what is more important. Think about how crucial that focal point is to the overall photo, and compare this to the upper or lower third of the image. I also base my decision on whether or not one choice would cause a distracting element to enter the frame. I scan the environment surrounding my subject. If I see a distraction in the sky, I place the subject high, effectively eliminating the distraction. If, on the other hand, I see something to the right of my subject that provides additional meaning, I place the subject to the left. This allows me to add depth to the photo by including a context for my subject. To be safe, when presented with these choices, I often shoot all compositional options and then study the images back at home to decide which one works the best.

Keep your horizon out of the "foul zone" (the central horizontal third of your image). If you notice any points of interest in the scene, place them on one of the four "sweet spots" (represented here by circles).

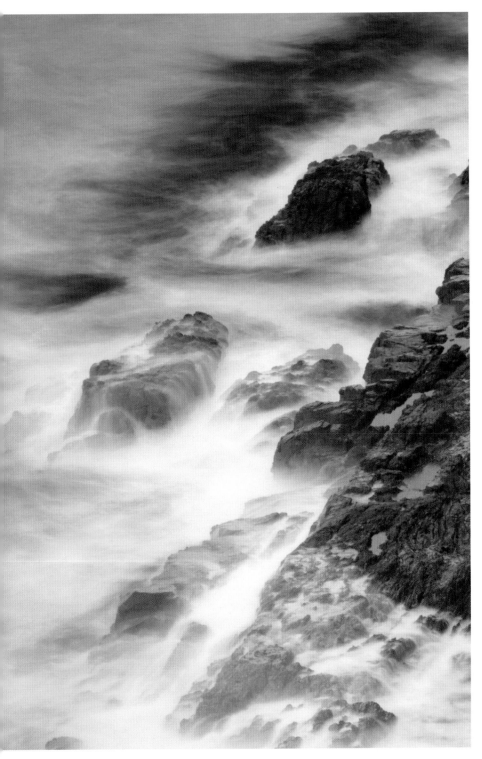

While walking along a coastal path overlooking the crashing waves, I decided to experiment with slow shutter speeds. With the waves blurring into a soft misty appearance, I placed one large rock on the upper right sweet spot to make use of the Rule of Thirds.

8 SECONDS AT f/11, ISO 160, 100–400MM LENS WITH 2X TELE-CONVERTER AT ROUGHLY 570MM

Ideal Reflections

First find a colorful subject. Then carefully choose the time of day and point of view for photographing the scene. Ideally, you want your colorful subject to be in direct light and the water to be in complete shade. For impressionist, artistic effects, find water that's in motion, and keep your directly lit subject off camera. Composing to exclude the object itself—and include only its reflection—can create some especially abstract and interesting results.

TIP: GET DOWN

When photographing colorful reflections, bend your knees and crouch down from time to time to see if this gives you a better, more frame-filling composition. Your goal is to get as much of that reflected color as possible.

Mount Shuksan, in northern Washington, has been dubbed "the most photographed mountain in America." It likely gets the name because skiers and tourists climbing Mount Baker on Highway 542 are treated to this amazing view from Heather Meadows. The small alpine tarn in the foreground is called Picture Lake, which gives you an idea of how many photographers visit this spot. When I first visited the lake, however, I was frustrated by the breeze, which caused the reflection to disappear in ripples. The ideal is a calm, windless day that allows for a crystal clear reflection of the surrounding landscape. When I returned the next day, the lake was calm. To bring out the foreground grass, I angled my flash down and fired it once during this long 2-second exposure. I also positioned the mountain and far edge of the lake at the top horizontal line in the Rule of Thirds grid. The most illuminated section of grass occupies the lower third of the image, while the sky and mountain occupy the upper third.

ABOVE: 1/45 SEC. AT f/3.5, ISO 100, 16–35MM LENS AT 23MM;
OPPOSITE: 2 SECONDS AT f/22, ISO 100, 16–35MM LENS AT 16MM

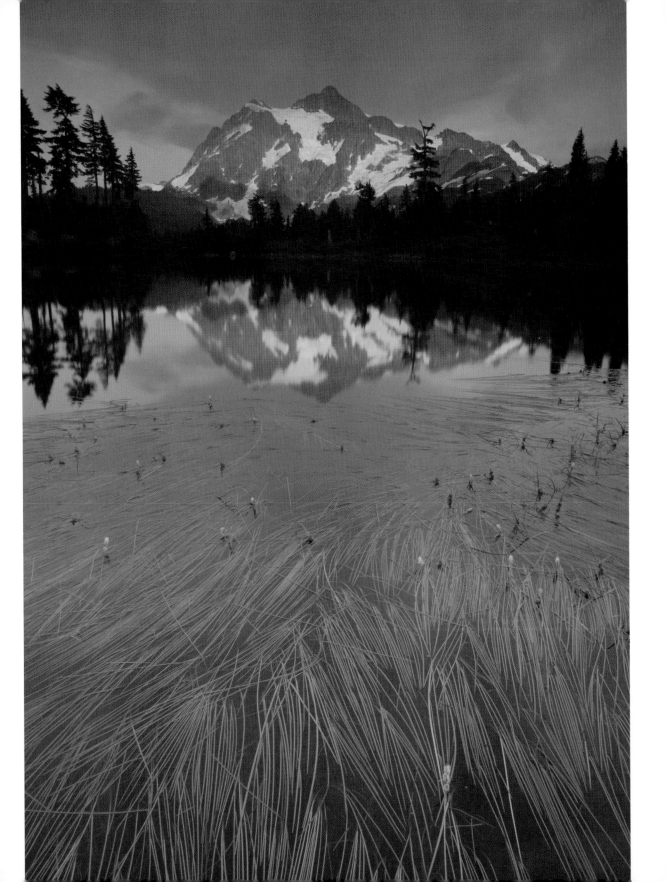

Leading Lines

HAVE YOU EVER been on a tour when the tour guide says something like, "Okay, so here we are . . . what would you like to do?" You'd probably like to respond, "Aren't you the leader? You're supposed to tell me where to go and what to do!" You want a strong and direct guide who will lead you to the right place at the right time.

Think of *leading lines* in photos in the same way. Leading lines offer you a magnificent way to give direction to the eye. Whether the lines are straight, softly curving, or zigzagging through the photos, viewers are more satisfied when you lead them through the scene. They feel a sense of relief when they don't have to make all the decisions. After all, you, the photographer, are the expert. You were the one at the scene.

Whether you use straight lines or soft, arcing S-curves, do your best to lead the eye to a visual "reward." In other words, compose so that the line leads to a payoff—an object of visual interest that gives the eye a sense of satisfaction after having traveled along the line you provided. And, one last thing: Aim to keep the eye on that line until the end, until the payoff. Just as when you get to the end of this book, and read the last sentence, you'll feel a sense of completion and satisfaction that isn't attained when you skip ahead, when the eye travels on its journey through the photo, giving proper weight to each element in the composition without skipping ahead or stopping short, the experience is much more successful and satisfying.

THE PSYCHOLOGY OF LINE

If you want to calm viewers, use flat horizontal lines (and perhaps try to capture a cool blue tone, too). If you want to excite viewers or make them sit up and take notice, use vertical lines (and perhaps a warmer tone). If your goal is to really excite or engage the viewer, make use of diagonal lines (and maybe use a hot, red color).

PRACTICAL MATTERS
Too Much Planning?

When it comes to making plans, schedules, itineraries, and logistical arrangements, you can't do too much. Every minute you spend planning your trip will enhance it and increase your odds of getting great photos. I've already mentioned that I visit Web sites both with tourist information about my intended destination and of photographers who've visited the area.

Don't stop there, though. Google "sunrise calculator" to find sites that tell you when to expect the sunrise, sunset, moonrise, moonset, and other important details. If you're hoping to photograph a mountain at sunrise, you'll save a lot of time if you can predict exactly where you need to be to see it—and when you need to be there. Use topographical maps and a compass to determine the location of a rising sun.

You can also seek the advice of other photographers who've visited the location. Bob Hitchman publishes a great newsletter with this kind of information called *Photograph America*. You can also turn to the Trip Planner section at www.BetterPhoto.com for advice on places, the best times to visit them, potential photo subjects, and more.

When it comes to planning, a compass and map will often help you predict the sunrise.

When you're looking for line, take the direction of the line into account. It plays a huge role. A flat horizontal line creates a peaceful feeling. Go too far, however, and you'll put your viewer to sleep. Vertical or diagonal lines, on the other hand, are dynamic and energizing, like the line of this fallen birch tree in autumn leaves.

1/30 SEC. AT f/4.5, ISO 100, 28–135MM LENS AT 80MM

Aperture and the Landscape

THE PRINCIPLES of exposure apply to any subject, of course, and we talked about the basic exposure elements in chapter 3. Now, as we continue with L.C.D., we'll take a look at aspects of digital exposure as they relate specifically to landscapes.

Aperture is typically the photographer's biggest concern when shooting creative nature landscapes. When I'm out in the landscape, I use Aperture Priority mode (truthfully, I use it almost all the time). This allows me to keep the aperture constant, letting the camera vary only the shutter speed (given that I also keep the ISO constant).

As you'll remember, smaller aperture openings yield greater depth of field while larger aperture openings yield shallower, more selective depth of field. Since you will likely be most concerned with depth of field when choosing how to photograph a landscape, it makes sense to hold on to your aperture, and let the shutter speed adjust to your needs automatically—most of the time. The only time you should stray from this general guideline is when your subject is moving or might possibly move. At such times, a fast shutter speed becomes equally or more important than depth of field, and you must think about both factors. The goal in such situations is always to find the perfect balance between the extensive depth of field you desire and the fast shutter speed you require.

TRIPODS

The side effect of working with small apertures for maximum depth of field is the need to use slow shutter speeds. This is one reason why tripods are such an important accessory. Without a tripod, you'll often be limited as to the maximum depth of field you can achieve.

Also, without a tripod you won't be able to capture creative effects with water and other moving subjects. With some subjects, you can have a lot of fun using a superslow shutter speed. Opening your shutter up for 4 to 30 seconds can give you an interesting "dry ice" fog effect when photographing waves. A 1/2- to 4-second exposure can create that silky, "cotton candy" effect in waterfalls and streams. Since you're leaving your camera's shutter open for an extended period of time, you must use a tripod.

In addition to a tripod, I recommend a remote shutter release. Using a tripod is only half the process. To ensure sharp photos when doing long exposures, you need to combine the tripod and a remote release. A shutter release will trigger the shutter to fire remotely, allowing you to shoot without touching—and thereby possibly moving—the camera.

Compromising to Get the Best Balance

For landscapes, you'll often want to use a slower shutter speed (so that you can achieve deeper depth of field without increasing your ISO). This will allow you to get photos with everything in focus and without any noise. When photographing flowers, you'll often need a faster shutter speed to freeze the action of the petals moving slightly in a breeze. However, you need to also keep an eye on your aperture to make sure your depth of field doesn't get too shallow. The name of the game is *balance*. In order to create the best results, you'll always want to balance these components of exposure.

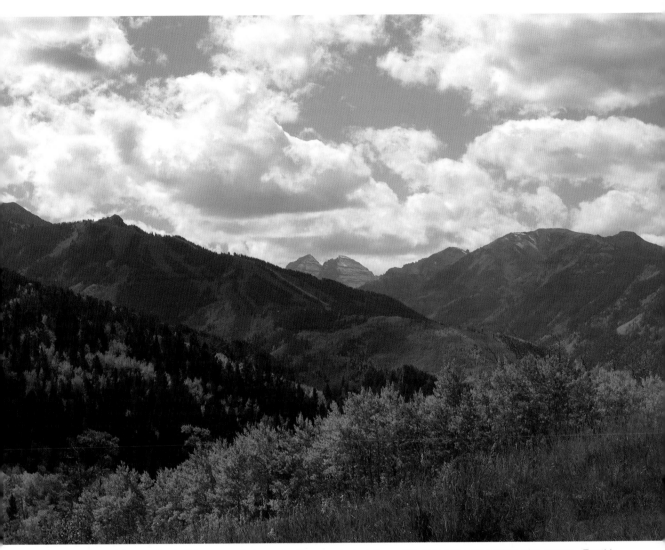

Most of the subject matter in this scene photographed by my student Karen Glenn is fairly distant from the camera. For this reason, Karen didn't need an especially large f-stop number. When the subject is distant, depth of field need not be especially extensive, so using a smaller f-stop number is okay. If you include a foreground element, however, and want extensive depth of field, be sure to use a small aperture (large f-stop number).

1/400 SEC. AT f/7.4, ISO 100, 18–55MM LENS AT 24MM

PHOTO © KAREN GLENN

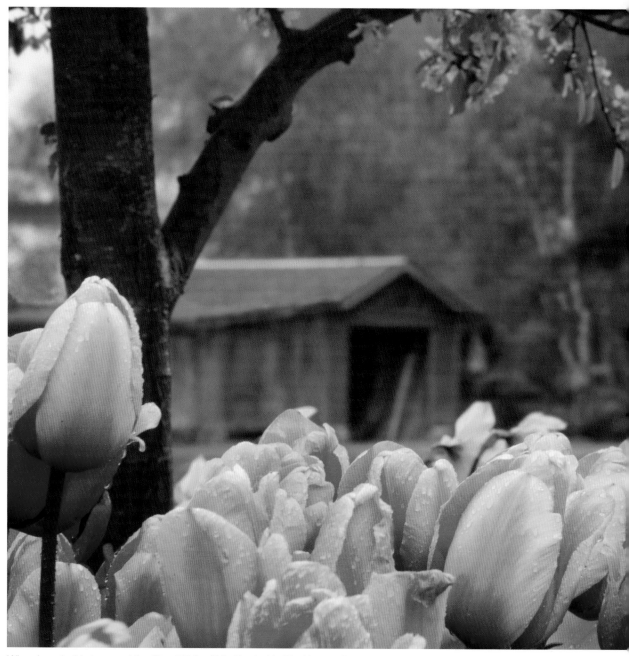

When I made this image at the Skagit Valley Tulip Festival in Washington State, I was initially attracted to the barn in the background. When viewing it though the viewfinder, though, I discovered that the photo worked better if I focused on the foreground tulips; this was partly because the tulips had such nice light on them and partly because the barn worked better as an out-of-focus "hint" or "suggestion." A small f-stop number produced the shallow depth of field that enabled the back-ground barn to play a soft, supporting role while the foreground tulips took center stage.

1/2 SEC. AT f/29, ISO 100, 70–300MM LENS AT 185MM

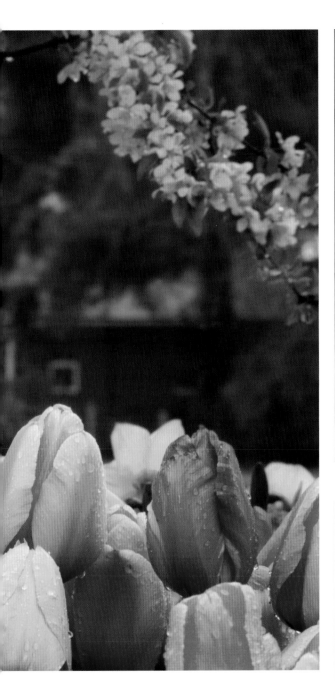

Ideal Settings

Shutter Speed

I prefer 1/125 sec. or faster when my composition includes a field of wildflowers or other plants on a windy day. At most other times, my main concern is depth of field. If my goal is to render both near and far objects with maximum clarity, I require a large *f*-stop number (a small aperture opening, remember), which in turn requires a slow shutter speed (given I keep the ISO constant). I often find myself using shutter speeds of 4, 15, or 30 seconds when photographing landscapes. In such situations, my tripod is a must.

Aperture

As noted above, I use a large *f*-stop when the scene demands maximum depth of field. When my goal is to isolate my subject against a blurry background, I use a small *f*-stop number (for a large aperture opening).

ISO

I turn to high ISO numbers when there simply isn't enough light, and either (a) I need to freeze a moving subject, or (b) for some crazy reason, I don't have my tripod. The only other time I use ISO 800 or above is when I forget to reset it to 100 after shooting low-light subjects (it happens to all of us).

PRACTICAL MATTERS
"I'll Be Back!"

When I'm planning a trip, I focus on one area and give myself enough time to fully explore that area in depth. This usually means spending no less than five days concentrated on photographic activity, at least during every morning and evening. This gives me a few days of shooting with a couple of built-in "weather days." Sometimes the entire trip gets rained out, but usually this five-day schedule includes enough latitude to make the trip a success.

Don't try to pack too much into a short amount of time. If you're feeling stressed, trying to pack too much into too short a time, tell yourself you'll be back. You're much more likely to enjoy your visit and get better photos if you don't spread yourself too thin.

Breaking the Rules

KATHARINE HEPBURN once said, "If you obey the rules, you miss all the fun." Of course, the truth is that you can have plenty of fun following the rules, too. And you still need to *know* the rules before you can break them. Great artists, composers, and authors are not ignorant of the rules that govern their disciplines; they know how to use them properly, and they also know how to intentionally break them. The next few pages look at some situations in which the exception to the rule will produce the best results.

TURN TO THE VERTICAL FOR LANDSCAPES

As mentioned before, get into the habit of turning to the vertical orientation as much as you possibly can. Most people have developed a strong habit of shooting horizontal images, especially for landscapes. Don't forget to turn your camera on end from time to time to photograph landscape subjects in the vertical orientation. The fact that this kind of shooting is called *landscape photography* doesn't mean you have to use the *landscape*, or horizontal, orientation. You can (and should) use the *portrait*, or vertical, orientation often. Whenever it seems like the subject might fit into a vertical format or be more interesting vertically, turn your camera.

Turning your camera to a vertical orientation is one of quickest, simplest ways to immediately make your images stand out from the crowd. Many people completely forget to photograph vertical images, but you're not shooting video—you can do whatever you want when it comes to orientation. So, if you think the subject will fit better or stand out more vertically, do it.
1/60 SEC. AT f/4, ISO 100, 16–35MM LENS AT 16MM

This photo opposite is a prime example of what you can get if you turn your camera to the vertical orientation when photographing landscapes.

Additionally, when I made this image on a recent photography workshop along the scenic southern coast of New Zealand, our guide (John Baker of Boise, Idaho) loaned me his Cokin sunset filter to and I love the results. That's one of many fun things about participating in photography workshops: You make friends and share gadgets.
1/8 SEC. AT f/10, ISO 1250, 16–35MM LENS AT 16MM

Some Rules to Obey

These kinds of rules are meant to be obeyed all the time.

❏ Don't pick wildflowers.

❏ Be considerate around all animals.

❏ Be gentle in "the wild," and aim to leave no evidence of your having been there.

❏ Be careful—keeping your distance—around potentially aggressive animals.

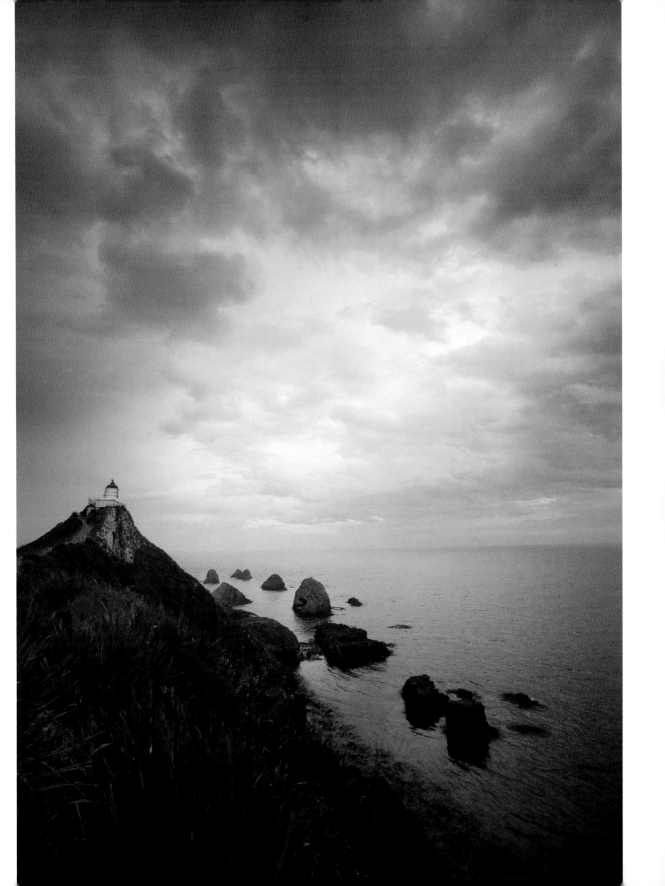

USE INTENTIONAL BLURRINESS

In addition to making streams, waterfalls, and waves blur so that they look like either cotton candy or fog, you can create impressionistic effects on non-water subjects. To blur a land-based subject, zoom your lens in or out as you take the picture.

You can also use selective focus to throw certain elements out of focus and intentionally render them blurry. And, you can try the panning technique with wildlife. When you pan, you move the camera to follow a moving subject as you make the exposure (see page 212). This renders the subject relatively in focus against an interestingly blurry and streaked background. If you do this, it helps to have a tripod with a ball head or an easy-to-use pan-and-tilt head; this way, you can take advantage of the sturdy tripod mount and still rotate the camera from side to side to follow the motion.

Some Rules Are Meant to Be Broken

Some rules should be ignored because they've become outdated. Digital photographers, for example, need not shoot in Manual (M) mode (unless they really want to). This is a misleading holdover from predigital days that often confuses beginning digital photographers. Even when you want to be the one in charge of your camera, you don't have to use the M mode. You have other choices. You can use Aperture Priority or Shutter Priority modes, for example. Additionally, photographers who use camera raw and the histogram have additional ways to ensure they get perfect exposure when shooting in a semiautomatic exposure mode.

PRACTICAL MATTERS
Safety in the Wilderness

The number one rule—one that should *never* be broken—is this: Travel in pairs or groups. You never know when you might get stuck in the snow or otherwise need a friend's help to get out of the woods, so to speak. Besides, it's a lot more fun with a friend. This idea of the mystique of the "lone wolf" photographer is passé. Do what it takes to find someone to go with you. And, if you're still not sure you really need a companion when traveling in the wild, read *To Build a Fire* by Jack London.

You could also hire a local guide to travel with you, or you could join a photography workshop. These options have the added benefit of providing an expert to guide you. And don't forget to let people know where you're going and when you'll be back. Print out your itinerary, tape it to the refrigerator, and then check in whenever you can so that others know where you are at all times.

Walkie-talkies and two-way radios are useful when you're traveling in pairs.

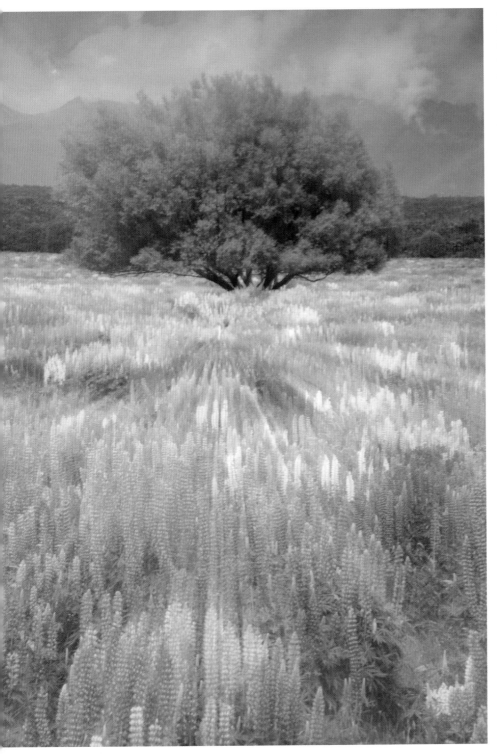

I created this image by mounting my camera on my tripod, choosing a slow shutter speed, and zooming my lens in and out as I made several exposures. By experimenting with a variety of shutter speeds and "zooming speeds," I was able to find one combination that worked.

4 SECONDS AT f/32, ISO 50, 28–135MM LENS AT ABOUT 65–135MM

GO SYMMETRICAL

Generally, when photographing a landscape, you want the horizon to be outside of the middle third of the picture. However, when you're photographing symmetrical compositions, such as subjects and their reflections in nearby water, a centered horizon line will often work best. This allows you to perfectly balance all elements. But note: This only works when you are *precise* about balancing the various parts of the photo.

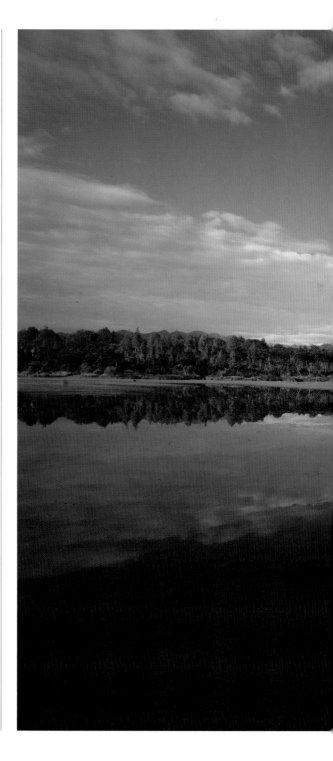

The clouds in the sky here are mirrored nicely by the reflections in the water of Lake Te Anua in New Zealand. Placing the horizon line in the middle balances these two halves of the scene, resulting in a successful symmetrical composition. Although this breaks the Rule of Thirds, it obeys the "rule of symmetry."
1/60 SEC. AT f/11, ISO 50, 16–35MM LENS AT 16MM

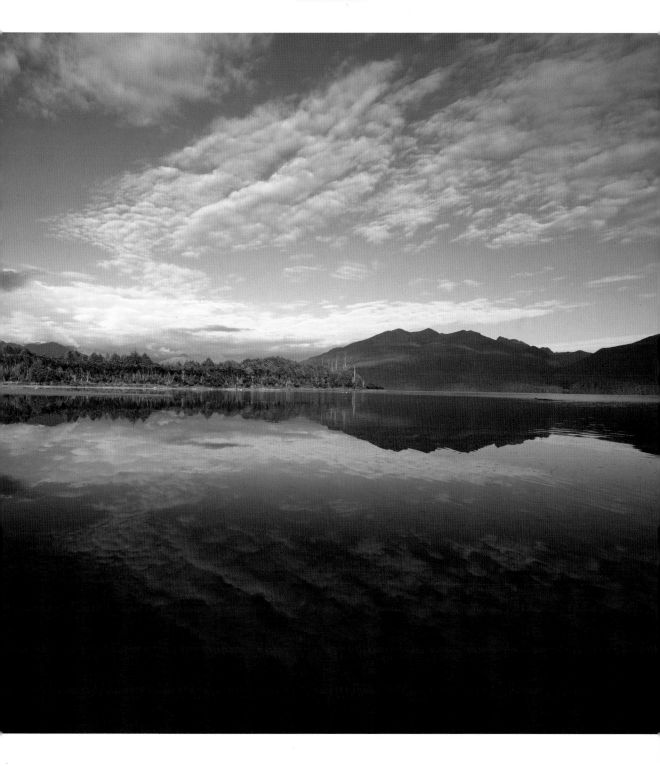

BE COOL

Most of the time, you'll find yourself feverishly searching for warm colors: the orange light of sunset, a bright red paintbrush blossom, the pink sky at dawn. However, there are times when a cooler tone, such as blue or green, will be more desirable in a photograph. These cooler tones seem to increase the perception of distance in an image and can create soothing and/or mystical emotional responses.

TIP: USE

YOUR BOOTS

In addition to a tripod, I recommend wearing waterproof boots when shooting this close to the water's edge. Be careful when shooting on the edge of the sea. Keep yourself and your camera dry, and never turn your back on the ocean. It's a powerful and potentially dangerous force, not to be underestimated.

The misty look around these rocks is actually the Pacific Ocean. I created the original image at left during the very last moments of daylight on a beach near Carmel, California. During a long, 30-second exposure, the waves blended together to create this "dry ice" effect. The effect also imparted some cool, blue hues, which work well with the complementary warmer, orange tones in the image and add a peaceful, slightly dreamy feel to the image. If you can't find cool hues naturally, you can bend the rules with your white balance settings. In the image opposite, I purposely set the white balance to the Tungsten setting to wash the scene with this blue tint.

I should also note that photos like this are simply not possible without a tripod. You need to be able to set up your camera on a tripod to capture the long exposure without your main subject being blurred from camera shake. That's what I did here, along with using my remote release to keep my hand from moving the camera when I pressed the shutter button for each attempt (I made over ten exposures of this scene to get this one keeper). Every few minutes, I had to quickly lift my tripod and run up the beach to avoid getting soaked by particularly far-reaching waves.

30 SECONDS AT f/10, ISO 100, 28–135MM LENS AT 41MM

ADD THE HUMAN ELEMENT

Many people think *signs* of humanity should not be included in a nature photo. Some go so far as to say that *people* should not be included. Why? Aren't people a part of nature, too? Including a person in a scene can give it both a sense of scale and a point of connection, an element with which we can identify. When compared to the human form, the other objects in the scene often look larger than they otherwise would. In addition, shooting "over the shoulder" can greatly enhance an image; as the person in the photo looks onto the scene, so does the viewer.

When done well, the use of this human element can add significant depth and symbolic meaning to a scenic nature landscape. With such an active reminder that we're viewing a beautiful vista, we can't help but project ourselves into the scene.

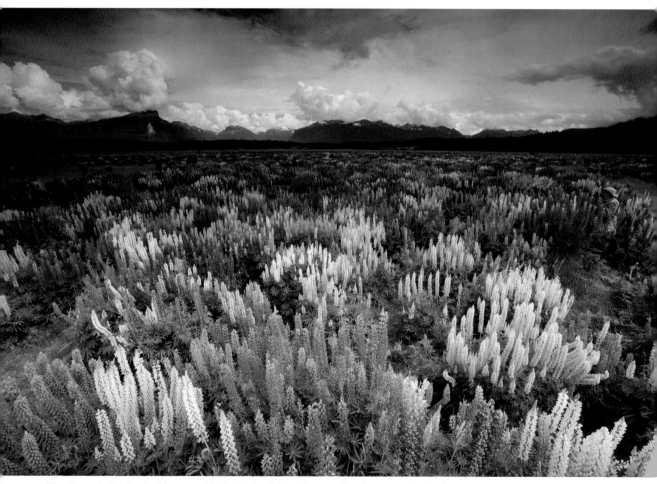

The dramatic lighting in this scene highlights the field of flowers. The foreground is bright and the background clouds look dark and stormy. I accentuated this background moodiness with a graduated neutral-density filter. In addition, this picture breaks one of the unspoken laws whispered among beginning nature photographers everywhere: No people allowed. This rule is misguided and is meant to be broken. The person in this photo (have you found her yet?) adds to the photo's success by giving the viewer a delayed surprise, as well as a moment of self-projection into the scene. Lastly, including the person gives the image a sense of scale.

1/125 SEC. AT f/16, ISO 400, 16–35MM LENS AT 16MM

Packing

As for myself, I bring everything but the kitchen sink. I pay for this in pain (the occasional soreness from carrying around a big pack). I would rather have this pain, though, than the pain of regret over missing a shot because I did not have the right lens, filter, flash, or other accessory. So, I take almost everything I own with me. I also like it because I just don't have to think as much when I'm packing.

In addition to the usual camera gear, I bring along:

- ❑ Water and snacks (these are most important to me, as "grazing" becomes a way of life when I'm out shooting)
- ❑ Batteries
- ❑ Memory cards
- ❑ Special card holder
- ❑ USB flash memory key
- ❑ Laptop
- ❑ Portable storage device
- ❑ CD-ROMs
- ❑ Car charger and power strip
- ❑ Cell phone
- ❑ 2-way radios
- ❑ Rain gear and clothing for "weather"
- ❑ Sunscreen
- ❑ Bug repellant
- ❑ Tarp
- ❑ Knee pad
- ❑ Stepladder (if traveling by car)

I tend not to travel light.

Before you depart on a photo-gathering expedition, make sure you have enough free hard drive space. I've calculated that, when shooting with my 12-megapixel camera, I fill about 4 GB (gigabytes) each day. Using this rough guide, I know that I need at least 50 GB of free disk space on my laptop (or alternate portable storage device) for a typical twelve-day trip or 20 GB for a typical five-day trip.

I pack a few CD-ROMs for burning but try to not use them unless I have to. If possible, I use the other storage devices first. If I do burn, I store my CDs in jewel cases. A USB flash memory key makes it easier to transfer files to a computer at an Internet café before uploading to the Web.

In the past, I placed fresh, ready-to-go memory cards in one pocket and used cards in another. Now, I avoid all confusion by keeping all cards in one case designed specifically to help photographers stay organized.

The tarp comes in handy when photographing macro subjects in early-morning dew. A knee pad is also nice when doing macro photography—it keeps your knees from getting sore when kneeling so much. An eight-foot stepladder is great (if you're driving and, therefore, have the means to transport it). It enables you to shoot from a higher, more unique point of view. If you're traveling by plane, you can buy a ladder after you arrive at your destination and then give it to someone before you leave. Just imagine the story you'll be giving them.

Whatever you do, don't go anywhere without bug spray and sunscreen. A great trip can quickly turn into an exercise in frustration without these two items. If you get beyond a certain level of discomfort, the photographic side of your mind will shut down to allow the rest of your consciousness to concentrate on survival. So, layer your clothing, carry plenty of water, pack a flashlight if there's any possibility of being caught out at night, and bring sunscreen and bug repellent. Take good care of your body so that your mind is free to be creative.

And lastly, my friend Kerry Drager taught me the most essential item to pack: a set of grubby clothes so that I don't have to worry about getting dirty.

Silhouettes

When you're photographing a sunrise or sunset, it's a good idea to look for something that adds a sense of place or context to the scene. The setting sun is nice, but a photograph of it will be much more effective if you include a silhouetted tree, for example—or even a person.

When sunset approaches, I scan the horizon for a simple object to silhouette. I then compose with the goal of making that element stand out as an interesting focal point; its clean, simple silhouette often adds dramatic depth to the scene. To keep things simple, change your point of view until nothing else is near the object. If you expose your silhouette correctly, all parts of it will be black, and you don't want the main object to "touch" (or merge with) other elements as they will all appear joined together. Keep empty space around your silhouetted object so that the eye can easily recognize and enjoy the shape.

In addition to sunrises and sunsets, any bright background (such as a bright beach or snow scene) can be used to create beautiful silhouettes. Simply find a foreground element in the shade and position yourself so that this foreground is in front of the bright background. Expose for the background by metering off an area of the sky that does not include the sun (I point my camera just up from the sun). Check your histogram after making the shot to see if the left end of the histogram is spiking up; if so, your silhouetted object is a nice, rich black.

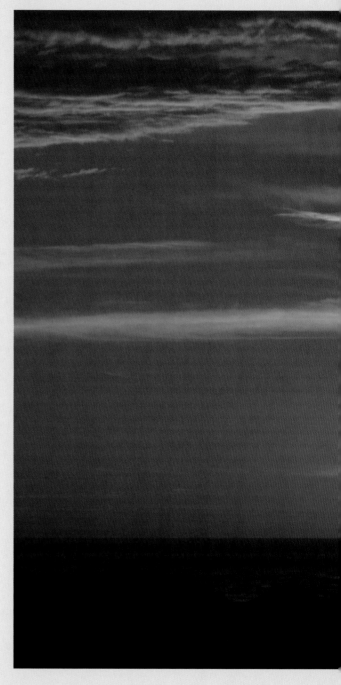

Adding a human element can often make a good photo great. Imagine what this sunset image would be like without the silhouette of the man. It would be okay but somewhat boring. Now that the viewer is looking over the man's shoulder, the impact of this image soars. You can identify with the subject and put yourself into the scene. The photo expresses qualities of inspiration and thoughtfulness.

1/2000 SEC. AT f/9, ISO 400, 28–135MM LENS AT 70MM

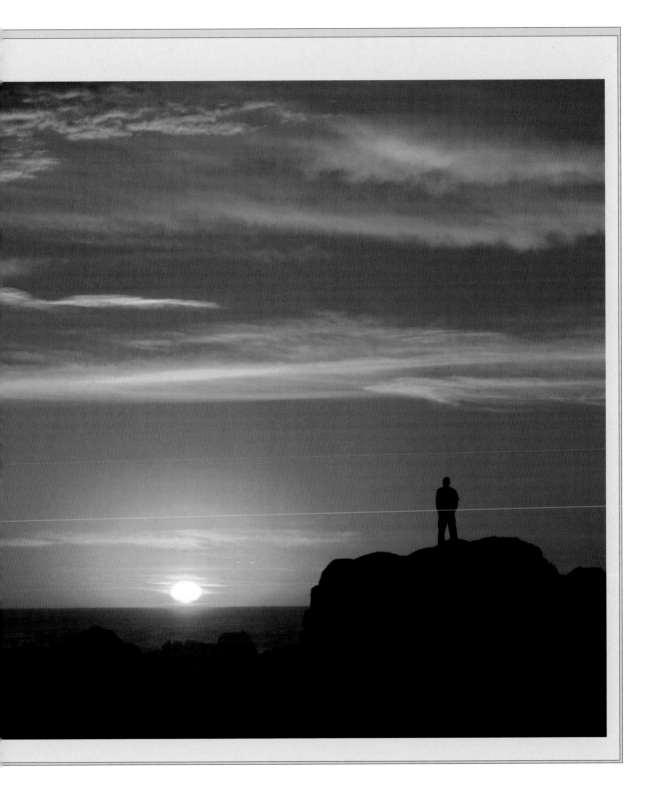

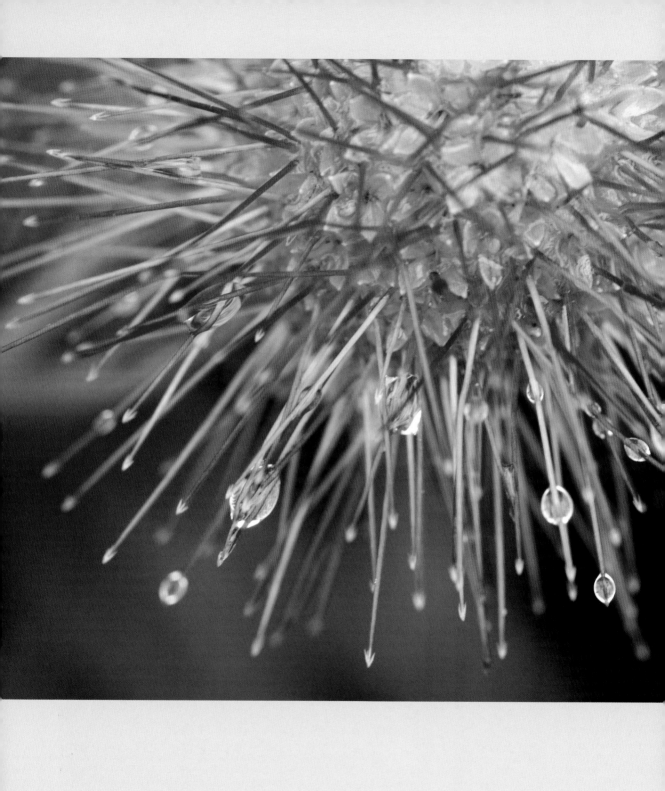

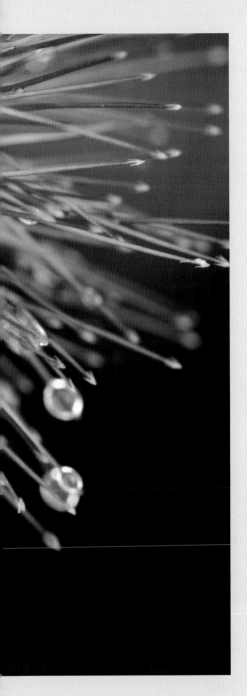

Macro Photography

YOU'LL FIND THAT MACRO, or close-up, photography opens up a world of opportunities for you. Getting a macro lens or filter, or switching to Macro mode on your camera, is second only to getting a tripod in increasing the amount of photographic options available to you. By simply moving in close, you can create unbelievable stunning photos. So, when you go out photographing landscapes, remember to scan each scene for smaller subjects. By moving in superclose to single elements, you can expand your repertoire and consistently produce nature images that wow your viewers.

One overcast morning after photographing cormorants, gulls, and albatross flying around some cliffs, I looked down at my feet and noticed these beautiful and fascinating vine blossoms intermingling with the ice plant. A macro lens allowed me to get superclose and fill the frame with this tiny subject.
1/40 SEC. AT f/9, ISO 800, 100MM MACRO LENS

What a Macro Image Needs

AS I DO FOR ANY photography, I believe in investing in the best equipment you can afford for macro work. Getting good gear will help you get good pictures, and I'll cover equipment on the next few pages. But the game doesn't stop there. You also need to consider what components make a great macro image. They are:

❏ Great light and color.

❏ Balanced and creative exposure.

❏ Strong composition (one that fills the frame and features a clear focal point).

❏ A supporting cast (for example, a softly blurred background or, in the case of flower subjects, another flower).

❏ No distractions.

In addition to photographing tiny macro subjects, keep an eye out for larger details. Whenever you approach a scene—whether it's as small as your own backyard or as big as the Grand Canyon—search the scene for small details. If photographed successfully, these details will often suggest the entire scene better than any wide-angle view could.

When there's more than one detail in the scene, I don't fret and try to fit them both in one photograph. I rejoice at the double jackpot! When this happens, I make two photos—one of each detail—rather than using a wide-angle lens to capture both in one composition. I will only pull out the wide-angle and photograph them together if their relationship is interesting and they can be included in the same scene in a balanced, organized way. At all other times, I concentrate on one detail at a time.

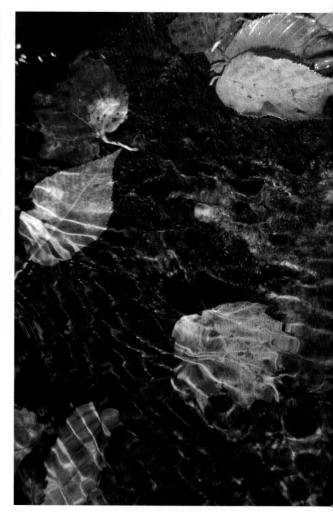

When I was shooting the gorgeous fall colors in Vermont, this submerged red maple leaf caught my eye (above). Although it looked cool with the neighboring leaves surrounding it, my instincts told me to move in closer. When I printed the result, I was thrilled. I much prefer the simplicity and visual impact of the tighter composition.

ABOVE: 1/125 SEC. AT f/4.5, ISO 100, 28–135MM LENS AT 110MM;
OPPOSITE: 1/180 SEC. AT f/6.7, ISO 100, 28–135MM LENS AT 135MM

As I mention at the end of chapter 4, sometimes it's better to break the rules. In the case above, a centered composition (a traditional no-no) offers more graphic energy and geometric balance to my eye than one that obeys the Rule of Thirds.

1/60 SEC. AT f/11, ISO 400, 100MM MACRO LENS

Not as typically "macro" as the images on page 134 and above, the photo to the right shows what I mean by larger details. Wading through a stream (with my running shoes tied to my backpack) as I searched for perfect flowers to photograph, my eye was drawn to these branches. When positioned diagonally through the composition and set against a background of stones along the stream bed, these branches took on an especially Zenlike quality to me.

8/10 SEC. AT f/36, ISO 50, 28–135MM LENS AT 90MM

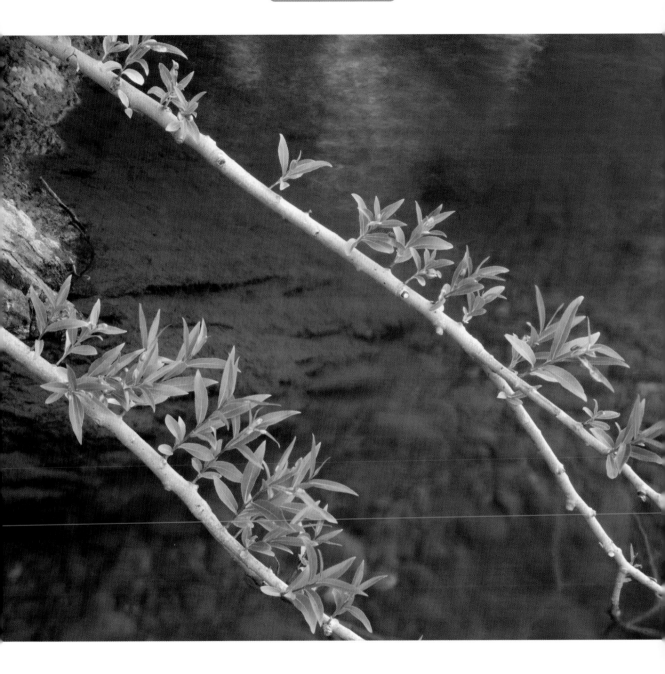

Equipment

WITH THE RIGHT GEAR, macro photography is easy and accessible. I'll cover the basics here. Those with a digital SLR camera can use current telephoto lenses, extenders, close-up filters, and specialized macro lenses. If you have a digital point-and-shoot camera, check your camera manual or the camera itself to see if your model features a specialized Macro mode. This is usually indicated by an icon in the shape of a flower.

Many compact digital cameras feature a special Macro mode.

ZOOM LENS WITH MACRO CAPABILITY

Many zoom lenses advertise "macro capability." This technology is okay (if a bit misleading). It does allow you to get somewhat macro photos, but it's more like what I would call *detail capability* rather than macro capability. The reason is that these lenses limit how close you can get to the subject before they lose sharp focus—and unfortunately, it's not close enough to be truly macro. Use this technology to get close to subjects the size of a softball or bigger. Use a specialized (dedicated) macro lens (or extension tubes) to get closer to smaller subjects such as flowers.

You don't need to do anything special when you use a zoom lens with macro capability. Just get as close as you can to your subject, while making sure the lens is still focusing. If the camera won't let you take the picture, you've likely moved in too close to your subject.

DEDICATED MACRO LENS

A dedicated macro lens is designed so that you can get physically close to your subject. Using this type of lens is the best way to get macro photos, especially of small subjects. I prefer my 100mm dedicated macro lens over other equipment options. It's one lens purchase I've never regretted making.

By allowing me to get incredibly close to a subject, this lens lets me make macro images in which the subject becomes enormous. It can open up a whole new universe within a flower, for example. What's more, I find this lens the easiest to use. I simply remove one lens and put on my macro. If photographing small flowers and insects interests you greatly, I recommend a dedicated lens. You can buy a 50mm lens, but I prefer the magnifying power of macro lenses in the 100mm range.

EXTENSION TUBES AND FILTERS

Other macro options include extension tubes and close-up filters. You place the former in between your camera and lens, and it enables your lens to focus at a closer distance. Close-up filters are better than they used to be. Look for the kind with two glass elements.

Either extension tubes or close-up filters would be an excellent way to go if you're on a budget or would like to try macro photography before refinancing your home to buy a macro lens. These accessories don't cost as much as macro lenses, but they're not cheap either. Look at the options, and see what's for sale at resellers of used gear, such as eBay. If you cannot find inexpensive extension tubes or close-up filters, consider saving up a little extra money to purchase a dedicated macro lens.

TRIPODS

When you're photographing small subjects at such a close distance, a tripod becomes essential. Without even considering the extended depth of field you get by being able to use a higher *f*-stop number (a smaller aperture opening), I would recommend a tripod simply because it will make it so much easier for you to keep your composition constant as you fine-tune your photographic work-in-progress.

In addition to the importance of choosing the best aperture (see page 64), I cannot stress enough the importance of using a tripod when doing macro work. This can be very frustrating, though, because most tripods won't allow you to get low enough to the ground when you're photographing small subjects, like flowers. If you find yourself enjoying macro photography like I do, I recommend getting a tripod that's specifically designed to let you get very close to the ground. Look for a tripod with a removable center column and with legs that spread as wide as possible.

REFLECTORS

A reflector is, basically, any surface that can be used to redirect light to fall on your subject. You would use one to bounce light back into the dark areas of your composition—and effectively fill in shadows and reduce contrast.

It takes some finagling to position the reflector in the right spot so that it bounces light into the shadows. With large subjects and scenes, you often need an assistant to hold the reflector while you compose and shoot. With small subjects, using a reflector is much easier.

Reflectors become less effective with more distant subjects, as the light value falls off (decreases) very quickly. So with landscapes, reflectors can add punch to a foreground element, but they don't do very well on distant parts of the scene. When photographing animals, you can use reflectors, but they are much easier to use when you're shooting in a controlled situation.

The situation in which reflectors really come into their own is when you're photographing macro subjects. Reflectors offer a great way to balance the light in your composition. You may even find using a reflector easier and more intuitive than using flash, because you get to see what you're capturing (i.e., the effects of the reflected light) before you press your camera's shutter button. (For an example of a reflector in use, see the setup on page 190 and the resulting photograph on page 191.)

Power in the Field

When you're out photographing in more remote areas, there's only one way to supply your camera with needed power: Bring a lot of batteries.

If, however, you're traveling by car, you have many more options. When I'm driving from destination to destination, I use an adapter that converts my car's 12-volt system to a standard plug. I purchased this adapter at an auto supply store so that I could have one adapter to fit all of the electrical items I depend on when shooting, from my camera batteries to my laptop to my rechargeable flashlight.

An adapter for battery recharging in the car.

Light and Macro

JUST AS YOU WOULD with any other type of nature photography, keep L.C.D. in mind with macro. So, regarding light, the questions to ask yourself when preparing to shoot a macro photograph are these: What would be the best possible light for this subject? And, when will the light be best on this detail?

To decide, you need to identify which qualities you like about the detail—in other words, which characteristics you'd like to accentuate. If texture is playing a big role, use sidelighting to bring out that element. If it's shape, consider shooting the subject backlit, as a silhouette. If color is the primary value of the photo, use soft light for maximum color saturation.

The beautiful thing about macro photography is that you can photograph in almost any light. If all else is failing, turn to your macro equipment, and

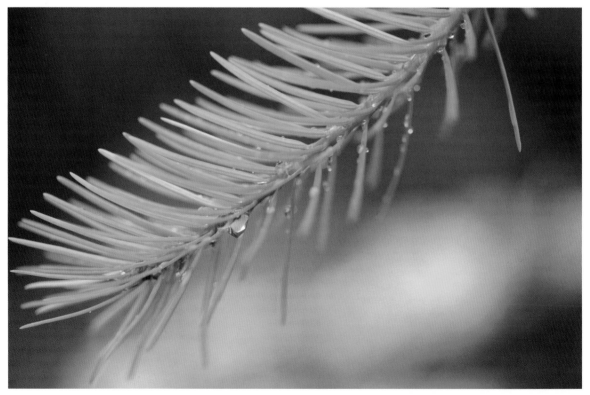

This pair of photos illustrates the difference a few moments can make. As the clouds passed for a few moments the image brightened up in my viewfinder. While the first photo features softer colors and edges, the second photo benefits from the accents of light reflecting in the rain droplets and a greater visual separation of the branch from the background. The images each tell a different story: While one is about softness, the other is about drama.

ABOVE: 1/60 SEC. AT f/2,8, ISO 100, 100MM MACRO LENS; OPPOSITE: 1/160 SEC. AT f/2.8, ISO 100, 100MM MACRO LENS

move in very close to tiny subjects. You'll be able to get great shots in almost any condition. In harsh, overhead midday light, for example, you can use a diffuser to soften the bright areas in your scene. Alternatively, you can use your flash to brighten up the dark parts of your scene, evening out extremes in contrast. (Flash works much better if you find a way to soften the light it produces, so see page 147 for accessories you can buy for this purpose.)

Times when conditions are unfavorable for landscape photography might actually be the best times to shoot macro. Since soft light is usually better than harsh, soft overcast is good as this kind of light increases color saturation without blowing out details in your image.

TIP: BACKLIGHT FLOWERS AND LEAVES

Early-morning or late-afternoon light provides great opportunities for backlighting. You can make the petals of a flower or the leaves on a tree radiate and glow like magic.

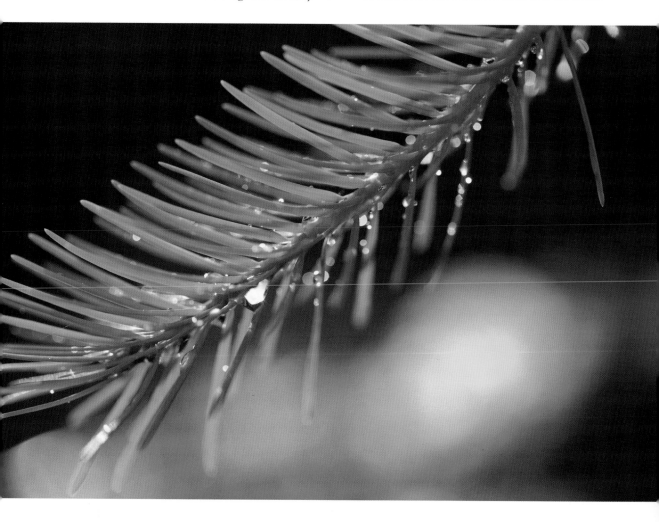

ADDING LIGHT WITH A FLASHLIGHT

If the light is too dim or diffused to use a reflector, consider lighting your subject with a flashlight. I carry a large, high-powered flashlight with me for this purpose, and it has come in handy on several occasions. I use it to "paint" subjects with light or simply add some punch to a less dramatic scene. Try a variety of lighting angles and intensities, checking the LCD screen after each exposure.

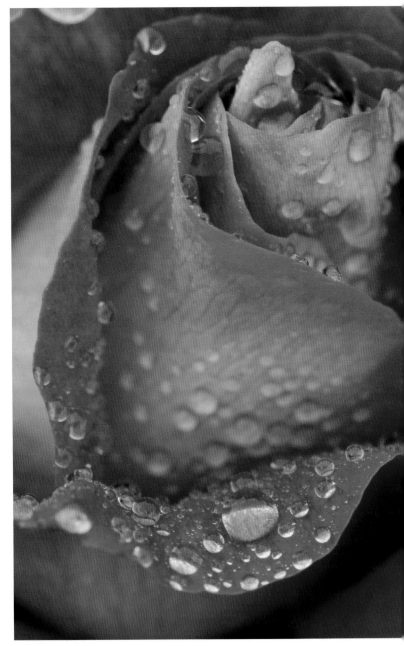

If the light is drab, you can give a flower a punch of dramatic light with a flashlight or reflector. Overcast light is actually very nice for some macro work, but on this rainy afternoon I also experimented with adding some light with my 1.5 million candlepower flashlight. This flashlight is a behemoth, and I always debate about bringing it along on trips, but I usually end up using it.

The raindrops were an added bonus, and the result justified the hassle of bringing along the big flashlight. I like the first version with the rose illuminated only by soft overcast light (right), but the second image (opposite) is more unique and has some of that dance of light I mentioned in chapter 1.

RIGHT: 1/80 SEC. AT f/22, ISO 320, 100MM MACRO LENS; OPPOSITE: 1/25 SEC. AT f/22, ISO 320, 100MM MACRO LENS

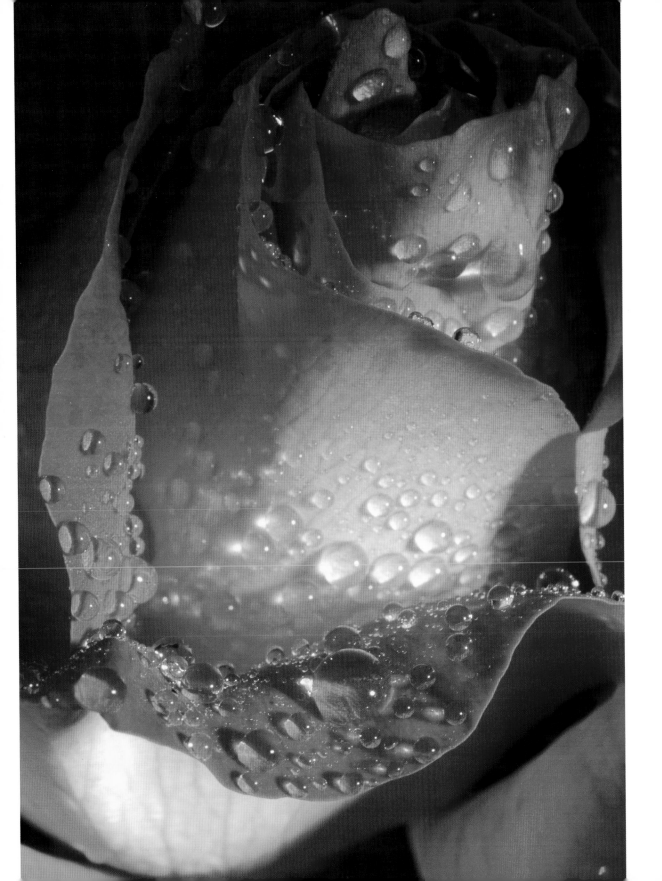

I was frustrated out in the field one morning by the lack of golden morning light. The overcast sky, I felt, had robbed me and, furthermore, wasted my precious time. After a while, I finally calmed myself down and went exploring. With my 100mm macro lens, I found many fun (albeit tiny) subjects to photograph. That's the power of macro. When you're struggling and frustrated due to an uninspiring sky or a seeming lack of subjects, go macro. You'll rarely be disappointed. Here, the image above approximates what I saw with my naked eye; the photo at right shows the view through my 100mm macro lens.

ABOVE: 1/640 SEC. AT f/2.8, ISO 100, 100MM MACRO LENS; RIGHT: 1/200 SEC. AT f/2.8, ISO 100, 100MM MACRO LENS

DIFFUSERS

A diffuser softens the light hitting a subject and can be made from any semitransparent material. You can purchase them at camera stores or make one yourself at home. When used correctly, a diffuser will shade the highlights in a scene. By using a piece of fabric or moving to a shaded location, you can reduce contrast by darkening the brighter parts of your scene. Diffusing light removes hard edges in the background. Just as you'd want your background to be soft and out of focus when shooting a portrait with isolated focus, you'd also want your background to be soft and even for macro, with fewer hard edges.

LIGHT TENTS

A light tent enables you to block the wind. This can lead to more successfully sharp photos.

You can also use it to diffuse light on a bright, sunny day. Instead of getting unpleasant harsh shadows, you'll see softer highlights and more detail in the dark areas of your composition.

In addition, you can use a light tent to increase the contrast between a bright subject and a dark background by laying a dark cloth over the part of the tent that's covering your background.

When you use a light tent, be sure to practice "low impact" photography, leaving the area unaffected by your presence.

A light tent is an accessory that has many benefits.

Image Management in the Field

To ensure your images are safely backed up, you can use laptops, portable storage devices, or both. Portable storage devises cost a lot of money, but less than laptops. The big difference is that you can do more things on a laptop. You can type in journal notes or e-mail friends and family (as long as you find a place with Internet connectivity).

I don't go without a laptop. At the same time, I've also come to rely on a portable storage device. It not only offers a quick way to show my images but also gives me the peace of mind of knowing that my images are backed up in two places.

Before you've backed up every image to your two hard-drive locations, don't be too aggressive about deleting. Try to refrain from deleting in the field at all. There are two reasons for this: (1) you could easily get confused and delete that all-star, prizewinning image, and (2) you could easily miss a better photo opportunity if your face is buried behind your camera.

Additionally, there's even one more reason to keep all of your images: There's no better way to learn than from your mistakes. Take time after each shoot to review a selection of images that you would call "failures." Study the EXIF information for each image. Take notes so that you can, over time, develop a list of dos and don'ts for the future.

Macro Composition: Noticing Everything

THE FIRST REQUIREMENT of great composition is to simply *see* the scene in its entirety. While this is true in all types of nature photography, it is especially true in macro, because if you don't look over the entire scene, you'll likely miss both the interesting close-up details as well as any cluttering extraneous elements.

Sounds simple enough, doesn't it? It's actually a lot of work. The key is balancing enjoyment with a small degree of carefulness. You don't want to rush too much, as this will cause your attention to details to diminish. On the other hand, it's not ideal to spend too much time with one particular lens, in one location, or with one particular subject. In order to get great shots you need to experiment, and to do justice to the creative options you have, the ability to work fairly quick is an important and helpful character trait.

I'll tell you the one thing that, above all else, increases your chances of seeing subjects and capturing them creatively: having fun! When you feel frustrated, anxious, hungry, tired, or stressed, let your hair down, take care of your basic needs, and then get back to work. Your ability to see the best subjects and the best compositions will improve dramatically.

When photographing details and macro subjects, relax and look around you. Your objective should be to notice every element and potential subject with which you are presented. In order to do that, you need to be free from distraction and in the moment. Cindy Hamilton, one of my students, noticed the beautiful colors and shapes in this myrtle tree bark and moved in close. I love how she balanced the two main colors in this frame-filling composition.

1/2 SEC. AT f/19, ISO 100, 105MM MACRO LENS

PHOTO © CINDY HAMILTON

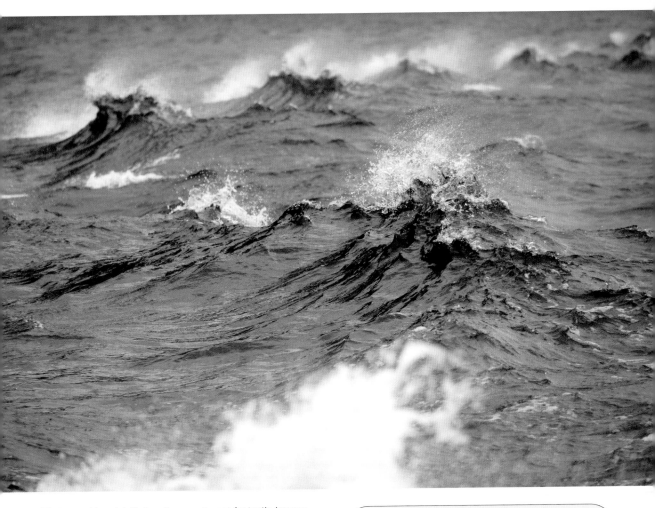

Photographing details is a fun way to get fantastic images, even when your main objective is to capture beautiful landscapes. Move in closer with a telephoto lens whenever it strikes your fancy. Details like these waves (from the wake of a boat I was on) can be the material for eye-catching photos, images that convey the larger scene in one specific detail. Plus, training your eye to notice smaller aspects of larger scenes (even if, like this image, they are not traditional macro renditions) will go a long way toward enhancing your macro work. I used a fast shutter speed to freeze the waves and composed the scene to make the most of the natural S-curve created by the line of waves.

1/500 SEC. AT f/8, ISO 500, 70–300MM LENS AT 300MM

TIP: CROP OUT THE SKY

Don't point your camera up from a low point of view unless you're sure you want to include the sky in the composition. When the sky is boring, get up on a stepladder, and shoot from a high point of view to eliminate the distracting sky.

Fill the Frame

IT ALMOST SOUNDS silly to bring this up, but since the definition of macro photography is getting close to your subject, the number one macro composition rule, then, is to move in as close as possible to your subject. Your goal should be to absolutely *fill the frame* with your subject.

Decisiveness is the key when it comes to composition. It's better to be bold and assertive than wishy-washy or timid. An example of this is the placement of subjects in relation to the edges of your composition. So, fill the frame completely with your subject. I'm talking about edge to edge, no corner left open. You may feel a bit shy at first, but just try this out and see how much it increases the impact of your photos.

Another example is, when your subject comes close to the edge, zooming in or moving in closer so that the subject is decisively cut off by the edge. Viewers will be more subconsciously pleased when you either cut the subject off or keep it—decisively, in its entirety—in the photo, rather than having it barely touch the edge of the composition.

Missed the Subject: Macro and Parallax

If you're using a compact camera and are often surprised to see that you've missed the subject, you're likely getting tricked by a problem called *parallax* or *parallax error*. This is when you see one thing and the lens sees something else, so what you see in the viewfinder may not match the final image. This problem becomes worse the closer you get to the subject. For a quick solution, use the camera's LCD screen instead of the optical viewfinder to check the composition. At all other times, I recommend using the viewfinder instead of the LCD screen when framing your shot. With macro photography, you can break this general rule and view the scene through your LCD screen.

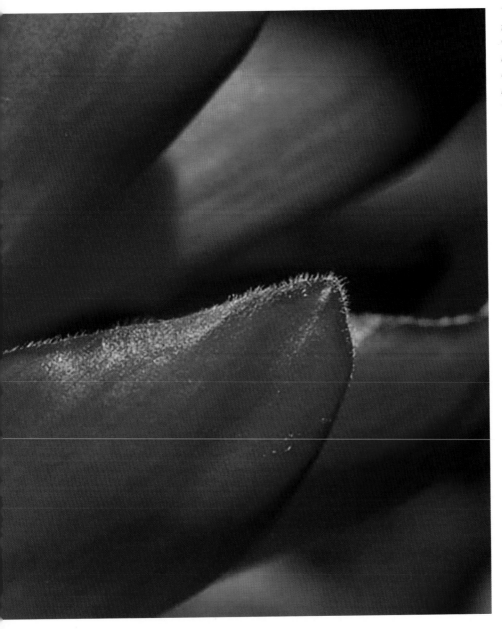

The images on the next three pages all show the variety you can get when moving in close. You can, literally, fill your frame completely with your subject, or you can include a bit of the surrounding environment to give your subject meaning through context. Here, my student Edgar Monzón moved in super-close to this pacaya plant.

1/90 SEC. AT f/13, ISO 200, 90MM MACRO LENS

PHOTO © EDGAR MONZÓN

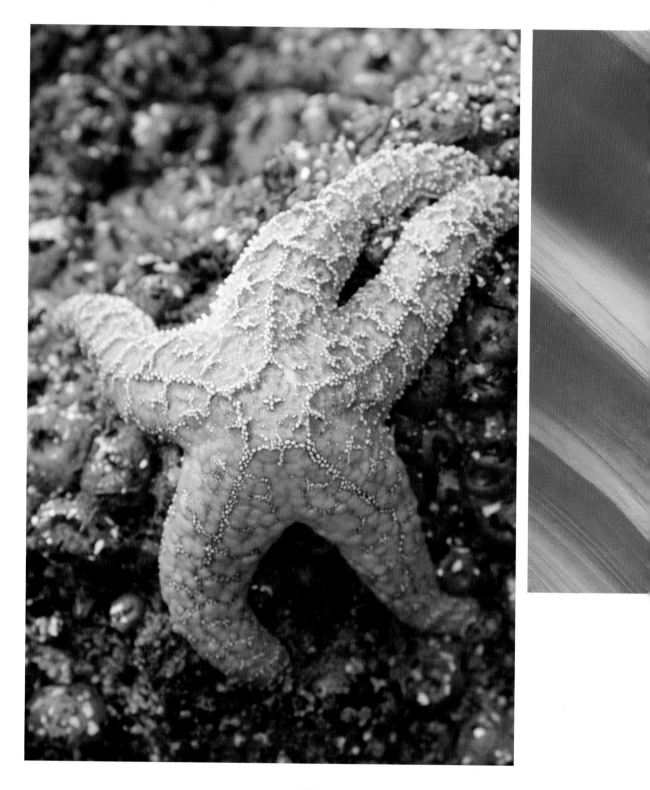

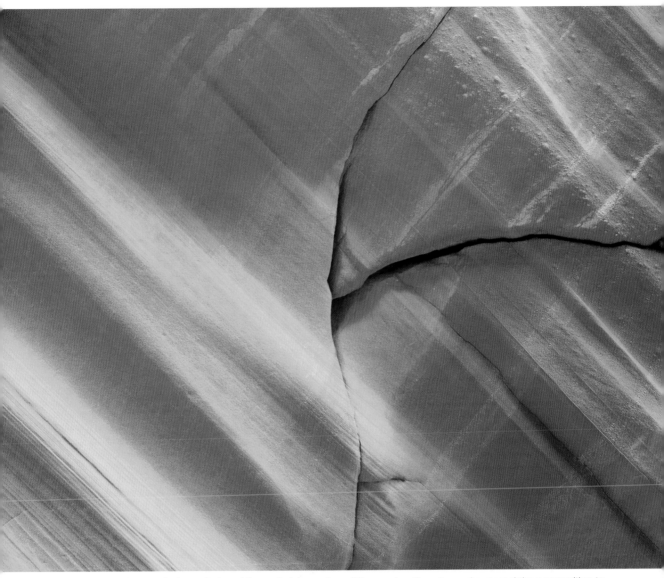

For this image of red rock above, I placed the main intersection of the cracks off center and arranged the composition to add a bit of energy through the diagonal striations in the rock.
1/5 SEC. AT f/8, ISO 50, 28–135MM LENS AT 35MM

I chose the vertical orientation for the starfish on the facing page to allow it to be large in the frame, with just a bit of the barnacle-encrusted rock behind it.
1/100 SEC. AT f/5.6, ISO 100, 28–135MM LENS AT 117MM

PRACTICAL MATTERS

Respect What You Photograph

Adopt a "low impact" philosophy when scouting and photographing nature. Avoid trampling, and do your best to leave no impression or evidence that you have been to each particular place. When photographing small subjects, use scissors to trim grass and weeds. Refrain from pulling out the roots, as this disturbs the neighboring plants and wildflowers. And *never* pick or destroy the wildflowers themselves. You may think, "What's one wildflower?" However, if this wildflower is rare, you could be doing a lot of damage, as it upsets the seeding cycle. Not to mention that you're one of many photographers visiting the area. If we're all a bit gentler and more thoughtful, the environment will be available to the others with whom we share the planet.

This standard image of a rose, made only a couple of feet away from the subject, is nice but not unusual by any means. Compare it to the second version in which the subject completely fills the frame. Which image has more impact? Also note how the center of the rose is placed on one of the four intersection points of the Rule of Thirds grid. You don't necessarily need to use the Rule of Thirds with every photo, but it sure does come in handy for many.

ABOVE: 1/125 SEC. AT f/4.5, ISO 100, 100MM MACRO LENS; OPPOSITE: 1/8 SEC. AT f/32, ISO 100, 100MM MACRO LENS

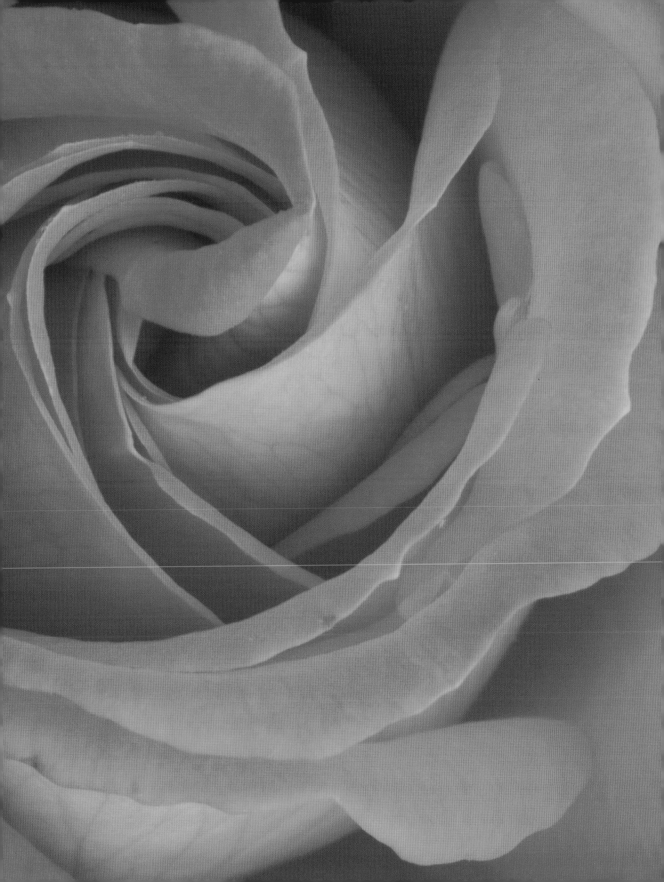

The Rule of Thirds Close-Up

WHEN FLOWERS and small details aren't big enough in your composition to fill the frame, you can use them as focal points following the Rule of Thirds. When seeking flowers to use like this, I look for perfect blossoms in their prime. I've learned to be very critical of any scars or defects, knowing from past experience that these will become glaring distractions in the final image. In addition to a clean, pure appearance, I also like flowers that are somewhat estranged from neighboring flowers and plants. A certain amount of isolation helps me create a simple, striking, and clutter-free composition.

The flower above would be less interesting without the context provided by the background. Moving back and placing the blossom on the top right intersection point of the Rule of Thirds grid created a more balanced and effective composition.

1/125 SEC. AT f/6.3, ISO 100, 100MM MACRO LENS

When I noticed the composition at right through my macro lens, I immediately felt attracted to the interesting contrast between the smooth texture of the forget-me-not and the rough texture of the granite behind it. In addition, the soft lighting helped bring out the color. The Rule of Thirds placement highlights this relationship between the plant and the rock.

1/8 SEC. AT f/8, ISO 100, 100MM MACRO LENS

Geometric Elements Close-Up

WHEN YOU NOTICE something repeating in an orderly fashion, stop and study it. It could be the makings of a great macro photo featuring pattern as the primary point of interest. Things to look for include line, pattern, and simple graphic elements.

Arranging objects in straight or curving rows can lead the eye through the photo in a satisfying way. Compose carefully to arrange the elements in an organized and thoughtful manner. Keep an eye on the background, and reposition yourself or use a smaller *f*-stop number (a larger aperture opening) if you need to make it softer and less distracting.

If you notice colorful leaves, feathers, or interesting stones nearby when photographing frame-filling patterns, use one as an anomaly to the pattern. When placing such objects, I put a little effort into making it look random. I want the scene to look interesting but still natural.

I discovered these fern fronds by the side of a busy highway. The graphic patterns interested me greatly. I carefully positioned myself so that the tip of the upper frond would line up with, and appear to touch, the central line of the lower frond. I had only enough time to make a few exposures, but I'm so glad I ventured to this side of the street. Look for patterns in nature—you'll find them everywhere once you start looking for them.

1/30 SEC. AT f/5, ISO 100, 100MM MACRO LENS

Since I was a kid, I've always been fascinated with the way lupine leaves collect rain water. I remember first seeing photos of this and feeling the desire to capture some images of my own. On a recent excursion, I finally got an opportunity and wasn't disappointed. To capture this image, I positioned my camera (attached securely to a tripod) very low to the ground and aimed to make the tiny balls of water line up perfectly, leading the eye into the picture.

1/10 SEC. AT f/32, ISO 400, 100MM MACRO LENS

TIP: CREATE YOUR OWN MIST

Carry a small spray bottle with water, and use it to add a bit of mist to the occasional macro subject that seems to need something extra.

A small spray bottle is an easy-to-pack accessory that often comes in handy.

ASSIGNMENT Try Different Points of View

Practice how you approach a subject. Move around and view it from as many different positions as you can. Go left, go right, go up, go down—always asking yourself which point of view seems to create the most interesting image. Keep in mind that you can use any lens or focal length at your disposal (use a variety of lenses to further explore all of the possibilities). When I do this, I look in particular for the following:

❏ Light hitting the subject in an interesting, pleasing, and even way.

❏ A background that's not cluttering, or taking attention away from, the subject.

❏ A foreground that relates to the background in an interesting way.

❏ Any geometric elements that can be used or accentuated.

❏ Any views that create a unique, unusual perspective.

Aperture and Macro

AS THE LAST PART of L.C.D., digital exposure for macro photography has some unique concerns. The aperture element of exposure becomes extremely important, for example. If you're a math buff, you'll like the reason: Depth of field is inversely proportional to the square of the magnification factor. And now, in plain English: The closer you get to a subject, the shallower depth of field becomes. In fact, every time you halve the camera-to-subject distance, you lessen the depth of field by a factor of four! When you're shooting from a distance of one inch or one centimeter, your depth of field is miniscule, and the slightest change in either position or f-stop numbers results in a completely different look to your photo.

The Importance of a Clean Sensor

You'll save yourself time in the long run if you're very careful about keeping your sensor clean. Avoid changing lenses in dusty or windy environments. Have your next lens ready to go before removing your previous lens. Carefully watch for small black dots, which are much easier to see on images shot with a large f-stop number.

They're also easier to see on a large monitor than on the tiny LCD on the back of your camera, so it's a good idea to check a few sample images each night you shoot. When you notice black dots, follow the instructions for cleaning your sensor in your camera manual. With my camera, I make sure my battery is well charged, turn to a certain "sensor cleaning" mode, remove the lens, blow with a hand blower a few times, replace the lens, and then turn off the camera. This process is the first thing I try when I need to dislodge and remove any offending dust. If the dust remains, I have two choices:

1 Purchase a special liquid and swabs (from a pro camera store) to clean the sensor.

OR

2 Take the camera to a pro camera store that offers sensor cleaning.

TIP: DON'T USE CANNED AIR

Don't use canned air to clean your sensor. The warnings about canned air junking up your sensor are true. You cannot avoid the problems by simply being careful. I stopped using canned air when I saw that my sensor had been gradually sprayed with microscopic amounts of the chemicals in the canned air. Save yourself the hassle: Use a hand blower instead.

With macro depth of field, the most important thing is to get your camera in the best position. When shooting close-up subjects, the depth of field can get extremely shallow. If your subject has any depth to it, you must first align the plane of your subject with the plane of your camera's sensor.

THE DEPTH-OF-FIELD PREVIEW BUTTON

The key to determining the best aperture is a feature that is called the depth-of-field preview button. Not all cameras have this, but if your camera does, make it a point to use it as often as

you remember. Your photographs will definitely benefit from habitual checking of the depth of field with this button.

It gives you an approximation of what will remain in focus when you take the picture. Without it, what you see through the viewfinder

is what you'd get when shooting with the lowest f-stop number ("wide open," as they call it). When you press the depth-of-field preview button, the scene in the viewfinder will darken. How much it darkens depends on how high your f-stop number is. For example, f/22 will cause the viewfinder to get very dark. However, if you can see the scene even dimly, you'll notice that the foreground and background elements are sharper. Use this button when doing close-up work to see firsthand how much your choice of aperture affects the look of your macro scene.

ASSIGNMENT Take Stock of Your Macro Work

Winnow down your collection of macro photos to find the very best. Go through these favorite images with the following questions in mind:

- ❏ How many did you create in the morning? How many in the evening? And how many during the middle of the day?
- ❏ How many did you crop after the fact?
- ❏ With how many did you use a filter?

Tally up the count to each of these questions to get a better idea of how you shoot. You don't have to continue shooting in this pattern. For example, if you learn that you excessively crop many images, and you'd like to make big prints of your images, you may decide to slow down and pay more attention to composition when you shoot. Look carefully at your scene through the viewfinder one extra moment to make sure that the edges are free from distractions. Then be sure that you're as close to the subject as you wish to be.

You need not strive for deep depth of field with every macro photo. If you use a small f-stop number, the shallow depth of field can accentuate the abstract qualities of the image. The most important thing when shooting with such a shallow depth of field is where you place the focus. Carefully make sure that you place the focal point on the part of the composition that most draws your eye. You don't want to lead the eye to a particular spot only to frustrate it by making it blurry. In this image, my student Kelly Toshach correctly placed the focus on the petal tips, a natural place for us to want to examine closely.

1/90 SEC. AT f/2.8, ISO 200, 100MM MACRO LENS

PHOTO © KELLY TOSHACH

HOW SHALLOW IS TOO SHALLOW?

The answer to this question is very subjective. If you enjoy the look of a macro photo with super-shallow depth of field, then you're in business. If you feel uncomfortable when you view the scene, perhaps you need more depth of field—perhaps the area in focus is just too shallow to give you a satisfying experience. Don't forget, to determine which degree of depth of field you prefer, use the depth-of-field preview button if your camera has one. If your camera doesn't have this feature, you must make an approximation of how much of the scene will appear to be in focus, judging by the *f*-stop number you plan to use.

BALANCING SUBJECT FOCUS WITH BACKGROUND BLUR

What happens when the background is too close to your macro subject? If you increase the *f*-stop number (using a small aperture opening) to get your entire subject in focus, you'll often find that the background gets too distracting. Using a smaller *f*-stop number (to get a larger opening), on the other hand, will result in parts of your subject being distractingly blurry.

I made this image of three bleeding hearts in soft light on an overcast day. I wanted to use a fast shutter speed (1/125 sec.) because there was a significant breeze that day, and every once in a while, the limb from which these blossoms hung would bounce and sway. I also wanted to retain as much image fidelity as possible, so I stuck with a low ISO (100). These two elements, when used together in such soft light, can mean only one thing: a small f-stop number. Note how this small f-stop number (large aperture opening) renders all but the left blossom out of focus. If I had moved to the right and carefully aligned the plane of my camera's sensor with the plane of my subject, all three blossoms would have been in focus. But I preferred it this way, with the one blossom singled out and the two others creating a repeating, echoing effect.
1/125 SEC. AT f/3.5, ISO 100, 100MM MACRO LENS

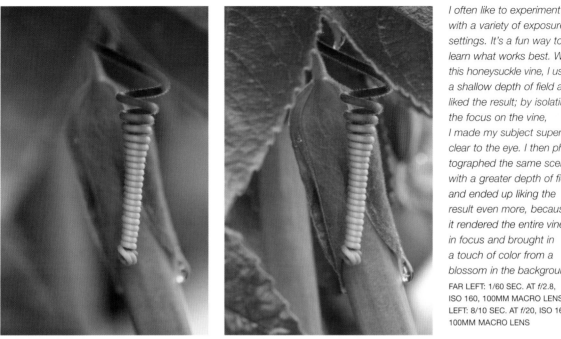

I often like to experiment with a variety of exposure settings. It's a fun way to learn what works best. With this honeysuckle vine, I used a shallow depth of field and liked the result; by isolating the focus on the vine, I made my subject super-clear to the eye. I then photographed the same scene with a greater depth of field and ended up liking the result even more, because it rendered the entire vine in focus and brought in a touch of color from a blossom in the background.

FAR LEFT: 1/60 SEC. AT f/2.8, ISO 160, 100MM MACRO LENS; LEFT: 8/10 SEC. AT f/20, ISO 160, 100MM MACRO LENS

ASSIGNMENT Cheat on Your Macro Background

Macro subjects are notorious for suffering from either too shallow a depth of field or a busy background. There is a way to work around this, though, and get the sharpest subject with the blurriest background. Biologists and naturalists won't like this trick, since they're interested in documenting the natural world as they find it—and if that's your interest, too, skip this assignment. If you're interested in creating the most artistically beautiful images, though—without holding "reality" in too high of a regard—here's the work-around: Fake the background.

To do this, photograph a somewhat evenly lit patch of dark green foliage. Turn off your autofocus, and manually set the focus as close as it will go. Photograph your greenery from several feet away to make sure it is totally out of focus. And make sure you fill the frame with the foliage. Process this image and make a 13 × 19-inch print with a matte or semigloss finish. If you can't print that big on your home printer, print as large as you can or order a print from a photo lab. Have this print mounted on foam core at a photo lab or frame shop. (To do this

yourself, you can get foam core and spray adhesive at your local craft shop.)

Once done, find a macro subject and place this background behind it, far enough away to keep it soft and blurry. Set your f-stop number as high you can without breaking the illusion, and make your photo.

With this method, you can capture images of dew-covered spiderwebs with every web strand sharply in focus; flowers with everything from the edge of the petals to the central stamen in focus; sharp small, nonfloral plants, such as mushrooms; and even slow-moving insects in crisp detail.

This process may not work with fast-moving subjects, such as butterflies, bees, ladybugs, and praying mantis on the go. These subjects will require faster shutter speeds, and using fast shutter speeds will require smaller f-stop numbers, given that you keep the ISO constant. Likewise, breezy days will require you to lower your f-stop number to keep moving subjects sharp—unless you purposely want to render them blurry as they move in the wind (see page 212 for more on this).

Shutter Speed and Macro

OFTEN WHEN you're photographing a small subject, such as an insect, shutter speed can make or break your photo. When zeroing in on especially active insects—such as butterflies, dragonflies, and bees—be sure to use as fast a shutter speed as possible. You can get great shots with shutter speeds as slow as 1/125 sec., but you need to wait for brief moments when the bug is resting and, therefore, still—and take many photos. I will often take ten or twenty images of a single bee as I follow it around a flower bush, knowing that only a few will be acceptably sharp.

> **TIP:** TURN OFF THE AUTOFOCUS
>
> Turning off your autofocus will often help when photographing fast macro subjects. If you're feeling frustrated because your autofocus keeps going in the wrong direction, causing you to miss the shot, simply turn it off. Set your focus on the flower or other location where you think the subject will be, wait for it to arrive, and then quickly physically move in and out of focus until you see the subject come into focus. This is what I did to capture the bee below.

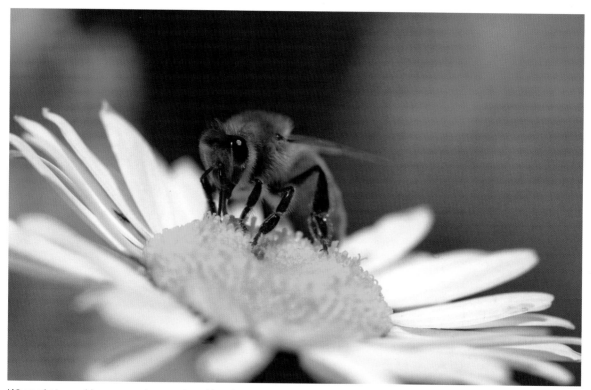

When photographing any moving creature, it's critical that you use the appropriate shutter speed. Most often, you'll want to freeze subject movement and, thus, require a fast shutter speed. When photographing this bee, I used a relatively fast shutter speed of 1/125 sec. and had to wait for moments when the busy bee was resting on a flower as it gathered pollen. After focusing on a close flower, I turned off the autofocus. When photographing insects, I often find it easier to prefocus and then simply move my camera back and forth until the subject is sharp.

1/125 SEC. AT f/7.5, ISO 50, 100MM MACRO LENS

Three Macro Exposure Tips

1 Flat subjects don't require deep depth of field. If you're photographing a flat subject, position yourself so that the plane of your camera is parallel to the plane of your subject and use an aperture of around *f*/8 or *f*/11.

2 Make sure your center of interest (the most important part of your composition) is in sharp focus. Don't frustrate the eye by leading it to parts that are of particular interest and then hiding those areas in blur.

3 Bright days work best for macro subjects. Ideally, you'll have an overcast— but not too overcast—sky to soften the light. The bright light will allow you to get greater depth of field without resorting to a higher ISO or slower shutter speed.

For this ladybug, I used an even faster shutter speed and followed him up and down this leaf until I got a shot I liked. Then, I kept shooting. Repetition—making many attempts to get one keeper—is the name of the game when it comes to photographing insects and other moving subjects.
1/1600 SEC. AT *f*/2.8, ISO 200, 100MM MACRO LENS

GETTING CREATIVE WITH SHUTTER SPEED

When photographing details, you may encounter fun opportunities to get creative with shutter speed. Instead of always striving for a fast shutter speed, consider what an image might look like if you intentionally blurred the activity in the scene.

When you want to create an artistic interpretation of your subject, turn to Shutter Priority mode, select a shutter speed from anywhere between 1/10 sec. to 4 or more seconds, and let your camera determine the best aperture automatically. After making the image, examine the histogram to ensure that the photo is properly exposed (watching, in particular, for blown out highlights), and examine your photo on the LCD screen to make sure the creative blur effect is what you want it to be.

Ideal Macro Settings

Shutter Speed

A shutter speed of 1/125 sec. is great for subjects swaying in a breeze. As depth of field is critical in macro photography, I take advantage of any opportunity I get to shoot with a slower shutter speed. This slower shutter speed allows me to use a higher f-stop number and get the entire subject in focus. For sharp results, it's best that you use a tripod and that your subject is perfectly still.

Aperture

This is where you can get really creative. For example, if I want an abstract close-up of a flower, I use a small f-stop number for minimal depth of field. Alternatively, I can increase the f-stop number so high that the shutter speed gets very slow. With this combination, I can make impressionistic, painterly images (also see page 174). If my goal is to have the entire flower in focus, I use a large f-stop number and a tripod. And, I religiously check how much will be in focus using my depth-of-field preview button.

ISO

I rarely go into the upper numbers when doing macro photography. I stick around an ISO of 100, unless I need a faster shutter speed in low light. When I need a greater cumulative exposure (overall brightness in my picture), I lower the f-stop number before increasing ISO (unless my subject is moving in the breeze and I need to stop it with the kind of fast shutter speed that I can only achieve with a high ISO).

The ideal shutter speed for intentional blurring changes depending upon the speed of your subject, so experiment. Play with a variety of settings, and study the results later to see what you like the best. I usually start with 1/10 sec. to 4 full seconds and then go faster or slower as needed.

OPPOSITE, TOP: 1/800 SEC. AT f/6.3, ISO 100, 75–300MM LENS AT 300MM; OPPOSITE, BOTTOM: 1/5 SEC. AT f/40, ISO 50, 75–300MM LENS AT 300MM

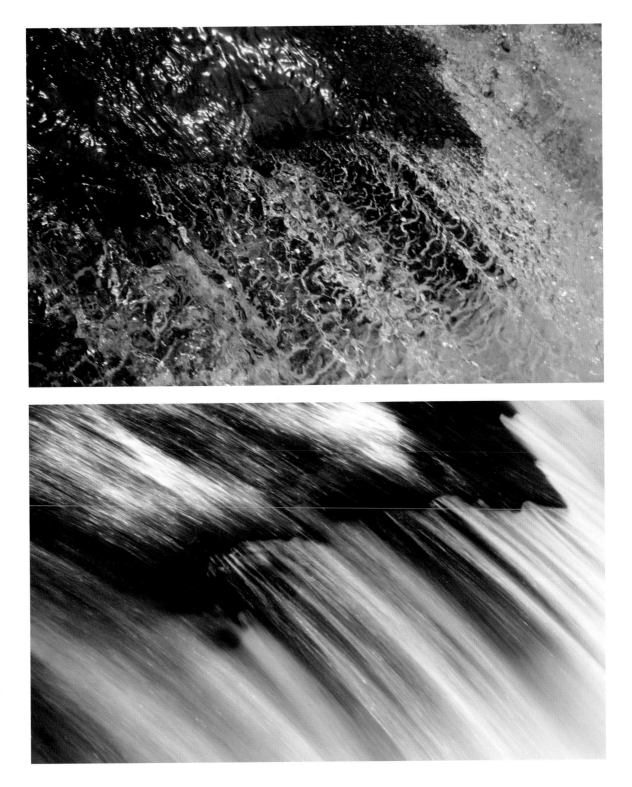

Macro Rule Breaking

THE ONE RULE you do not break in macro photography—the cardinal rule—is: Keep your subject large in the frame. Other than that, there are many ways in which you can get creative breaking the rules.

USE BRIGHT AND BUSY BACKGROUNDS

Most of the time, it's good to avoid bright backgrounds. However, if they're colorful and far enough away from a macro subject, background highlights can sometimes add the perfect splash of color. Busy backgrounds—especially when thrown out of focus or arranged in an organized way—can be made to work; instead of distracting from the subject, they give it additional meaning, depth, and interest.

SHOOT THROUGH STUFF

When you find a single flower, look around it for a flower of contrasting color. Then, get extremely close to this second flower (so that it's almost touching your lens), and aim through it at your main subject. The goal here is to create a soft blur of color that produces an impressionistic look. Be sure to keep your blur small, nondistracting, and soft. When doing this, keep the following things in mind:

❏ You need shallow depth of field so that the second flower or object blurs sufficiently.

❏ It helps to retain some definition in the blur so that the eye understands and enjoys what it is seeing. You don't want the eye to get confused, like something went wrong.

❏ Avoid colors that come close to flesh tones; the resulting blur will just look like your finger hanging over the lens.

❏ It's best if the object you're shooting through is a strong, graphic shape.

USE YOUR WIDE-ANGLE LENS

As mentioned on page 52, one way to simplify a composition is to use a telephoto lens and get closer. (The only reason I often tell people to move in closer is because everywhere I go I see this tendency to include the whole scene in the image.) However, there are times when even your macro photos will be better if you zoom out or use a wide-angle lens. Yes, I most often find myself moving in closer, but occasionally, the surrounding elements add meaning and depth to the main subject. In such situations, I turn to my wide-angle lens and include more elements in the photo.

Photographing details doesn't mean you have to keep your telephoto lens on your camera at all times. You can often get even more creative results if you use a wide-angle lens that allows you to get superclose to your subject. Lines and proportions can be distorted, and you can include distant objects in the background in your composition.

CREATIVELY CROP

While the tendency in close-up work is to center the subject and include every part of it, feel free to experiment with photographing only part of your subject. If you're shooting a flower blossom from above, for example, try compositions like the one on page 134 in which almost half the blossom is excluded from the composition.

When I found this isolated white daisy, I positioned my camera extremely close to a yellow flower nearby and moved around until the yellow foreground blur occupied a good part of the frame without obstructing my view of the subject.

1/2500 SEC. AT f/2.8, ISO 200, 100MM MACRO LENS

BACKLIGHT YOUR SUBJECTS

Believe it or not, many photographers are under the mistaken impression that they should always position themselves so that the sun is at their back when taking pictures. Actually, this is fairly good advice for beginning photographers. Photography is generally easier when dealing with a frontlit subject than a backlit one. However, some of the most exciting floral portraits can be made when you turn into the sun and use backlighting on your subjects.

When the sunlight filters through translucent petals and leaves, you would be surprised at how much amazing beauty you can capture in your macro imagery. Results will generally be better if, again, you fill your frame with these translucent subjects. Also, you'll be more likely to get your exposure correct if you exclude the sun itself from your composition.

To create this abstract image of specular highlights on wet grass, I used a macro lens and lay on my belly in the wet, backlit grass. In such shooting situations, it really helps to have a waterproof tarp on hand. It also helps to use your lowest f-stop number (shooting "wide open" with a large aperture opening). This will make all the out-of-focus dewdrops in the background appear perfectly round instead of octagonal.

ABOVE: 1/125 SEC. AT f/5, ISO 100, 100MM LENS/PHOTO © RICHARD TURPIN; BELOW: 1/250 SEC. AT f/2.8, ISO 100, 100MM MACRO LENS

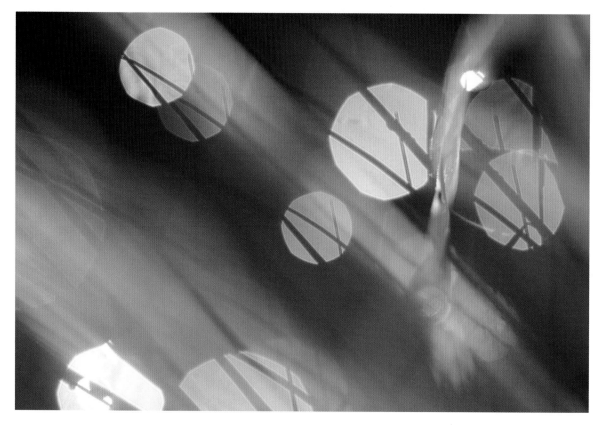

Blow Things Out in Photoshop

When processing this image of three tulips in Photoshop, I deliberately increased exposure until one of the colors channels was blown out (creating bright yellow in the background). The red channel remained dark (increasing shadows until there was no detail in the dark areas). The resulting image has a punch and appeal that I couldn't have attained without making these enhancements in Photoshop.

1/180 SEC. AT f/5.6, ISO 100, 100–400MM LENS AT 400MM

PURPOSELY BLUR THE SUBJECT

The bottom image on page 169 demonstrates intentional blur. But you don't have to stop there. For instance, have you ever tried panning a bee or butterfly close-up? Additionally, you can zoom in on a subject while keeping the shutter open. This will result in an impressionistic rendering of the subject.

In addition to zooming your lens while making an exposure (right), you can photograph flowers that are blowing in the wind (opposite bottom) or move your camera up and down (opposite top left) or side to side (opposite top right) to create zigzagging blurs of color. Either way, the result will look like you "brushed" color across your picture.

RIGHT: 1/5 SEC. AT f/36, ISO 50, 28–135MM LENS ZOOMED FROM 70MM TO 125MM; OPPOSITE, TOP LEFT: 4/10 SEC. AT f/36, ISO 50, 28–135MM LENS AT 135MM; OPPOSITE, TOP RIGHT: 1/6 SEC. AT f/16, ISO 50, 28–135MM LENS AT 135MM; OPPOSITE, BOTTOM: 1/4 SEC. AT f/29, ISO 200, 28–135MM LENS AT 35MM

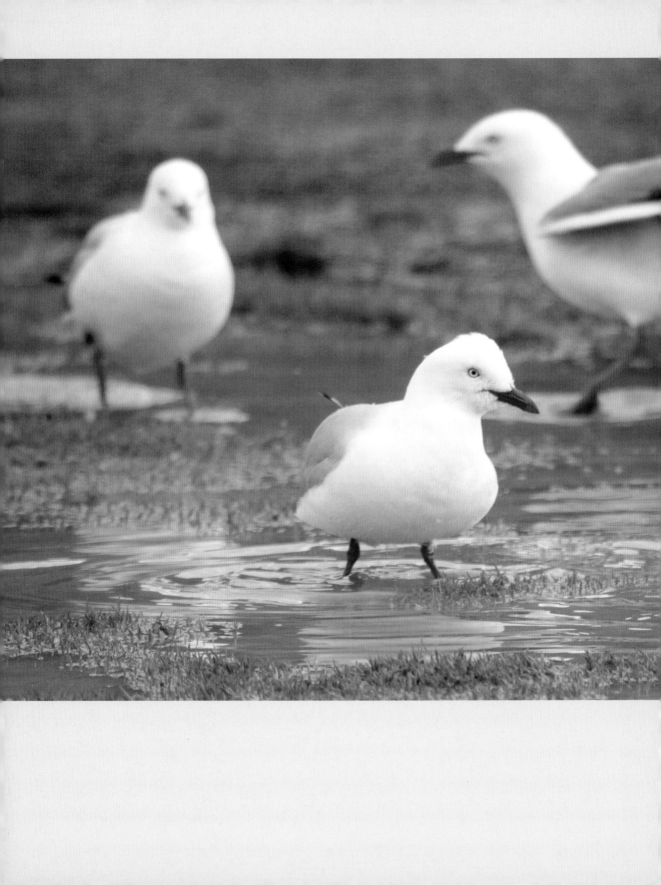

Wildlife

I PHOTOGRAPH ANIMALS simply because I love them. I've been an animal lover since I was a kid, delighted at the arrival of each issue of *Ranger Rick*. Today, I continue to be fascinated with the animal kingdom, and I photograph wildlife for the pure joy of it.

I'm sure many of you feel the same way. You photograph animals because you feel a connection to them and enjoy their character, intelligence, and personality. For others, wildlife photography awakens the hunter within. Such photographers seek the thrill and rush of tracking and locating wildlife. If you belong to this latter group, I applaud you—it's much better to hold a camera in your hand than a gun. So, whether you're in it for the thrill of the hunt or because you feel a connection with animals, let's look at the basic techniques for photographing wildlife.

Getting down on the animal's level helps the viewer feel like part of the animal's world rather than a detached observer.
1/400 SEC. AT f/11, ISO 1250, 100–400MM LENS WITH 2X TELECONVERTER AT 800MM

Translating Words into Images

THE GOAL in wildlife photography is to convey the character of the animal you're photographing in your images. So, the first step is to see that character, appreciate it, and, most importantly, describe it in words. This is key, and it will actually help you even when you're photographing subjects other than wildlife. You must be able to describe the characteristics you're about to photograph.

So for example, a *tall* giraffe, a *scary* lion, and a *cute* wolf pup are all acceptable descriptions of subjects. They're a start, but they could certainly be more descriptive. A *long-necked* giraffe, a *ferocious* lion, an *adorable* pup are better, but some of the descriptive power is weakened because these are, for the most part, clichés.

There are two ways you can go to get more descriptive: Either switch the clichés around (a ferocious pup, a long-necked lion, an adorable giraffe) or dig deeper to find more original words. The first method is creative but, as you can see, may not be realistic enough to give you much practical direction. Using the second method, however, you might come up with a *skyscraping* giraffe, a *panic-inducing* lion, and a *big-eyed* wolf pup. These descriptions make it easier to imagine those subjects.

Once you successfully describe your subject, you can go about finding ways to express this verbal description visually—to translate words into images. To emphasize the tallness of a skyscraping giraffe, for example, you might want to position yourself right below the towering giraffe and photograph looking up at it. This might also convey the feeling of a child looking up at a parent, which gives you a new adjective and description: a *parental* giraffe.

Sometimes when working with wildlife, you're obviously going to have to capture the exact right moment to best convey what the animal is about. Be patient. Don't allow anything to distract you as you watch and wait. When you see a moment coming, start shooting and keep shooting until the action is completely over to get that one shot that captures the most expressive moment.

To get close and get great eye contact in your wildlife images, you better be very close to those big eyes. When I talk about getting close, I usually mean getting close by using a zoom lens. If you're shooting in a controlled environment, using a wide-angle lens and getting even closer could make those big eyes look even bigger. Don't do this, though, if it will cause the animal or others in the vicinity any distress. And *never* get close to pups or cubs in the wild. If you do that, you're just asking for it.

Move in close and create a tight composition—and wait for that moment that captures the personality or humor of the animal.
1/180 SEC. AT f/6.7, ISO 100, 100–400MM LENS AT 340MM

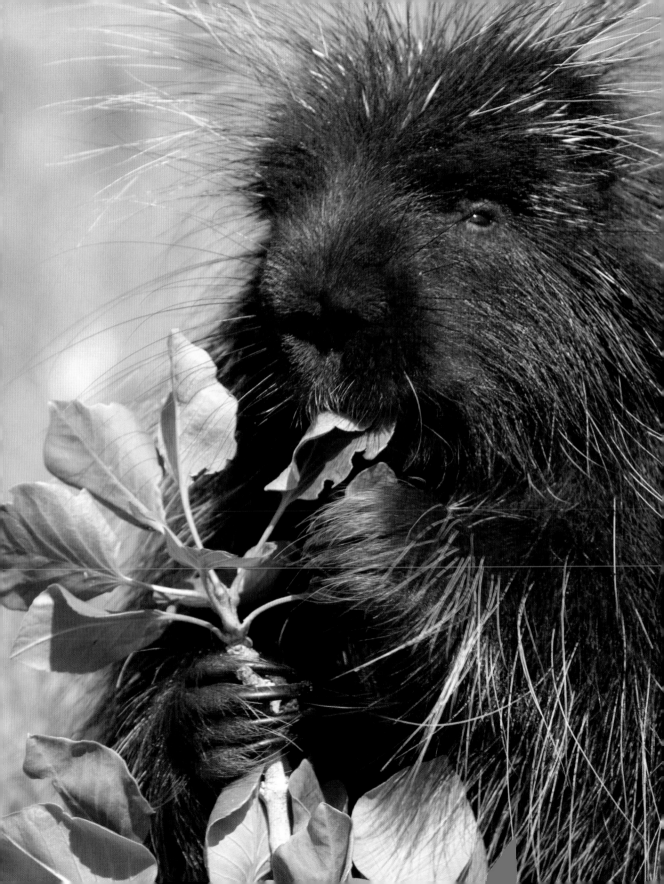

I love to see people photographing animals for the joy of it. If you enjoy photographing animals but feel frustrated sometimes, hang in there. You can make great wildlife photos. All it takes is perseverance, practice, and habitually putting yourself in opportunity's way. Additionally, it helps to take things one step at a time: Before you book that trip to the Galapagos, start by photographing animals in your local area. This will save you a lot of money and make it easier for you to get great images right from the start. Visit local farms, zoos, or wildlife refuges. (I took this picture at a dude ranch in Montana.) Even some pet stores can be excellent places to practice. Just ask the store manager if it's okay before you start.

1/125 SEC. AT f/5.6, ISO 100, 100–400MM LENS AT 400MM

Techniques to Convey Character

These tricks will help show an animal's internal qualities, such as intelligence, curiosity, joy, and love.

❏ Move in close (without jeopardizing your safety or the animal's comfort level).

❏ Get down on the animal's level.

❏ Look for moments of perfect eye contact and interesting facial expressions.

❏ Depict relationships between multiple animals in a scene.

❏ Include the surrounding environment.

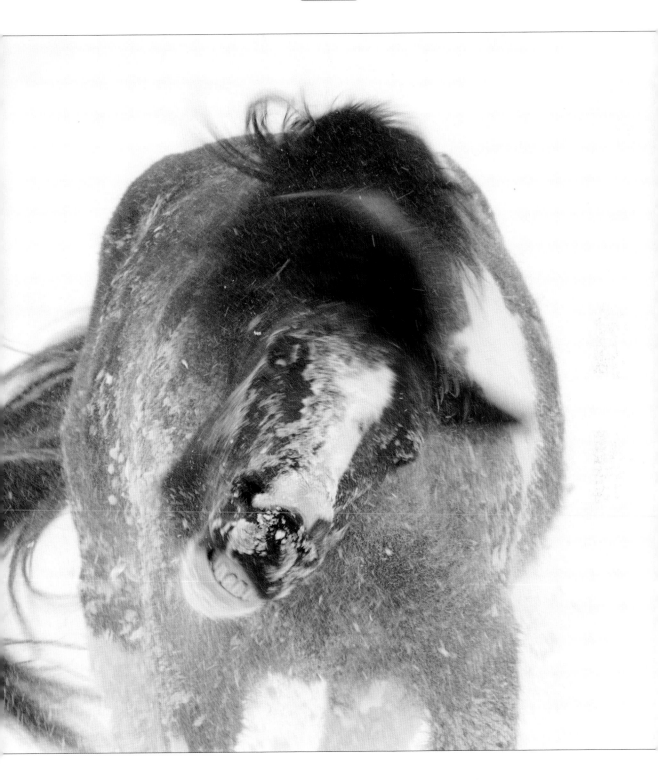

Light and Animals

IT ALL GOES BACK to L.C.D., and as with any subject, photographing wildlife in the best light is the single most fundamental component to getting great images. This doesn't mean that you should only photograph animals on beautiful, blue-sky days—far from it! While such days are great for certain kinds of animal images, overcast days are better for others. So, the trick is to use the light you're given in the way that makes the most of it.

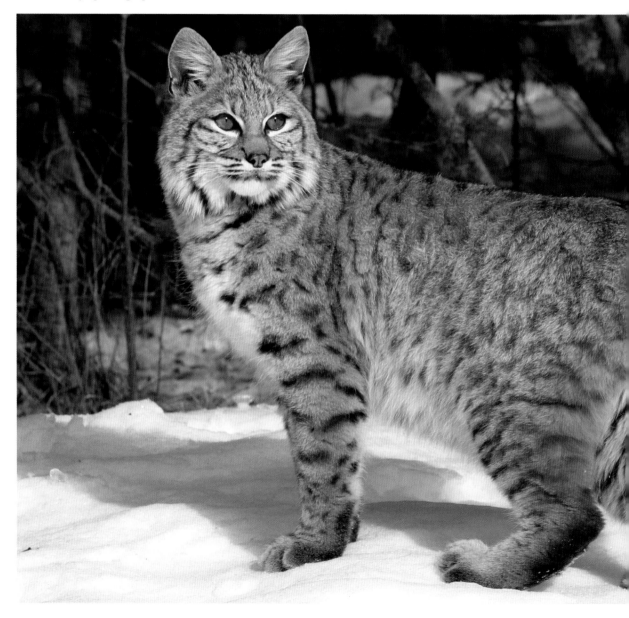

Photographing animals in the early morning and late afternoon can produce some awesome images. If your location is just right, and if the animal cooperates, you can capture it (photo-graphically speaking) in golden light. If you're especially fortunate, the low sun might reflect in the animal's eyes, adding a wonderful spark—and an extra feeling of life—to your wildlife portraits.

In addition, the mornings are often excellent times to photograph animal activity. Animals are often active and alert at these times. Although you may not need to work at the crack of dawn, you'll likely find that you'll make most of your favorite wildlife activity images within the first hour of light.

Still, while I find that I make 80 percent of my landscapes in the morning or evening, I make only about 50 percent of my wildlife images at these times. This is because I'm often interested in making animal *portraits*, and soft light is often best for portraits. For this reason, I take many wildlife photos in overcast conditions and closer to the middle of the day. Photographing wildlife, you can often create winning images at times other than the morning and evening.

CLEAR SKIES VS. CLOUDY SKIES

Some days, you'll find fantastic clouds and other days will feature a clean blue sky. One situation is not necessarily better than the other. The trick is to make either one work for you. Clouds add visual interest to the background without distracting too much from the subject. However, blue skies can add a nice punch of color to the composition. While cloud cover can be a godsend in that it diffuses otherwise harsh light, blue skies, espe-cially when the sun is low in the sky, can cast your subject in soft, glowing light.

For this photo, I wanted the bobcat looking into the frame rather than out of it. In addition to getting good eye con-tact or a good view of the eyes, it's ideal if you can create a bit of eye sparkle. Sometimes, you can use your flash to create catch lights (highlights) in the eyes.

Here, I was attracted to the color in the coat, but I also noted the light from early-morning sun reflecting in the eyes. With my finger on the shutter button, I watched carefully for those moments of best reflection, and once I saw the first hint of it, I fired off several exposures (to be sure I got one keeper) using my continuous shooting mode. You have to be prepared for these brief moments; since animals don't usually enjoy having the sun in their eyes, these opportu-nities will come and go in a second.

1/200 SEC. AT f/9.5, ISO 100, 28–135MM LENS AT 200MM

During the last light of the day, a group that I was with enjoyed a visit to a wildlife refuge on the coast of New Zealand. This yellow-eyed penguin, in particular, seemed to be doing us the kindness of posing in the end-of-day light (above). It just doesn't get any better than this.

When photographing wildlife in captivity, I generally try to avoid compositions that include signs of humanity. Objects such as this manmade shelter (above, right) are too visually distracting to have artistic applications (while they may appear innocuous through the viewfinder, they'll loom large in your final photos), but they can be informative, showing the captive environment.

ABOVE, LEFT: 1/800 SEC. AT f/11, ISO 400, 100–400MM LENS WITH 2X TELECONVERTER AT 800MM; ABOVE, RIGHT: 1/60 SEC. AT f/10, ISO 200, 100–400MM LENS WITH 2X TELECONVERTER AT 380MM

I really love these two wolves on the facing page and was thrilled when they posed together like this. As my goal was to show their character, I was happy to depict the relationship between the two. This was an incredibly windy morning in Utah, but a nice benefit of the wind was that it cleared all the haze and blessed me with a blue sky.

Use what you're given. If you're granted overcast skies, simply exclude the sky itself from the composition (as it will appear as an uninteresting white emptiness), and use the softly glowing light to illuminate your wildlife portraits. If you're blessed with blue skies, that's great, too. Be sure to include that color in your composition. You may even want to use a polarizing filter, as I did here, to intensify the blue of the sky. Whatever you're given—clouds or clear sky—make the most of it.

1/750 SEC. AT f/5.6, ISO 100, 28–135MM LENS AT 85MM

Keep an eye out for interesting supporting elements, such as reflections and shadows. The low light of early morning allowed this horse's reflection to shine clear and bright. It didn't hurt that the surface of the lake at this ranch was relatively calm. The slight ripples give the reflection a fun, creative effect. Be careful with composition in such a situation. You don't want to crop out something as visually stimulating as this reflection.

1/90 SEC. AT f/8, ISO 100, 100–400MM LENS AT 340MM

Rim lighting is another interesting lighting situation to look for. This occurs when the sun hits the subject from behind, causing the edge of the subject to appear to glow. In this case, it's the edge of the animal's fur, but you'll also see this happen with foliage and other subjects.

In addition, when presented with a nice snowy environment, experiment with creating high key images. The white-on-white composition above keeps this image lighthearted. That goes very well with the expression of curiosity on the fox's face. Just be careful to get your exposure right when photographing scenes like this; camera meters tend to underexpose them, so you'll likely have to increase exposure with your exposure compensation feature.

LEFT: 1/200 SEC. AT f/8, ISO 100, 100–400MM LENS AT 300MM; ABOVE: 1/200 SEC. AT f/11, ISO 100, 100–400MM LENS AT 230MM

Exposure Compensation with High Key Images

With snow-filled scenes, use the exposure compensation feature to increase the amount of light getting to your sensor. Make sure your white tones remain white by setting your exposure compensation up to +1 or +1 2/3. When I'm presented with a snowy scene, I first increase the exposure compensation to +1, take a test shot, and then examine my histogram. If I see the right-most end of the histogram spiking up along the left edge, I decrease the exposure compensation until that line disappears. If you prefer, you may be able to set a warning indicator light to go off in the LCD screen when the right-most histogram end spikes.

Flash: Unnatural Light in the Natural World

WHENEVER POSSIBLE, I try to use natural light before turning to flash. Flash can, all too often, appear artificial in nature photography. The eye knows what natural light looks like and expects it. Flash is usually easy to spot by even the most inexperienced eye. However, if you use just the right amount of flash, it can even out extreme contrast, putting detail and color back into the dark areas of a scene.

I also occasionally use flash to add catch lights to animal eyes. As I mentioned on page 182, I've found that the best way to add eye catch lights is to photograph when the sun is low in the sky (in the morning or evening); but, if low-angled, direct light is just not available, I turn to flash.

If your camera offers *flash exposure compensation*, you may need to use this feature to reduce the amount of light the flash outputs. I recommend taking a photo and then reviewing your histogram to determine if any important parts of your subject are washed out (too bright). If so, reduce the flash exposure compensation to -1. This will lessen the harshness of the light and should reduce overexposed highlights. If some remain, try dialing your flash exposure compensation down more until every important part of your picture is not overexposed.

Note that you may also need to dial down your regular exposure compensation, setting it to -1, as well. Exposure compensation lets you adjust the overall brightness, and since you're adding a bit of light via the flash, you may find that you need to lessen the overall exposure to keep your photo from being overexposed. Again, test things out by photographing your subject once with these settings and then checking the histogram to make sure your exposure is good.

If you'd rather stick with natural light—and your subject allows you to get close—try using a reflector instead of a flash to fill in the shadows. This can often give more natural results than flash. One important thing to remember is to turn off the flash when the light is directional and beautiful. When the light is perfect, don't risk diminishing its effect with artificial light. If it ain't broke, don't fix it!

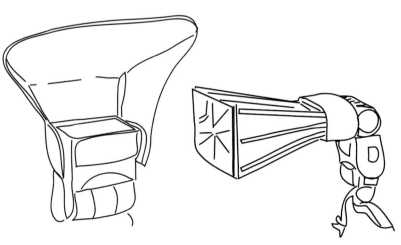

If the flash is too harsh, decrease or diffuse the light coming from it with accessories designed for this purpose. One I like to use with close subjects is the Lumiquest Bouncer (right). If you're photographing birds or distant animals, the Better Beamer (far right) will intensify your flash by focusing in into a more concentrated beam. In addition to helping your flash reach more distant subjects, the Better Beamer can get 1 to 2 stops of additional depth of field. By intensifying the light, you can increase your f-stop number without having to slow your shutter speed or increase your ISO.

This portrait of a macaw, photographed by my student Melissa Heinemann, shows how flash can sometimes save the day. The gorgeous colors you see here would likely have been lost due to the darker surroundings. In times like this, flash is often a worthwhile compromise.

1/160 SEC. AT f/6.3, ISO 200, 70–300MM LENS AT 700MM (105MM EQUIVALENT IN 35MM FILM)

PHOTO © MELISSA HEINEMANN

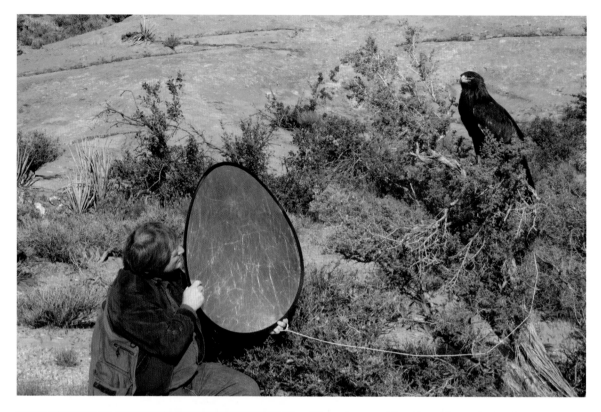

Four Things to Try before Turning to Flash

1 Try to use a different kind of natural light: Go to a different location, wait for the cloud cover to change, or if the animal will remain in the same location, come back at a different time of day.

2 If you need to fill in shadows, use a reflector.

3 If light is low and your subject is fairly stationary, use a tripod.

4 If your subject is active and moving a lot, increase ISO so that you can get a faster shutter speed.

When all else fails and you must turn to flash, use the manual controls, a flash diffuser, or the flash exposure compensation to tone down the amount of flash being delivered.

When photographing this golden eagle, I noticed that the left side of its face was in shadow. Although my eyes could compensate and see detail in this area, I knew from previous experience that these areas would be rendered too dark by the camera. I asked the animal handler if he could both hold the bird and assist. He enthusiastically agreed and held up the collapsible reflector I carry in my backpack, angled until the light was reflected into the dark shadows. The result is an image with much less contrast between the two sides of the eagle's face.

ABOVE: 1/125 SEC. AT f/11, ISO 100, 28–135MM LENS AT 75MM;
OPPOSITE: 1/90 SEC. AT f/11, ISO 100, 100–400MM LENS AT 300MM

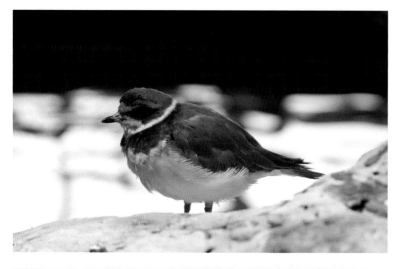

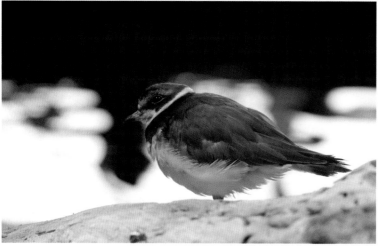

If the light is a bit lacking, use fill flash to add catch lights to the eyes. Just compare these two images above of the same shorebird at the Monterey Bay Aquarium. The first is lifeless. But in the second, I was able to capture a catch light reflected in the bird's eye. Isn't it amazing what a tiny sparkle can do for a bird portrait? The only thing that's different in these two images is the slight angle of the bird's head and catch light in the eye.

TOP: 1/250 SEC. AT f/7.1, ISO 1600, 28–135MM LENS AT 135MM; BOTTOM: 1/200 SEC. AT f/8, ISO 1600, 28–135MM LENS AT 135MM

Soften, diffuse, or use flash exposure compensation to lesson the harshness of flash, especially when photographing animals in close proximity. Since this lynx (opposite) was in dappled light, I used a small dose of fill flash to brighten things up and add sparkle to the eyes.

1/500 SEC. AT f/5.6, ISO 400, 28–105MM LENS AT 105MM

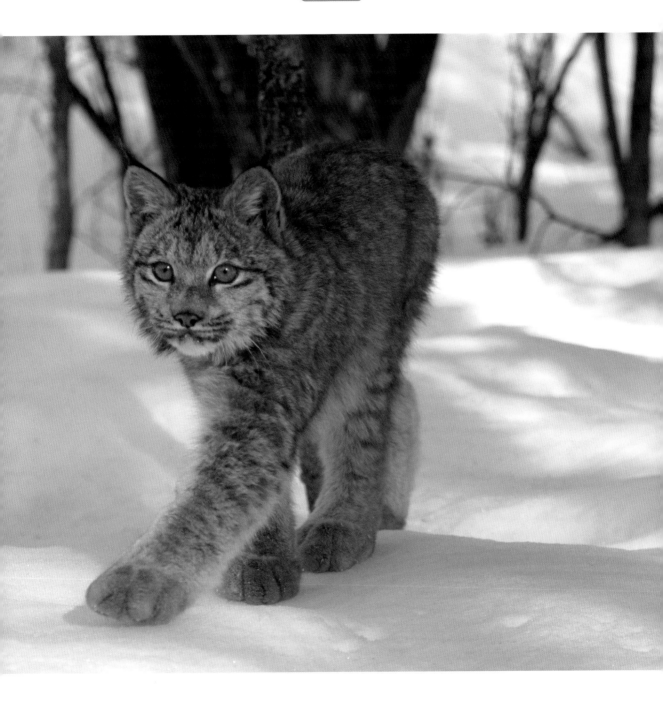

Composition and Animals

THERE ARE TWO common problems with the majority of wildlife images: the subject is either too far away or it is centered in the photo, creating a static, boring composition. You'll be best off if you refrain from always centering your subject as your default compositional choice. If you have time, compose thoughtfully. You may decide a centered composition is best, but when you experiment with placing your subjects differently,

and according to the Rule of Thirds (see page 54), you might find that you enjoy an off-centered subject better.

THE BEST RULE OF THIRDS INTERSECTION POINT

So, once you're visualizing the imaginary Rule of Thirds grid as you compose, how do you decide which of the four grid intersection points—or

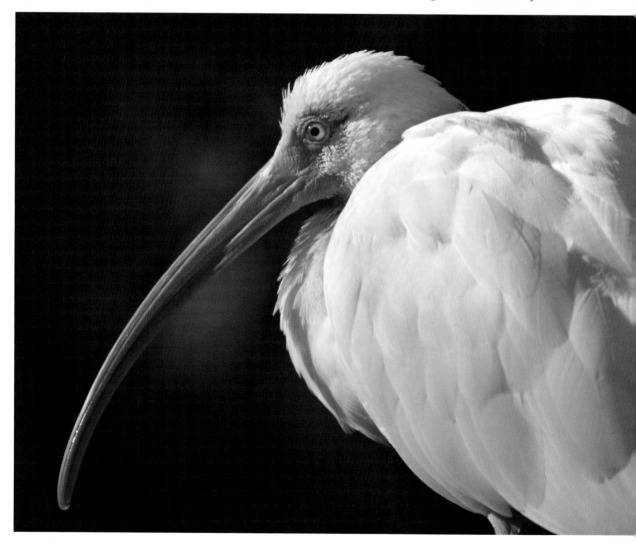

sweet spots—are best for your subject placement? Look at all the options. Which one works best? Which of the four points does all the following?

❏ Keeps the subject the "star" of the composition.

❏ Renders the supporting cast, or background elements, interesting—but not too interesting.

❏ Ensures that the story being told is the one you want to tell.

If none of the four intersections meet all these criteria, then consider moving in closer to your subject and eliminating negative space or distractions. There's no one perfect composition. The key principle is that you place the subject thoughtfully, attempting a variety of compositions whenever it is possible.

> **TIP:** MOVE INTO THE FRAME
>
> When using the Rule of Thirds while photographing birds and other animals in motion, place your subject so that it is moving into the frame rather than exiting it.

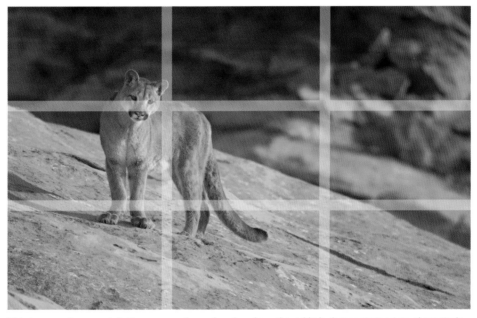

This image of a mountain lion among the red rocks of southern Utah demonstrates two characteristics of a strong environmental portrait. The first is the combination of eye contact and a curious look to help express the character of the animal. The second is the Rule of Thirds placement, which further defines the animal by providing the space to give a taste of the environment.

1/125 SEC. AT f/5.6, ISO 100, 100–400MM LENS AT 400MM

My student Rob Berkley was most interested in conveying the wonderful sense of line in the beak of this white ibis. He said, "When I [photograph] wildlife, I try to make myself as still as possible—making only slow movements. I take a few [exposures], then inch forward as quietly as possible, take a few more, and repeat. That way, I get at least a few good photos. I keep this up until I am as close as possible before the animal moves. This can be challenging with a tripod, but patience seems to work. With this ibis, I really knew what I was looking for. I have long admired the beautiful curve of their bills."

1/500 SEC. AT f/8, ISO 400, 80–400MM VR LENS AT 400MM (600MM EQUIVALENT IN 35MM FILM)

PHOTO © ROB BERKLEY

Getting Closer to Wildlife

BESIDES USING the Rule of Thirds, the single most helpful trick when photographing wildlife is to simply move in closer to your subject. There are three ways to get close enough to animals to make effective images of them:

1 Use highly powerful telephoto lenses.

2 Wait patiently in a blind for the animal to come to you. (A blind is a structure that camouflages photographers, hiding them from animals.)

3 Photograph animals in game farms, wilderness parks, and zoos.

Using a powerful telephoto lens will help you more often than you can imagine. If you're interested in wildlife photography, I highly recommend that you purchase a lens that's 300mm or stronger. I often use a 100–400mm zoom lens and sometimes couple this with a 2X teleconverter. The teleconverter lessens the amount of light getting to my sensor, and disables my autofocus, and I *still* find if very helpful to get the close-up compositions I enjoy most with animal photography.

TIP: DON'T FEED THE BEARS

Be safe and respect the animal you're photographing! Here's the formula on wild animal safety:

Soft + Fuzzy + Cuddly + Cute + Wild = Wild (and potentially dangerous!)

Regardless of how much your subjects remind you of your kid's stuffed animals at home, don't be fooled into forgetting that these are wild animals.

What If I Can't Get Closer?

Sometimes, you simply cannot get close enough to your subject. You might then be tempted to place your subject on one of the Rule of Thirds sweet spots and call the resulting image an *environmental portrait*. Be aware, however, that this only works if your center of interest is, indeed, interesting and the environment adds meaning to the overall photo.

For example, if your center of interest is an egret but the surrounding area is a dull, colorless shoreline, this environment may not add visual appeal, meaning, and depth to your subject. On the other hand, if the surrounding environment is visually intriguing, your resulting image may succeed, even though you couldn't get as close as you wanted to your subject.

When photographing this skunk in captivity, I got as close as I possibly could without disturbing it. I then got down on my belly to shoot from a low point of view as the critter came especially close to me.

1/180 SEC. AT f/6.7, ISO 100, 28–135MM LENS AT 41MM

If you have the time, you may enjoy tracking animals in the wild or waiting for them to come to you as you wait patiently behind a blind. If this isn't an option, you can often get excellent images of animals by visiting your local zoo, a wildlife refuge, or a game farm that specializes in helping photographers get powerful images of animals in controlled situations.

If you encounter an animal in the wild, think twice about moving physically close to it. This can both put you in danger and harm the animal. Instead use a telephoto lens. If you want to get physically close without stressing the animal, again, look into visiting a game farm. Many of these are specifically interested in helping photographers and moviemakers.

There's nothing wrong with staying away from a totally wild animal, or staying away from an animal's home or cubs for that matter. You'll be doing both yourself and the animal kingdom a favor. And believe me, photographing animals in a controlled environment is still exciting. Ask anyone who has done it—you get the thrill without as much of the risk to either you or your subject.

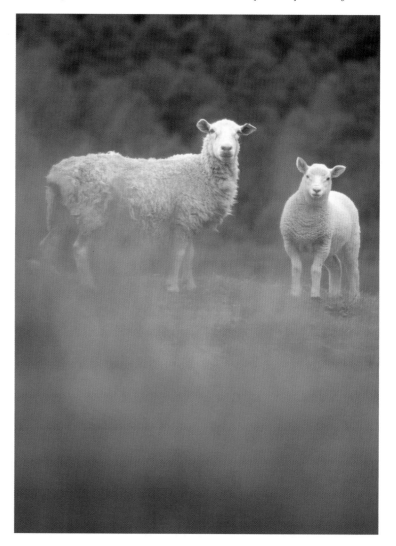

Showing the relationship between two or more animals will help you define the individual animals' characters. I made this image of a lamb and her mother from a very low point of view, thus including the foreground grass and conveying a sense of place. I rendered the grass blurry both to hide ugly distractions in the hill and to give the viewer a sense of sneaking up on the animals and spying on their private world. If you love animals, by all means don't limit yourself to truly wild, dangerous creatures. You can also have a lot of fun photographing domesticated animals, like these sheep on a farm in Paradise Valley, New Zealand.

1/60 SEC. AT f/7.1, ISO 50, 70–300MM LENS AT 300MM

The SLR Lens Magnification Factor

If your goal is to move in closer to the subject—to magnify it more in your lens—then for those of you with digital SLRs, I have good news. You may be in luck. Unless you're using a camera with a full-frame sensor (usually found only on the more expensive digital SLR cameras), your lens will capture a smaller field of view than it would on a traditional 35mm SLR (due to the smaller sensor). This will have the effect of magnifying your lens, usually by a factor of about 1.5 times. This can be a great advantage when you're photographing small animals, such as birds, from a distance.

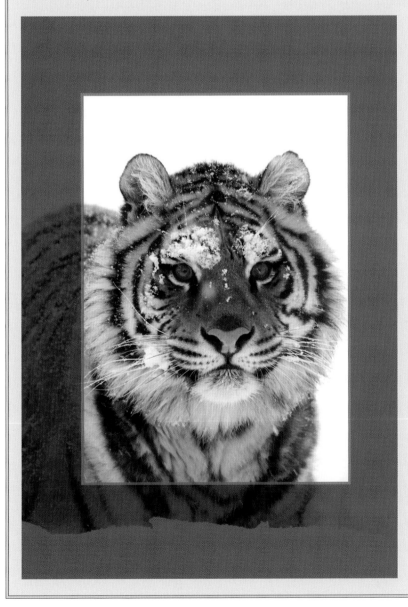

This is the original version of the cropped image on page 207. The red line signifies how much of the scene I would have captured had I been using a digital SLR with a smaller sensor. You can see that the resulting lens magnification can be useful when you're trying to get closer to wildlife. However, when you're trying to include more of the environment, such as when making a wide-angle scenic landscape, this magnification can be rather limiting. Most manufacturers make special lenses that allow you to get wide-angle images, so photographers working with smaller sensors aren't totally out of luck; but of course, buying another lens is an added expense in an already expensive hobby.

1/125 SEC. AT f/4.5, ISO 200, 100–300MM LENS AT 190MM

Go Wide, Go Vertical

RESIST THE URGE to zoom in close for every single shot. It's true that tight, frame-filling composition is often an essential component for creating powerful, eye-catching wildlife images. However, as I've mentioned, it's also a good idea to photograph the animals in their natural environment. Show a bit of the area in which they live if it is photogenic and adds a "storytelling" element to your main subject. In other words, use your wide-angle lens from time to time.

In addition to using your wide-angle lens, also remember to shoot vertical compositions from time to time. Turn your camera on its side whenever possible for more variety and uniqueness.

TIP: TRY SPECIAL EFFECTS

For fun special effects, try using the rear curtain sync flash when photographing moving animals. For example, when photographing birds, you could use this feature to get both an interesting blur effect of the bird in motion and a sharp flashed subject, as well. When these two visual elements combine together, the effect can be dynamic and powerful. As with panning, though, this takes a great deal of experimentation. Keep trying until you get several images you like. This will give you a selection from which to choose when you're reviewing your images later.

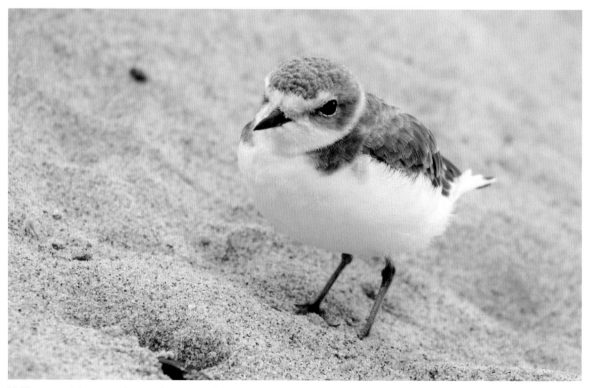

Neither one of these two images is necessarily better than the other. Each simply shows a different view of this cute shorebird at the Monterey Bay Aquarium. However, shooting a vertical version will pay off more times than you can imagine. Develop a habit of always thinking—right after you create a horizontal image—"Now it's time to take a vertical."
ABOVE: 1/500 SEC. AT f/8, ISO 1600, 70–300MM LENS AT 300MM; OPPOSITE: 1/640 SEC. AT f/8, ISO 1600, 70–300MM LENS AT 300MM

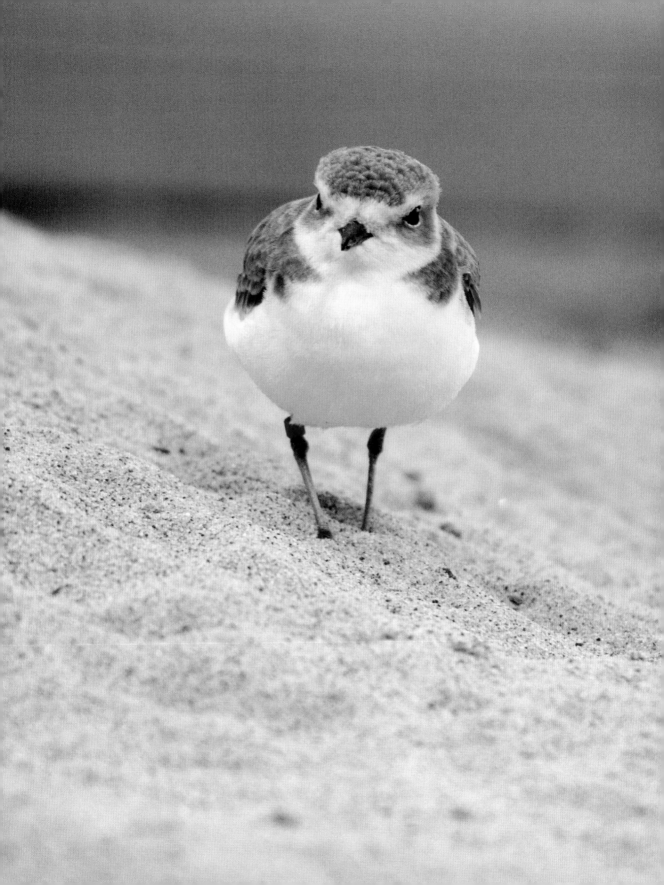

Five Wildlife Composition Tips

1 If it's safe, shoot from a lower position. It's important to do this only if it's safe because squatting down to a low position can trigger a predatory response in an animal. But, if it's safe, get down low when possible, and create images that show animals walking toward you through the underbrush and trees.

2 Do your best to make the most of the natural environment surrounding the animal. This will make a world of difference in creating photos that look convincing and natural. Your goal should be to go beyond the typical zoo picture. To do this, it helps tremendously if you include some of the animal's natural environment in the image.

3 It really helps when the subject of the photograph stands out from a contrasting background. Do your best to defeat the animal's natural camouflage system so that the eye can more easily enjoy the subject.

4 Compose to include every important part of the animal. For instance, if you're photographing a bobcat, the bobbed tail is its trademark. You certainly wouldn't want to exclude it in a full-body portrait. The ears on a lynx are one of its special characteristics; strive to keep them in your composition. Get in the habit of taking your eye on a tour around the frame of your viewfinder before you press the shutter. If you see something half in and half out, question your composition and consider changing your view to either exclude the element entirely (if it's not important) or include the whole enchilada, as they say.

5 If possible, use interesting lines to lead up to your wildlife subject. Always keep an eye out for geometric elements in the scenes you frame up. If you see interesting lines around the animal, or even as a part of the animal (as was the case in the image of a white ibis on page 194), be sure to make the most of this graphic element.

When making an animal portrait, it's perfectly okay to use the Rule of Thirds solely on the vertical axis. Especially when you're doing portraits in the vertical orientation, you don't need to arbitrarily move the subject from right to left. Instead, center the subject's eyes from side to side in the vertically oriented frame, and then place them on the upper third line of the vertically oriented Rule of Thirds grid.
1/90 SEC. AT f/5.6, ISO 100, 28–135MM LENS AT 135MM

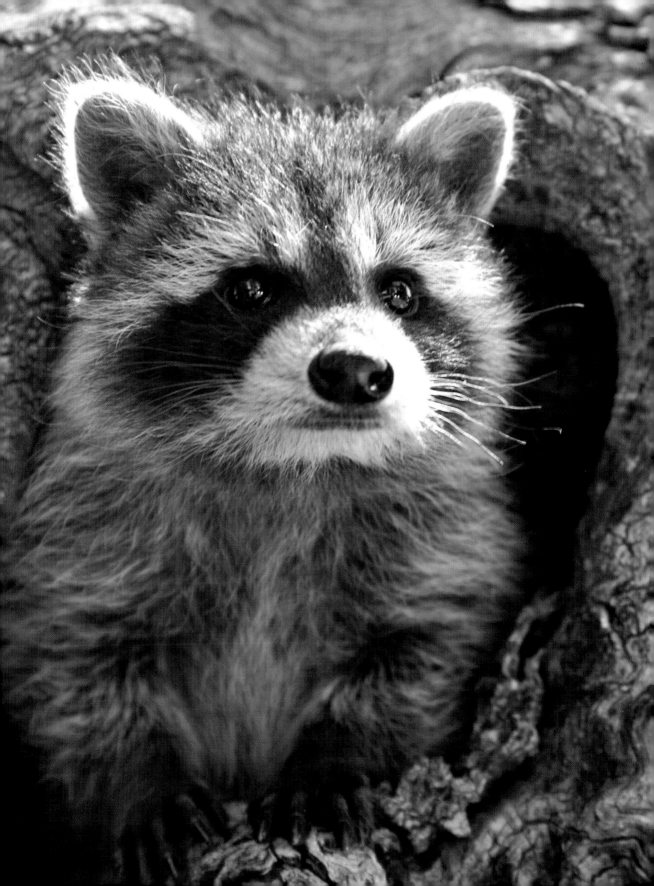

Digital Exposure and Wildlife

YOUR KEY CONCERN regarding exposure when photographing animals will be shutter speed. Most of the time, your primary need will be to make sure your shutter speed is fast enough. This fast shutter speed will allow you to freeze animal movements without any blur. To do this, use Shutter Priority mode and select a shutter speed of 1/500 sec. or faster, or try Aperture Priority mode and select an *f*-stop that results in a fast shutter speed. If you cannot get this fast 1/500 sec. shutter speed, even when your *f*-stop number is as low as it will go, consider increasing your ISO. It's much better to have a sharp, noisy (grainy) photo taken with a high ISO than a blurry, noiseless photo.

Having said that, I still strive to use the lowest ISO I can without creating unwanted blur from subject or camera movement. I find that I turn to a higher ISO in especially low light, when I don't want to use flash, when I'm handholding my camera, or when I'm photographing particularly active animals (such as birds in flight). These are the times that require a higher ISO, which in turn will afford me a fast shutter speed.

PLACEMENT OF ISOLATED FOCUS

Most of the time when I'm photographing wildlife, the light is low and, as mentioned above, my subject requires a fast shutter speed. The combination of these two conditions, plus with the fact that I prefer to use as low an ISO as possible, usually means that my aperture will be large. In other words:

Low Light + Fast Shutter Speed + Low ISO = Large Aperture Opening (small *f*-stop number)

This means that my depth of field will usually be somewhat shallow. It's a rare situation in which I have the opportunity to use a large *f*-stop number for depth of field. I can only do this when the animal is motionless, the light is bright, and/or I choose to use a high ISO. At all other times, my plane of focus will be limited. When shooting tight, close-up portraits, therefore, isolating the subject against a blurry background is usually not a problem. It's easy to keep the background out of focus with a shallow depth of field.

While this isolated focus can be great because it allows your subject to take center stage, you have to be careful about where you place the focus. Be absolutely sure to focus on the subject's eyes. Since animals move frequently and fast, the only way to ensure sharp focus on the eyes is to first lock your focus and then make several pictures, using your continuous shooting mode or motor drive to fire off a rapid series of photos.

Focus Modes: Single Shot vs. Servo Tracking

Most cameras simply focus on whatever object is in the center of the frame. Some cameras, however, give the user a choice between this centered-focus option and one that's designed to adjust focus as a moving subject travels through the scene.

After experimenting extensively with focus modes that promise to track the subject, I prefer to stick with *single shot* focusing most of the time, only resorting to the *servo*, or tracking, modes on occasion. When both prove inadequate, I prefocus or lock my focus on an object that's at the same distance that my subject will be. Like an actor on stage, the animal will ideally be at this "mark" when I press the shutter. I then turn my auto-focus off, wait until the animal is just about to make it to this mark, and take the picture.

BIRDS AND OTHER
FAST-MOVING ANIMALS

If your camera offers it, you can switch to a Sports mode, which favors exposures with faster shutter speeds. However, I prefer to manually change my settings so that I can stay in an exposure mode that keeps me in the decision-making loop. Instead of handing over the reins, and thereby nullifying my ability to learn, I keep my camera in Shutter Priority, Aperture Priority, or the shiftable Program mode. I turn to ISO 400 or higher, if necessary, to get a faster shutter speed.

As mentioned, I often need 1/500 sec. to sufficiently freeze the action. Sometimes, I can get away with 1/250 sec. or even 1/125 sec. if the bird isn't moving much. When forced to use a slower shutter speed, I rely on the continuous shooting mode (or motor drive) and fire off several images. This increases my odds of getting one picture that renders the bird in perfect sharpness.

There are two keys when photographing birds: magnification and speed. Attracted to the brilliant colors of this western tanager, my student Alicia Lehman zoomed in close and used a fast shutter speed. To get this fast speed, she set the ISO to 400 and the f-stop to the wide open aperture of f/5.6.

1/800 SEC. AT f/5.6, ISO 400, 70–300MM LENS AT 300MM

PHOTO © ALICIA LEHMAN

SHUTTER LAG

You absolutely need a camera that takes the picture when you press down the button. If you've recently purchased a compact (albeit expensive) digital camera and are experiencing this frustrating shutter lag, I recommend that you buy a digital SLR camera. If you cannot afford one now, start saving up. Using a camera without this shutter lag problem is essential to capturing the right moment when photographing wildlife.

> **TIP:** DO (SOME OF) WHAT HUNTERS DO
>
> Go to a local hunting supply store and look for two items: A game call (great for getting a brief moment of animal eye contact) and Jon-e hand warmers to place in your pockets when you're photographing wildlife in winter.
>
>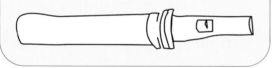

MINIMUM HANDHELD SHUTTER SPEED

If you're not using a tripod, the general rule when handholding your camera is to use a shutter speed that's roughly 1/focal length of your lens. When shooting with a 70–300mm lens at 300mm, strive for a shutter speed of at least 1/500 sec. However, getting such a shutter speed shouldn't cause you to put your tripod away. Use it every chance you get, unless it's actually causing you to miss the shot.

When you have a slower shutter speed or are using an extreme telephoto lens (such as the 10X options on some compact digital cameras), it is absolutely essential that you use your tripod to stabilize your camera.

If you use a lens with a feature called image stabilization (IS or VR for *vibration reduction*), it is a very good idea to turn this feature off while your camera is mounted on a tripod. The newer models do a better job, but older models actually cause vibration if used when mounted on a tripod.

TRIPODS

Even when shooting with a relatively fast shutter speed, use your tripod. This will greatly increase the number of keepers you get. If you find your tripod terribly frustrating, you may need to purchase a better model. Many of the less expensive tripods are difficult and frustrating to operate. Tripods by Gitzo or Bogen/Manfrotto offer quick and flexible controls that make using them much more practical. Furthermore, consider purchasing a ball head instead of the typical pan/tilt variety. This kind of tripod head will allow you to change your view quickly and follow your subject, while still retaining the additional stability you need for tack-sharp photos.

> ## Ideal Wildlife Settings
>
> **Shutter Speed**
> A shutter speed of 1/125 sec. is generally the slowest that I want for most wildlife. A speed of 1/500 sec. or faster is ideal but low-light conditions will often make this difficult to achieve without increasing the ISO or *f*-stop number. Sometimes, I can get away with slower than 1/125 sec., but I've found that using 1/125 sec. results in many more keepers.
>
> **Aperture**
> If the subject is moving fast, is in low light, or is somewhat far from the camera, I tend to shoot wide-open—at the lowest *f*-stop number available.
>
> **ISO**
> I strive to keep my ISO at around 100 unless I need to increase it to achieve a fast enough shutter speed.

This portrait of a Siberian tiger in winter (opposite) features excellent eye contact. I couldn't have caught this moment without the fast response my digital SLR offers.
1/125 SEC. AT f/4.5, ISO 200, 100–300MM LENS AT 190MM

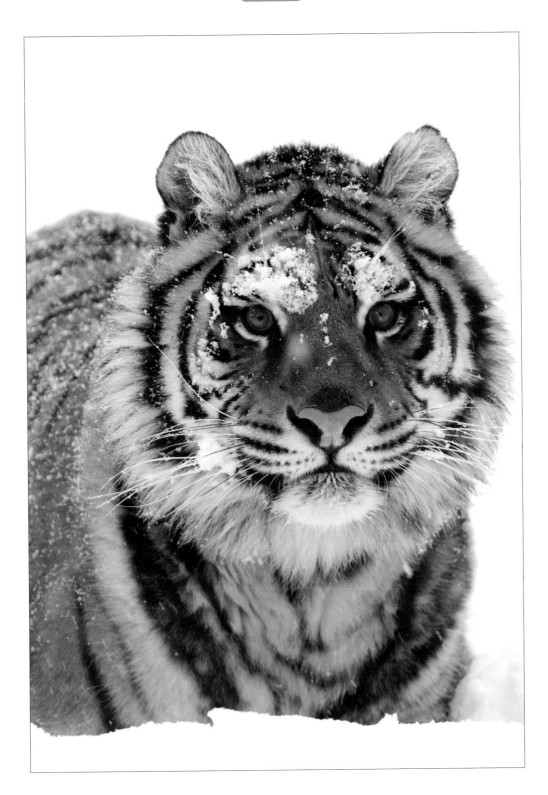

Breaking the Rules with Animals

NOW THAT YOU'VE LEARNED the general guidelines to keep in mind when photographing wildlife, let's toss them out the window!

CENTER YOUR SUBJECT

Although I'm a big fan of the Rule of Thirds, there are times when centering your subject will have more impact. Experiment with various compositions as you shoot. If you notice that a completely centered subject has more punch, or feels more humorous (if that's the effect you're after), then go ahead and use a centered composition. If you decide to do this, just be sure you don't include an inordinate amount of negative space around your subject.

In this image of a Harris hawk, I centered the main point of interest—the piercing eyes. This goes against the traditional Rule of Thirds, which I often employ. In this case, the centered placement accentuated the effect of that arresting stare, so it was the best composition for this subject.

1/125 SEC. AT f/5.6, ISO 100, 28–135MM LENS AT 135MM

Asset Management

I have a story to tell you. It's called "The Rise and Fall of Jim's Favorite Photos." It's a cautionary tale, one that I hope will motivate you to be very careful with your digital images. I should preface it by saying that I have accidentally deleted photos before. This was not the first time. On a previous occasion, I had accidentally deleted photographs, and when that happened, I learned many things. One was to stop using a memory card once you realize that you've accidentally deleted good image files. As long as you don't keep shooting, you have a good chance, through the use of special recovery software, to bring your photographs back from the dead—even after you've deleted them.

And now to my story: On a recent trip, I spent thousands of dollars and traveled to the far side of the world to get photos. If I had gone any further, I would have been returning home. One day on this trip, I got the photos I wanted and had a great time in the process. Later that day, I got mixed up and reformatted my memory card. It was a full 4 GB card, so many images were deleted (including the cute lamb pictured on page 216).

Unaware that I had reformatted the wrong card, I proceeded to fill it with new photos. I off-loaded these and reformatted my card again. Twice! It was only then that, with a great sinking feeling in my heart, I realized how I'd gotten mixed up. I used recovery software, and honestly, I'm amazed that it retrieved any images at all. It actually pulled back about sixty photographs after the card had been formatted twice. But, wouldn't you know it? All of my favorite images were destroyed.

What's the moral of the story? There are actually two. First, you can recover images that you've deleted, as long as you stop using that card immediately. Second, you can save yourself this heartache altogether by being organized and taking the following suggestions to heart. These are the resolutions I developed after going through this experience:

❏ Always free up as much hard drive space on your laptop or portable storage device—*before you leave home*. Archive everything you can. Don't plan on burning things off and making room while you're traveling. It's much too difficult to find the time to do this while you're on the road. You will be more likely to rush and make mistakes. Clear your storage space before you leave. I calculate an average of what I shoot each day (4 GB). So, for a ten-day trip, I would need at least 40 GB of free space.

❏ If you use multiple memory cards, number them with a permanent marker (and you might as well put your name and contact information on them, while you're at it). Using them in a numeric order can help you stay organized.

❏ Use a separate portable storage device to hold a second, backup copy of what you shoot. Have two copies of everything until you get home.

❏ Don't weed out those dud images while you're on the trip. Let it go. Enjoy the trip. Do the deleting at home later.

❏ If you get in a bind and have to burn CD-ROMs or DVDs, be sure to burn two copies, to verify what you burn, and to bring along protective jewel cases. I've also lost images due to faulty CD burners and scratched disks. Now, I avoid burning while on the road and use an Epson portable storage device to store backups of my images, in addition to those archived on my laptop, until I get home.

INCLUDE MORE

I usually advise beginning photographers to trim things down—to move closer to the subject—since it's usually better to simplify the composition. To do this, the general tendency is to reach for the telephoto lens with wildlife. It lets you get tight portraits without including anything in the picture that might distract the eye from the subject. However, this sometimes produces images that lack excitement and visual interest. If you find that all of your wildlife portraits look static, like headshots, you may want to go in the other direction and shoot with a wide-angle lens.

Using this lens can often enable you to show more of the animal's environment. You may be able to place the subject according to the Rule of Thirds and depict what life is like in those surroundings. In addition, you can go further and have even more fun. Wide-angle lenses can be great for close-up portraits with a great deal of distortion. When done successfully, this can add a fun, humorous element to your animal images.

Whenever the environment lends itself to a wide-angle interpretation, be sure to try it out. Sometimes, it doesn't work. And sometimes, you can't use a wide-angle lens, not because the environment is distracting or the subject doesn't look good, but simply because it would be too far away or too dangerous. Use your best judgment. If getting close to make a wide-angle portrait would endanger you or others, for example, forego it and continue shooting from a safe distance. Many times, however, you'll find that it is just the rule-breaking technique you need to create unique wildlife photos.

ASSIGNMENT **Practice both Prolific and Selective Photographing**

Before you head out on this assignment, make sure you're fully prepared. Set your camera to continuous shooting mode or use a motor drive. Make sure you have enough memory card storage on hand to be able to shoot a consecutive series of images without fear of running out of memory. Put fresh batteries in your flash and camera, and have spares in your pockets.

This assignment has two parts. For the first part, photograph animals *prolifically* for one month. By *prolifically*, I mean *a lot*! Whenever you come upon an animal you'd like to photograph, make at least ten different interpretations of it. Select different lenses, points of view, compositional techniques, times of day, proximities, and exposure settings. Photograph your one subject in as many different ways as you can. Don't bracket, though. Instead, choose exposures that change the creative effects in your photo (for example, changing depth of field or motion blur).

For the second part, photograph *only one* interpretation of each animal subject you come upon for the next month. This means one view (you can snap a few images of that same view, if you like, to ensure that you get a keeper). You can only create one kind of interpretation, however. So, be selective. Think about what would most express the character of your subject, then fire off a few shots and consider yourself done.

After you complete both parts of the assignment, compare the photos from each working method. Which images do you like better? Which techniques produced the better results, working prolifically or working selectively? Whichever you prefer, use that style from now on.

By photographing this mountain lion looking away from the camera and into the scene, I feel I give viewers an opportunity to identify with the animal, as if they were looking over its shoulder.

1/125 SEC. AT f/6.7, ISO 100, 28–135MM LENS AT 135MM

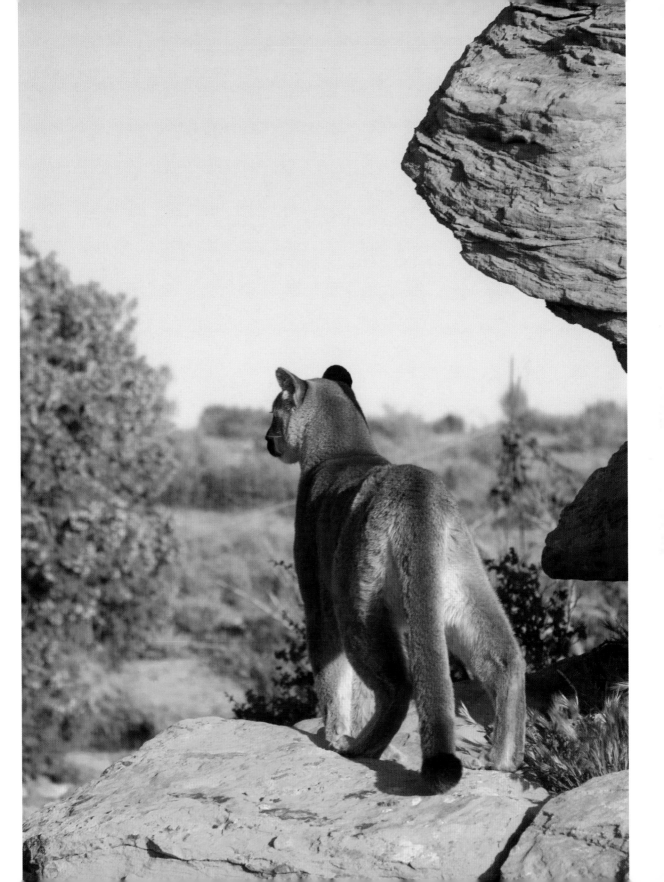

USE INTENTIONAL MOTION BLUR

Experiment with panning—following the movement of the animal with your camera to render a relatively sharp subject against a blurred background. This produces images that more successfully convey the feeling of speed than do static versions.

Panning is most effective when you photograph as the animal is running at a right angle to you (right in front of you). Choose a slow shutter speed (somewhere between 1/30 sec. and 1/125 sec. depending on the speed of the animal and the weight of your lens). Then, prefocus your camera and pan the action as it passes. With practice, you can use this technique to get some cool motion-blur images.

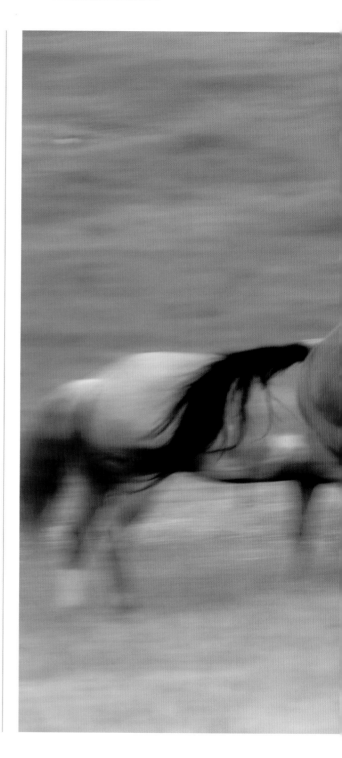

This is an example of panning, or tracking, an animal as it passes you. With a slow shutter speed, you can sometimes blur the background while keeping the subject relatively sharp. This takes a great deal of experimentation, so don't feel bad if you don't get a winner in your first few tries. I often have to take ten or more panning images to get one keeper. Here, with my large, heavy lens, I found that shutter speeds in the 1/90 sec. to 1/125 sec. range were ideal. The shutter speed was slow enough to blur the background but not so slow that the entire image suffered from camera shake.

1/90 SEC. AT f/4.5, ISO 400, 100–400MM LENS AT 175MM

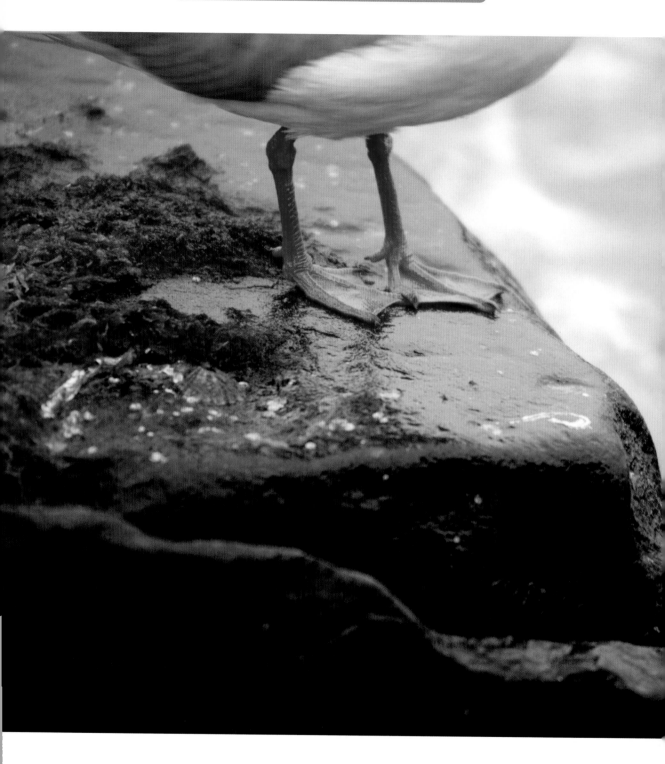

USE CREATIVE CROPPING

Most people assume that a good wildlife photograph must include every part of the animal. This is not always true. Sometimes, you'll find that your images are more effective, creative, and powerful when you include only a small part of the animal. Zooming in on this one detail will often give you a more suggestive image—one that triggers the imagination. When you can tickle the imagination, you're creating an emotional response. You get viewers interested in your image, and that's a very good thing.

Take a look at this close-up of a gull's feet. Of course, most of the time you would endeavor to include the entire animal in your composition—or, at least, the most important parts, such as the face and eyes. When photographing this gull, however, I was much more attracted to its bright feet. So, I creatively composed in a way that would feature those details. The end result obeys the Rule of Thirds but breaks other rules, and the effect is a unique and somewhat humorous image.
1/20 SEC. AT f/5.6, ISO 200, 70–300MM LENS AT 300MM

Final Thoughts: The Five Most Important Lessons

I never get a chance to tell students the most important ingredients. Everyone always wants to learn about things like exposure and composition. While these are important, the following, deeper—dare I say, spiritual—concepts will actually play a much bigger part in your photographic success. These are the things that will most help you the make outstanding imagery:

❑ **Don't be afraid.** All too often, fears of every size and flavor interrupt the creative process. Find a way to deal with anxiety so that you can set yourself free to explore, create, and enjoy. Two things I often do are breathe deep and fill my thought with my goal—what I want, rather than what I do not want, to happen.

❑ **Have patience.** Whether photographing wildlife or waiting for the best light to illuminate your landscape, you need to be *able* to wait. By this, I don't mean to simply do nothing, however. That's a sure way to make patience only something saints can achieve. Instead, fill the time with something else. Consider everything you're grateful for, mediate, think up other kinds of images you'd like to create. As they saying goes, "Wherever you go, there you are." Enjoy the moment as you wait for your subject or the light to be at its most photogenic. Often, I keep myself occupied by photographing other nearby subjects.

❑ **Make time.** Get out there. Plan a trip. There's nothing better than actual experience when it comes to improving as a photographer. If you haven't done the assignments in this book, browse through the choices now that you've had a chance to get to know all your options. Select one and go for it.

❑ **Take baby steps.** Approach each challenge in a way that feels right to you. I find that the best way to do this is simply to ask myself (often), "What's

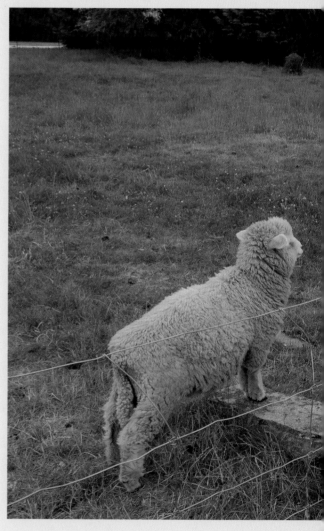

next? What am I most interested in or fascinated by? What do I love about this area, subject, or scene?" Answering these questions thoughtfully will lead you in the right direction on your photographic endeavors.

❏ **Use your infinite resources.** Patience, creativity, energy, and love. Consider what you've been given, instead of what you need. Then you'll make the most with what you already have and with what is right in front of you. In this process, you will find more and more options and opportunities.

If you would you like to learn more, boot up your computer and stop by www.BetterPhoto.com. There you will find a fun and friendly group of photography enthusiasts, tons of free articles, and a great place to share your photos. We also offer online photography courses. Have fun getting out there and making better photos than you've ever made in the past!

PHOTO © JANA JIRAK

Resources

CAMERA GEAR, PHOTO INSTRUCTION, AND TRAVEL PLANNING WEB SITES

These are just a few of the many helpful Web resources out there. Plus, don't forget your local camera stores and businesses; you might get higher prices at first, but the payoff comes in increased, direct customer support.

Arca-Swiss, Kirk, and Really Right Stuff

In addition to purchasing tripod legs, you'll need a great tripod head. You can buy one from Bogen/Manfrotto, Gitzo (see their listing below), or another company like Arca-Swiss, Kirk, or Really Right Stuff. Really Right Stuff also makes plates that lock perfectly onto your camera, allowing you to attach your camera to your tripod head in an efficient way. Arca-Swiss's Web site was under construction at the time of this writing, but you can find plenty of information about their excellent tripod heads at Really Right Stuff or through a Google search.
www.kirkphoto.com
www.reallyrightstuff.com

B&H Photo

Both a Web site and a camera superstore in New York, B&H offers extremely low prices, a huge selection, and a knowledgeable, helpful staff.
www.bhphoto.com

Better Beamer and Lumiquest

These devices will help you diffuse or project the light from your external flash. Visit your local camera store or the Lumiquest Web site for information regarding the many products available for this use. My favorite is the Lumiquest Pocket Bouncer. If you often photograph birds and wildlife from a distance, learn more about how the Better Beamer works or how to purchase one by searching the Web.
www.lumiquest.com

BetterPhoto

Even if I were not its president, I'd vouch for this site as the best photography resource on the Web. We have the world's best online photographic education—courses in which you get to shoot and upload assignment photos so that they can be reviewed. In this way, you get direct feedback from top-notch professional photographers. You'll also find a fun photo contest, a Q&A section, the Trip Planner, as well as a very supportive community.
www.betterphoto.com

Bogen/Manfrotto and Gitzo

These two companies make the best tripods. Especially if you find your inexpensive tripod so frustrating that you never use it, consider purchasing a Bogen or Gitzo tripod. They cost more, but they are worth every penny. Which brand you choose depends upon your personal preference. Many pros love Gitzo because the tripods are lightweight, sturdy, and require no extra tools to maintain. I use a Bogen/Manfrotto because I find it equally light and sturdy, and in addition, I like the ease of the quick-release levers and leg controls.
www.bogenimaging.us
www.gitzo.com

Cokin and Singh-Ray

Cokin offers inexpensive filters, including the square/rectangular ones that I recommend. Singh-Ray manufacturers the absolute best filters, but they're expensive. You might want to start with a few Cokin filters, and then as you learn how helpful these filters are you can upgrade to the high-quality Singh-Ray options. Or, if you already know you're going to love neutral-density and graduated filters, cut to the chase and save yourself a little money by using Singh-Ray right from the beginning.
www.cokin.com
www.singh-ray.com

eBay

With so many people selling both new and used digital cameras, lenses, tripods, flashes, accessories, laptops, desktop computers, portable storage devices, you name it, eBay has become a great resource for shoppers. Try the Buy It Now option if you don't want to wait through an auction. And always check the feedback on your seller; make sure he or she has a good record with many past sales and many positive comments from previous buyers. Also keep eBay in mind when it comes to selling your own equipment. It's a fantastic way to make some money back on your old gear as you upgrade.
www.ebay.com

Epson

I love my Epson inkjet printer. I also highly recommend Epson's portable storage device. It will give you peace of mind when you're traveling on a photo adventure. I transfer images from my CompactFlash card to this device as well as to my laptop before reformatting my card. This lets me rest assured that I have my work backed up in two places before I move on to the next shoot.
www.epson.com

Expedia, Orbitz, and Travelocity

When I travel, I first check my preferred airline (Alaska Airlines—they're the best!). If I can't find flights at AlaskaAir.com, I go to Expedia, Travelocity, or Orbitz. These online travel agents give you full control and many options when it comes to making your travel arrangements. You can even book hotels, rental cars, and more.
www.expedia.com
www.orbitz.com
www.travelocity.com

Hotwire

If you don't need to stay in a particular hotel or rent a car from a particular rental company, try Hotwire. This service has often led me to the best deals. As long as I have some flexibility, I check Hotwire to see if I can save a great deal of money—before I book through the above travel agent sites or directly with the hotel or rental company.
www.hotwire.com

Lensbabies

If you're using an SLR digital camera (one on which you can change lenses), you might enjoy using a Lensbaby. These fun, creative little devices allow you to easily bring one spot in a scene into focus, while rendering the rest of the scene gradually blurred out. You can also create such effects a photo-editing program like Photoshop, but you can save yourself time and create this effect while you're shooting with the help of a Lensbaby.
www.lensbabies.com

MyDigitalDiscount

An online reseller offering incredible deals on memory cards, adaptors, and card readers. As I said in my previous book, I go here first when I need to add to my supply of memory cards.
www.mydigitaldiscount.com

The Weather Channel

As digital nature photographers need to get out early, know the weather, and plan accordingly, it's essential to first check the forecast. I don't check the weather to see if I will be heading out. By the time I check the weather, I am already committed to getting out there; the forecast simply helps me know what kind of photography I'll likely be doing. Even if it's inaccurate, it gets me thinking about what photo ideas I can pursue. Much more accurate than the weather forecast, times for sunrise, sunset, tides, and other variable conditions also greatly help me plan when and what I'll be shooting. To find a good sunrise/sunset calculator, simply Google that phrase; you'll be led to many options.
www.weather.com

SOFTWARE

Adobe Photoshop

Adobe has created—and continues to improve—what is, in my opinion, the world's best software for digitally

manipulating and optimizing photographs. Whether you're interested in simple cropping or sophisticated color enhancement, Photoshop and Photoshop Elements are two fantastic tools for digital photographers. Also, if you're struggling to view and edit your raw files, visit Adobe.com for the latest camera raw definitions. www.adobe.com

Recovery4All.com

This data recovery software is a bargain, considering what it can do for you. If you ever have the unfortunate experience of deleting precious photos, stop what you're doing, download this software, and see if it can recover what you've lost. You may just be pleasantly surprised. dmoz.org/Computers/Hardware/Storage/ Data_Recovery/

MY SEVEN FAVORITE NATIONAL PARKS (PLUS ONE OTHER NATURE RESOURCE)

Be sure to consider spending time in one of these amazing locations or the national park of your choosing. To learn more about any of our great national parks, browse Tim Fitzharris's excellent book on the subject (listed on page 222), or visit the main National Park Web site at www.nps.gov.

Death Valley National Park

This deep gouge in the California desert may be North America's lowest, hottest, and driest place, but from autumn through spring, it's an exciting expanse of color, light, and life. Attractions include a 100-mile valley, rugged canyons, wrinkled hills, snow-capped mountains (of up to 11,000 feet), Badwater (282 feet below sea level), a real-life mirage (Scotty's Castle), and a townlike oasis (Furnace Creek). The best times to photograph are the early morning and late afternoon, when low-angled sunlight casts a warm glow and creates dramatic shadows (perfect for sand dunes), and at dawn and dusk, when the twilight colors turn Death Valley into a magical—and even surreal—desert showplace. www.nps.gov/deva

Glacier National Park (Waterton-Glacier International Peace Park)

Glacier is well known for it's awesome photographic opportunities all throughout the park, especially at Wild Goose Island and along the Going-to-the-Sun Road. Summer is a great time to visit Glacier, with the possibility of photographing alpine wildlife such as mountain goats, bighorn sheep, and perhaps even a moose. In July and August, you might be treated to some awesome wildflowers, too. While you're there be sure to also visit Waterton Lakes just across the Canadian border. www.nps.gov/glac

Mount Rainier National Park

If you like waterfalls, silky streams, snowy peaks reflected in still lakes, forests laced with swirling mist, and fields of sub-alpine wildflowers, look no further than Mt. Rainier. This peak is an active volcano (though not as active in recent times as Mount Saint Helens further to the south). There's so much to photograph here that you should plan to spend lots of time (avoid the weekends if you're visiting in the summer). As at Glacier and many other wilderness parks, July and August can be the best months to take pictures here. Just be prepared to patiently cope with the crowds and traffic. www.nps.gov/mora

Redwood National Park

When my wife and I were first married and attending UC Berkeley, we would occasionally drive up to Redwood. What a treat! Every time, we returned to the cement campus feeling refreshed and invigorated. The trees themselves are awe inspiring—soaring to heights of over 300 feet and carrying a history sometimes spanning back two centuries. And, the photographic opportunities aren't limited to the trees. There are fern forests, seascapes, and Roosevelt elk (visit Prairie Creek Campground for this, our favorite along with Jedediah Smith to the north and Patrick's Point to the south). If you're up for a hike, try Fern Canyon; you won't be disappointed. www.nps.gov/redw

Yellowstone National Park

The first national park, Yellowstone features bubbling hot springs, powerful geysers, bison, elk, bear, coyote, and so much more. It's impossible to capture Yellowstone in a brief paragraph; it is unparalleled. All I can say is if you plan to visit, give yourself at least a week to explore this wonderful park. Winter is a great time to photograph wildlife, while summer offers more pleasant temperatures (and greater crowds, of course). Whichever season you visit in, you'll lose yourself in all the possibilities found in this park.

www.nps.gov/yell

Yosemite National Park

If you love waterfalls, dramatic views, and serene settings, you'll love Yosemite Valley. There's a reason why this national park has attracted great photographers such as Ansel Adams, Galen Rowell, and countless others—it's a magical place. Since it's so popular (among photographers and non-photographers alike), I recommend that you visit either during the shoulder season (just before or after summer) or, better yet, during winter. You can't ask for anything better than Yosemite after a winter storm. Winter wonderland doesn't even begin to describe it.

www.nps.gov/yose

Zion National Park

There are many amazing parks in southern Utah and northern Arizona (including the Grand Canyon, Bryce, and Canyonlands). However, for red rocks, towering eroded mesas, glowing walls inside slot canyons, and snow-dusted stone (in winter), my favorite is Zion. Early spring and late autumn are great times to visit, when it's cooler and you have a chance of getting some snow. You can also visit during the warmer times, but be warned—you want to get your shooting done early and have plenty to do indoors during the hottest parts of the day.

www.nps.gov/zion

Triple "D" Game Farm

Obviously, this is not a national park, but if you love animals and would like to photograph them outside of a zoo but still without invading their habitat or spending weeks tracking them, consider a photographer's game farm. Such companies as Triple "D" in Montana offer excellent photography sessions that balance animals' needs with photographers' needs (such as safety as well as great photo opportunities). Jay and Kim Deist run an excellent service and are highly recommended for animal lovers and wildlife photographers.

(406) 755-9653

www.tripledgamefarm.com

Suggested Reading

Creative Nature & Outdoor Photography
by Brenda Tharp (Amphoto Books, 2003)
A world-class photographer as well as a fantastic instructor at BetterPhoto.com, Brenda covers everything you need to know in this beautiful, eye-opening book. Her goal is to help you expand your vision and discover the deep wellsprings of creativity within you—and she succeeds.

Digital Landscape Photography by Tim Gartside
(Muska & Lipman, 2003)
I might disagree with a few minor things in this book, but despite this, I found Tim Gartside's book an inspiring and helpful guide. With tips, step-by-step instructions, and stunning images throughout, the book is beautifully designed and easy to read.

Digital Nature Photography Closeup by Jon Cox
(Amphoto Books, 2005)
This book is gorgeous! Jon really has outdone himself. The photos are not just accurate, naturalist recordings of nature—they go far beyond that. They are inspiring and will motivate you to become both a better photographer and a better person—one who treats the environment with respect. Jon's writing is accessible, accurate, and useful. I particularly benefited from his explorations of the histogram, camera raw, and the digital darkroom. Highly recommended.

Fine Art Flower Photography by Tony Sweet
(Stackpole Books, 2005)
This book takes a different approach than most. Instead of including pages and pages of text, with a few photo examples spread throughout (or worse, inserted into the middle of the book), this guidebook is all about inspiration. It features one huge image per spread, each with a caption explaining Tony's technique. It's refreshing, inspiring, and a surprisingly effective way to learn how to photograph flowers.

John Shaw's Nature Photography Field Guide
by John Shaw (Amphoto Books, revised
edition 2000)
Comprehensive, detailed, and pragmatic, John Shaw's field guide is a must for every nature photography enthusiast. Digital photographers may find the references to film outdated, but you'll find every other aspect of this guide to be extremely helpful, especially with regard to exposure. Also, has great tips on composition and practical guidelines to use when preparing for a trip or when out in the field. Every aspiring nature lover should have a copy of this book. (Also take a look at John Shaw's Focus on Nature, another fantastic book from John Shaw.)

National Geographic Photography Field Guide:
Landscapes by Robert Caputo (National
Geographic Society, 2001)
Following up on the great National Geographic Photography Field Guide, this thinner guidebook focuses specifically on landscapes—and shines in the process. Every chapter is packed with world-class photography tips. Most of the excellent examples are by Caputo himself, but outstanding photographers such as Sam Abell, Bruce Dale, and James Blair have also contributed many stunning photos. This book is a clear, honest, and practical guide, full of techniques that work.

National Park Photography by Tim Fitzharris
(AAA, 2002)
This book is so beautiful and so inspiring that, after reading it, I made a plan to visit twenty-four national parks over the next four years. Tim is a truly amazing nature and wildlife photographer. What's more, his ability to write far outshines the competition. His text is filled with practical, helpful tips—the kind of information you would really use. If you find your greatest sense of peace and tranquility once inside one of our great national parks, you'll love this book. It's a true gem.

Index